MORE
Fantasy Art
MASTERS

MORE Fantasy Art MASTERS

The Best Fantasy and Science Fiction Artists Show How They Work

DICK JUDE

Watson-Guptill Publications / New York

First published in the United States in 2003 by Watson-Guptill Publications,
a division of VNU Business Media, Inc., 770 Broadway, New York, NY 10003
www.watsonguptill.com

First published in 2002 by
Collins, an imprint of
HarperCollins*Publishers*
77-85 Fulham Palace Road
Hammersmith, London W6 8JB

Library of Congress Cataloging-in-Publication Data

Jude, Dick.
 More fantasy art masters : the best fantasy and science fiction artists
show how they work / Dick Jude.
 p. cm.
First published in 2002 by Collins, an imprint of Harper Collins,London.
Includes bibliographical references.
 ISBN 0-8230-3127-6
 1. Fantasy in art. 2. Science fiction--Illustrations. I. Title: Best fantasy and
science fiction artists show how they work. II. Title.

N8217.F28J835 2003
741.6'092'2--dc21
ISBN 0-8230-3127-6 2002154358

Editor: Diana Vowles
Designer: Colin Brown
Photographer: Richard Palmer
Art direction and jacket design: John Thompson

Color origination by Colourscan, Singapore
Printed and bound by Imago in Singapore

1 2 3 4 5 6 7 8 / 09 08 07 06 05 04 03

Page 1: Dave Seeley, *Dream Thief*
Page 5: John Harris, *The Building of Babylon* (preliminary sketch)
Page 6: Anne Sudworth, *Ash Trees at Long Meg*
Page 7: Darrel Anderson, *pipeDream*

To Alison, Rhiannon and Felix, who were here
but didn't see much of me,
and to Eileen, Paul and Damian,
who I wish could have been here to see it all.

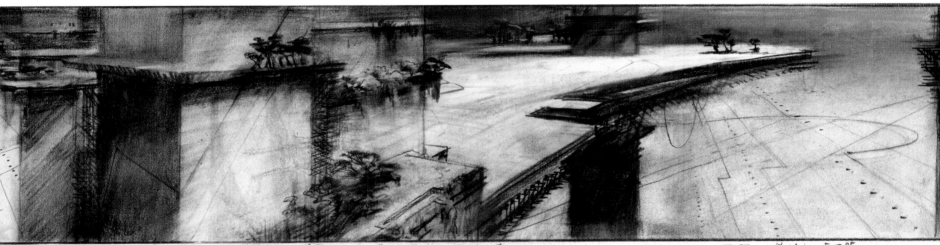

gh for The Building of Babylon - Mastery of Change Client - Imagination John Harris '1985.

Acknowledgements
Sincere thanks must also be offered to Cathy Gosling and Caroline Churton
at HarperCollins, whose patience was certainly tested this time.
To each of the artists for their unlimited generosity of time, co-operation and support.
To Diana Vowles for once again agreeing to work with me.
To Colin Brown for designing the pages.
To Alison Eldred, surely the patron saint of all lost fantasy artists?
To Iain Emsley for his last-minute help with the words and to Jenny Abrook
for unscrambling a potential digital nightmare or two.
Your contributions eased my stress levels considerably.

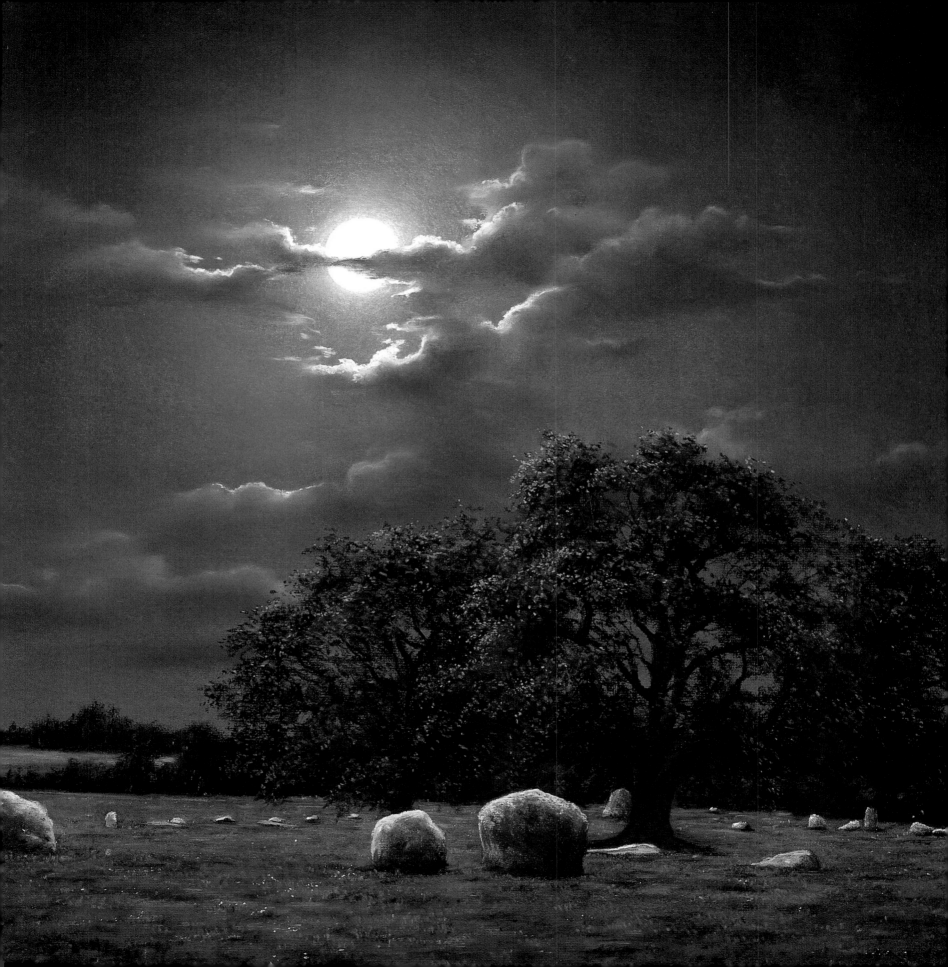

CONTENTS

INTRODUCTION

Fantasy is a very open-ended term, and a word that means many things to many people. To much of the movie-going public, in this age of Tolkien and George Lucas, it immediately brings the promise of pixies and princesses, wizards, dark lords and starships. To others, the term brings to mind the imaginative stimulation provoked by the unreal worlds of Brueghel, Bosch and the Surrealists. The sheer "fuzziness" of the term also allows the pictures in this book to sit comfortably beside each other, as it works equally well whether describing the range of science fiction paintings or the warrior-and-dragon type of image popularized by the term for centuries.

Here be dragons

Ron Tiner points out in the *Encyclopedia of Fantasy* (Clute & Grant, Orbit, 1997), that the fantastic representations of beasts in cave paintings at Altamira and Lascaux are legitimate examples of early fantasy art that predate the term fantasy. Throughout the history of the human species, art has been used as a language to describe the known and to interpret the unknowable. As early humans struggled to explain the mysteries of the biosphere, its weather systems and natural disasters, all kinds of theories were advanced and accepted as attempts to rationalize the frightening unpredictability of the world in which they found themselves and, as we all know, one picture can speak louder than a thousand words.

Explorers returned from their journeys telling tales of all manner of impossible creatures which were promptly recreated in pictures and statues and sincerely believed in for centuries until science and archaeology began to sort out the fact from the fiction. That said, even in an age where we can calculate the elements in distant stars and clone life, the dragon is still as potent a symbol worldwide as it has ever been. A complete stranger to our planet would find so much evidence of this fantastic creature in pictures, carvings and words scattered across the cultures of the world that they would surely assume they would eventually find this mythical beast living somewhere.

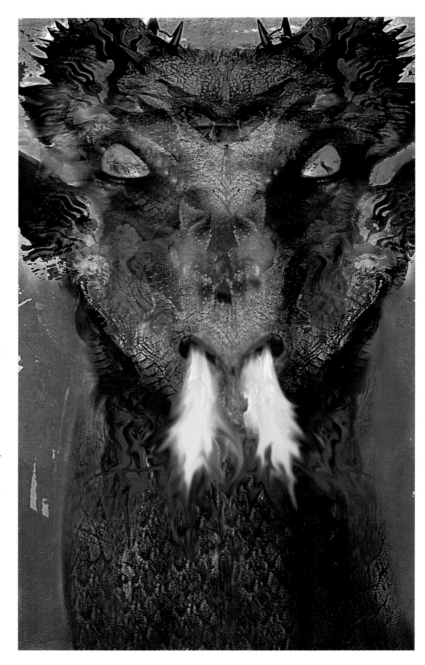

Greg Spalenka
Dragon
Digital, 2000

Renaissance men

Throughout the Renaissance art became increasingly stylized, with rules not only for composition but also for the presentation of the characters depicted. Almost all European paintings dealt with scenes from the Bible and the classical literature of antiquity, but using symbol systems so developed that a good education was needed for a full understanding of the content. The paintings of Brueghel and Bosch are still admired today as works of inventive fantasy but were originally meant to be viewed and appreciated within the framework of orthodox Roman Catholicism as allegorical visions of human foibles. These were effectively paintings that would have appeared on book jackets had there been a populace that had been taught to read and the mass-market publishing that stocks bookshops today. Such complex symbol systems certainly appear within the conventions of the fantasy genre, but they are nowadays occasionally subject to ridicule that would have brought down a terminal visit from the inquisition in times of yore.

The 19th and 20th centuries released a cascade of highly stylized, fantastic schools of art. As it had originally brought tales of fantastic lands and beasts, exploration now brought the art of Japan and Africa to the notice of European artists. From Japan, a more limited color palette and with it a new sense of color harmony was absorbed from the woodblock prints of Ukiyo-e by the Impressionists. From African sculpture the artists Braque and Picasso began to form new ways of negotiating the impossibility of representing three-dimensional images on a two-dimensional plane. Their work initiated the Cubist movement in their attempts to present several planes of an object as one painting in a highly stylized geometry. The Surrealists seized on the new theories of psychoanalysis and attempted to portray images straight from the subconscious. In the 1900s fantasy art finally came of age and it was small wonder that the ever-growing book business seized on such potential and a major genre of literature and art was born.

With conventional rules of perspective and classical composition discarded in search of a more honest form of picture-making, much art became even more fantastic and other-worldly. The artists became more concerned with the nature of the materials chosen and the resultant surfaces that were created took mainstream art further from the cozy traditions of portrait and landscape painting. The understanding dawned that the term "representation" was in fact a "re-presentation" of the subject the artist had chosen to portray—a point of view individual only to the creator of the piece, to all others effectively a fantasy into which they could read whatever they wished.

Darrel Anderson
Chess Bone City (*detail*)
Digital, 2000

21st-century fantasy

This new book resulted from the interest generated by the first volume, *Fantasy Art Masters,* in which many well-known artists discussed their approach and techniques. The range of images offered within that collection were primarily painted or digitally produced, but there are many more ways of producing a picture than this. This new book also explores the creative processes and inspirations of illustrators and artists but it covers a wider variety of styles than its predecessor.

Painting is well represented by the work of Keith Parkinson, whose accomplished acrylic and oil paintings have graced the covers of many books by the best fantasy authors in the field and many fantasy game packages. Phil Hale's fine art approach to oil paint is less illustrative and is driven by the challenge of developing his brushwork and his responses to the subject matter into the perfect expressive tools. He eloquently describes the problems that a career in illustration imposes for an artist with these drives. Judith Clute shares with us how she solved her desire to paint landscapes while living a dedicated urban existence by fusing people, animal and snatches of classical art into surreal juxtapositions that suggest both landscapes and stories.

The medium of pastels and Conté was entirely missing from the first book but is beautifully represented here in the work of Anne Sudworth, who uses this emotive medium to great effect in her night-shrouded pictures of trees, skyscapes and ancient monuments, and in the work of John Harris, whose pictures show us scenes on a giant scale at the limit of description. His pastel work not only gives him a swift means of getting the pictures onto the paper but in many ways allows him to create more fluid and less specific pictures. Because of this, his sketches are as important as the final painted, published version and, in many ways, more satisfying. He too admits that he sometimes finds illustration rather confining.

Greg Spalenka brings a whole range of techniques to his art, all neatly encompassed by the term mixed media. Collage and painting are the primary tools for creating many of his pictures, sometimes augmented with photography and computers. Several pieces in his section also show how fantasy illustration functions as socio-political commentary. The highly distinctive art of Ian Miller has long been identified with his meticulous pen-and-ink illustrations as well as his slightly macabre and menacing images. Yet it is photographer J. K. Potter, using traditional darkroom techniques of blending negatives at the printing stage, as well as collage and hand tinting photographs, who has delivered the most visceral images in this collection. His is an individual creative voice in an age when the computer is the tool of choice for this type of image-building.

It would be entirely unrepresentative to present a collection of leading-edge artists without the inclusion of some practitioners of digital art, and this book is blessed with two of the best. Architect-turned-artist Dave Seeley masterfully manipulates the tools of Photoshop and digitally blended photographic images to produce quite dazzling pictures for magazines and book cover illustration, while Darrel Anderson shows us the stunning pictures his self-created digital tools can be used to produce and discusses his creative technique in particularly painterly terms.

Judith Clute
Meniscus
100 × 70 cm (39 × 27¹/₂ in)
Oil on canvas, 2000

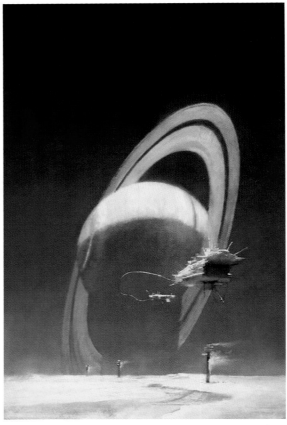

John Harris
Saturn
89 × 58.5 cm (35 × 23 in)
Oil on canvas, 2002

It should be pointed out that to enable the work of these highly talented artists to be assembled in book form, many of the pictures reproduced here are seen at only a fraction of their true size. Those from digital files have no dimensions in their captions as this is an arbitrary measure, but many of them can be printed on sizes of A1 and above. The dimensions of some of the traditional paintings give a clear indication of the scale of the reductions. Despite the care taken in reproduction, much detail has been hidden within the reduced image area. The impact of the brushstrokes and surface details suffers from the limitations of the four-color printing process and the reader is therefore urged to view the artists' websites, where many of the pictures may be viewed in high resolution.

In the beginning

Children represent what they learn by using a range of symbol systems: movement, music-making, role play, language and mark-making. Early picture-making can symbolize feelings, thoughts and ideas; it does not have to directly represent the object itself but more the child's perception of it. This is a cross-cultural phenomenon in early childhood which is gradually affected by specific cultural values and imperatives; that is, industrial society's need that they acquire scripted language and mathematical systems. Only a small group of individuals continue picture-making as a primary mode of representation throughout their lives since most of their peers veer away from such symbolic experimentation in late childhood. Exactly why this happens is debatable; the adult brain losing the adaptability of youth and the pressures of school and education are without doubt significant factors in this migration from the visual arts. Whatever the explanation might be, we are fortunate the featured artists chose to remain among the select few.

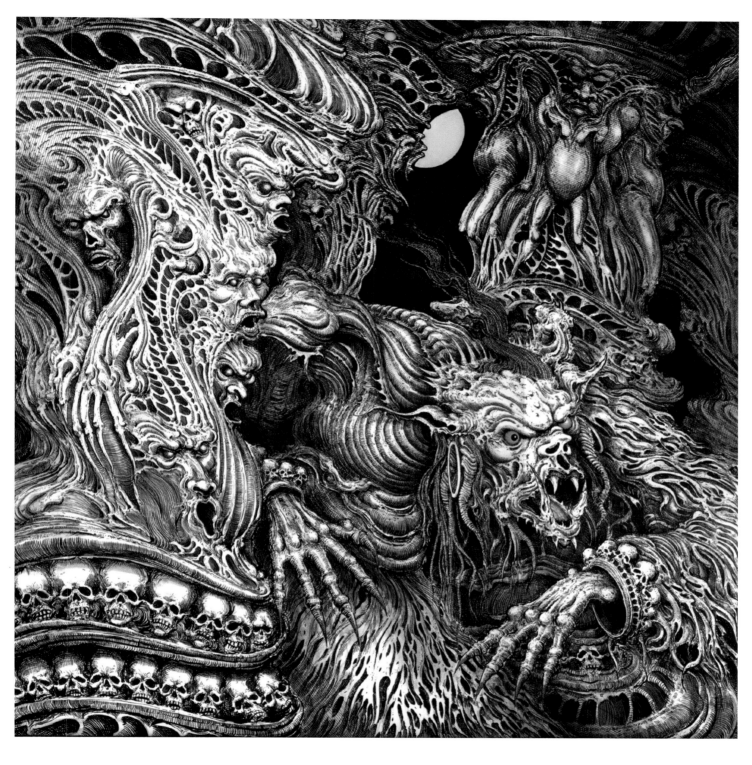

Ian Miller

Aku Djinn
30.5 × 30.5 cm (12 × 12 in)
Pen and ink, 1998

KEITH PARKINSON

"Many parents might have been skeptical about the prospects of a son who decided he wanted to paint fantasy pictures as a career choice. But compared to sex, drugs and rock 'n' roll as the alternative, they were enthusiastic."

At some point during high school Keith Parkinson realized that college was looming as the next step on the education ladder—but that wouldn't really be an issue for him, as, like many kids of his age, he aimed to be a future rock star. It was the 1970s, he was a drummer in a progressive rock band and making it to the big time with his bandmates was obviously the way things would be. But although this career path appealed to the 16-year-old Keith, he knew in his heart of hearts the chances of success were slim.

His parents were of the opinion that he should have a fall-back plan and although they never tried to prevent him from pursuing this ambition, when he also expressed a desire to explore his artistic interests the joint sigh of relief was heard in the next town.

"Many parents might have been skeptical about the prospects of a son who decided he wanted to paint fantasy pictures as a career choice, but with sex, drugs and rock 'n' roll as the alternative they were enthusiastic," says Keith. "It's also possible that they thought I had some artistic talent."

Keith created his first oil painting when he was 13 years old. "I'm not sure what made me go into the art store and buy a set of oils at that point in my life, but I left the store carrying one of those sets with about ten colors, some brushes and a canvas, went home and painted a Spanish galleon," he says. "In retrospect I realize it was a disaster on many levels, but my folks framed it and hung it in the front room. The painting was a much bigger deal to them than it was to me. The fact that it got such a warm reception must have lodged in some dark corner of my teenager brain, though, because I decided that this art thing was fun."

The ladder

"I didn't realize how limited my perceptions were. It seems to me that we learn only gradually to see the world around ourselves with more accuracy, and seeing is the key. As an artist, if you want your art to ring true, you need to know what your subject matter truly looks like—not the symbols we are trained by our cultures to see, or simplified versions that our visual shorthand substitutes, I mean seeing what our environment actually is. Of course, that perfect clarity of perception is a lofty goal, forever slightly beyond our reach. Each step we take that brings us closer to it, though, is growth, and as a goal that is attainable.

"Most artists can look back at their humble beginnings and see how far they have come artistically, but looking ahead is a different story. Each step up that metaphorical ladder is hard won, and when we gain a new understanding it tends to open our eyes to the next rung on the ladder. I think this slow growth of perception is a blessing. If I had had a true sense of just how limited my ability was at the beginning, I might have given up.

"Art is all about the journey—each step is an end in itself. As artists, what we do along the way defines us. Each time we strive to better ourselves, our efforts are our reward. While I don't have the knowledge or understanding to reach that next rung of the ladder, I do have an idea of what I'm looking for.

"I think there is a spirit that is part of life, and being able first to feel it, then to see it, is crucial if you want to portray it in a painting. This quality is often referred to as 'character,' and when paintings or people have character they project individuality. They are unique. I think the best art is able to capture this spirit of uniqueness and make the viewer feel it. It's this clarity of perception and the ability to bring it into my art that is my ultimate goal."

The slippery first rung

Keith put his foot on the slippery first rung early on. He liked to sit at his desk and draw pictures of spaceships. NASA posters with artists' conceptions of future ships that would carry US astronauts to the moon and beyond decorated his room. "I copied them faithfully over and over again," he says. His first spaceship was drawn two or three years before Neil Armstrong took that famous step in 1969. He loved the notion of space travel and of real rocketships, and wanted to be an astronaut until he discovered just how difficult it was to grasp the knowledge of math that was required.

BIOGRAPHY

Upon graduating from Kendall College of Art and Design in Grand Rapids, Michigan in 1980, Keith took a staff artist position at a company called Advertising Posters, generating artwork for the arcade video industry.

He then spent five years as staff artist at TSR, producing book, magazine and calendar illustrations for their primary lines—Dragonlance, Forgotten Realms, Amazing Stories and Gamma World.

A 14-year freelance career followed, during which Keith covered best-selling books by Terry Goodkind, David Eddings, Anne McCaffrey, Orson Scott Card, Weis and Hickman, C. J. Cherryh, Terry Brooks and Dennis McKiernan. Keith received many awards during this time for various works, the most notable being the Chesley Awards for best hardcover jacket illustration in 1988 and 1989.

Since the beginning of his freelance career Keith has licensed his artwork for use on computer games, puzzles, foreign publications and many other miscellaneous products.

In 1995, FPG financed and published Guardians, Keith's first foray into game design. This was a new experience for him and FPG as well. Many of the top artists in the fantasy art field contributed to the game by illustrating Keith's characters.

In the last few years Keith has devoted more time to writing and has moved the focus of his commercial artwork into the software industry, producing art for the popular EverQuest online game by Sony and THQ's Summoner.

After spending nearly nine years in southeast Pennsylvania, Keith moved to Arizona in June 1999 with his wife Mary and their two sons, Nick and Zach.

www.keithparkinson.com showcases almost all of his work and carries his complete line of art-related products

The Sapphire Rose (detail)
Oil on canvas, 1991
This was Keith's cover for *The Sapphire Rose* by David Eddings (Ballantine Del Rey). "It was an exercise in using figures to determine the composition. It took me a day and a half to work out the positions of the three troll gods and their weapons around the central character. The goal was to bring the viewer's eye into the scene and focus it on the central character. Toward that end, all of the straight lines incorporated in the designs of the weapons funnel the viewer's eye towards the knight."

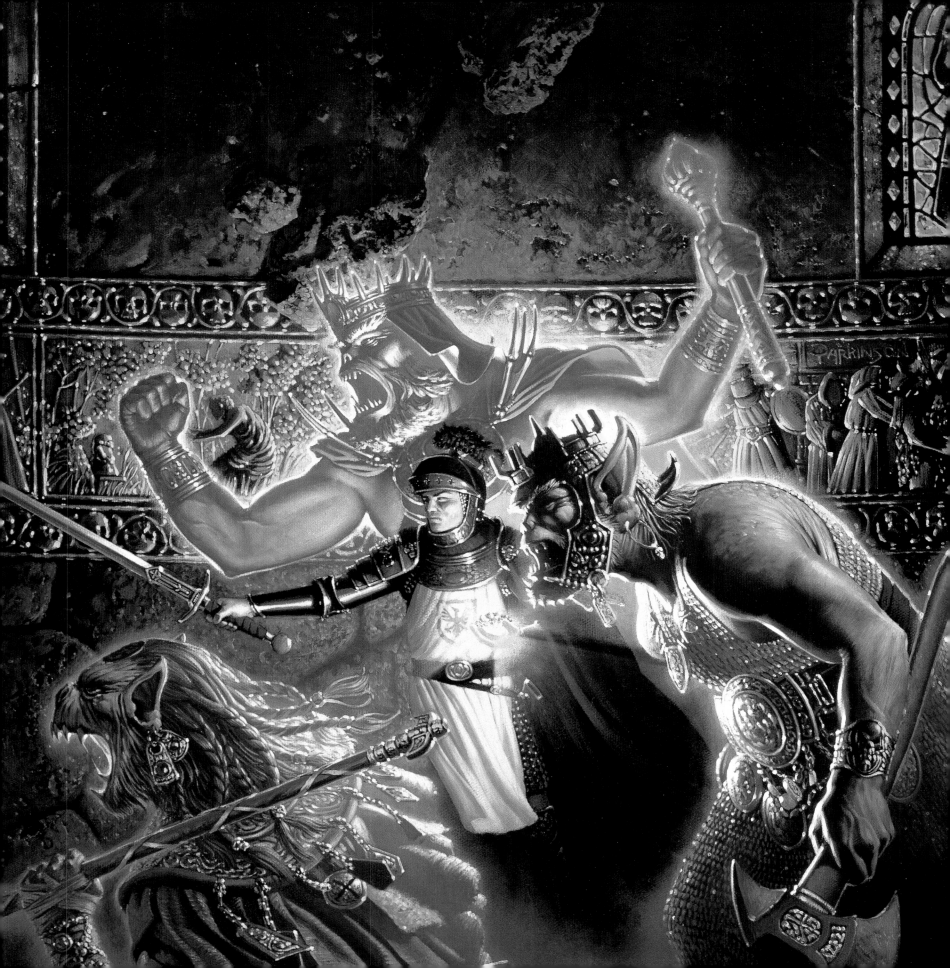

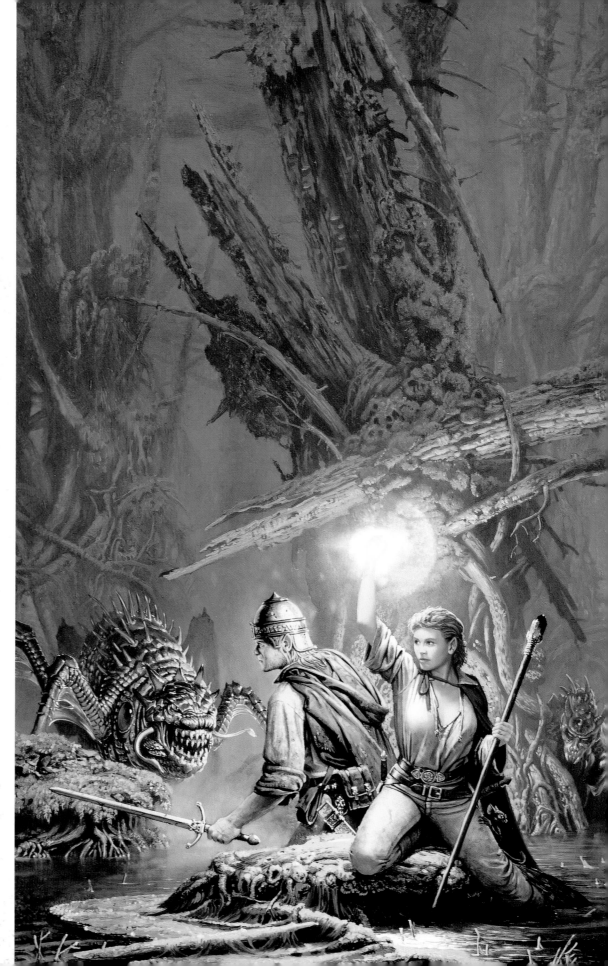

"I read science fiction because it was the next best thing to real astronauts and back then there was only so much of the real thing available. I read everything that looked even vaguely promising," Keith says. "I say 'looked' promising because it was always the covers that drew me in.

"I continued to draw pictures of space stations, moon bases and alien worlds until I reached my last year in high school. A teacher named Bruce Rae then invited me to join a special class for promising artists, and that course opened my eyes to the world of fantasy art. Over the course of the school year I produced a series of fantasy paintings and at the year's end took slides of them to turn in for course credit."

After the school year ended Keith sent the slides to some of the paperback houses in New York, thinking he was ready to paint book covers. He received polite rejections from all of them, but the art director at Ace took the trouble to give him constructive criticism that he took to heart. He spent the next year at Michigan State University then transferred to Kendall School of Design at Grand Rapids, Michigan, for his remaining three years and learned about the business of art.

"Six months after I graduated, I answered an ad in the *Chicago Tribune* and landed a job painting back glasses for pinball machines and video games. This was during the time that video arcades were the fad and Pac Man ruled the industry. With a full-time position to occupy my days and freelance jobs to fill my evenings, I realized that meeting deadlines meant getting very little sleep.

"After a year and a half in Chicago I took a job in the TSR art department in Lake Geneva, Wisconsin, and had the opportunity to work with other illustrators. In many ways that was the best of all situations—I had a steady pay check, a seemingly endless supply of fantasy products that needed covers and other artists that I could learn from and compete with."

The Elfqueen of Shannara
76 × 45.5 cm (30 × 18 in)
Oil on masonite, 1991

The objective for Keith in this illustration, the cover for *The Elfqueen of Shannara* by Terry Brooks (Ballantine Del Rey), was to produce an image with large enough figures to be seen from across the aisle at the book store but still leave room for the large-type treatment the publisher had planned above the picture area of the painting. "Since people are usually vertical, at least on book covers, setting them thigh deep in a swamp was an effective solution visually that also worked well conceptually with the storyline."

Chernevog

76 × 45.5 cm (30 × 18 in)
Oil on canvas board, 1990

The cover for *Chernevog* by C. J. Cherryh (Ballantine Del Rey) is a good example of Keith's more general approach to illustrating a book. All of the elements portrayed are key parts of the story, although they do not represent a particular scene. The illustration gives a sense of the story rather than showing a slice of it.

"This is one of my favorite pieces and one of only three I have hanging in my house. The reasons for this are several. One is that the composition worked exactly as I planned it. The entire story revolves around the sleeping figure's heart. When most people look at the painting, their eye goes right where I wanted it to—at the hands clasped over Chernevog's heart.

"I like working with different textures and this piece is full of them, from the damp clothing he wears to the moss and leaves and the wet dead wood. While I was working on this piece I taped dead leaves and twigs to my drawing board as inspiration. As it was autumn there was no lack of reference to choose from.

"Even though Chernevog is sleeping and not animated, there is a sense of time passing. The falling leaves are the reason. Their slow descent shows that the world is changing—the old fading in preparation for the new year to begin. The owl, always the symbol of wisdom, watches it with typical owl-like Zen understanding.

"I showed this painting at the World Fantasy Convention one year, and when I came to pick it up there was a poem taped to the wall beside it, written by one Kelly McLain. I have always saved it because I thought she had got the point of the piece so well."

Chernevog
Can I come into your quiet world?
You make it so very inviting.
I thought to ask if you needed help,
But I feel that you are protected.
The ocean of leaves that surround your island,
And the owl that stands guard for you.
You leave me feeling entranced.
And you pull me into your world.
Thank you for the invitation,
I should never like to leave.

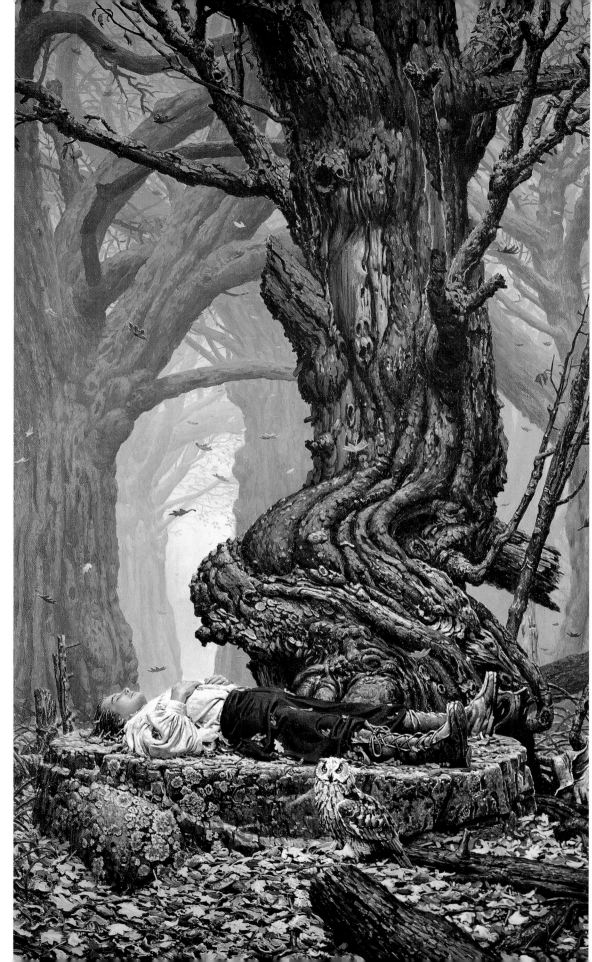

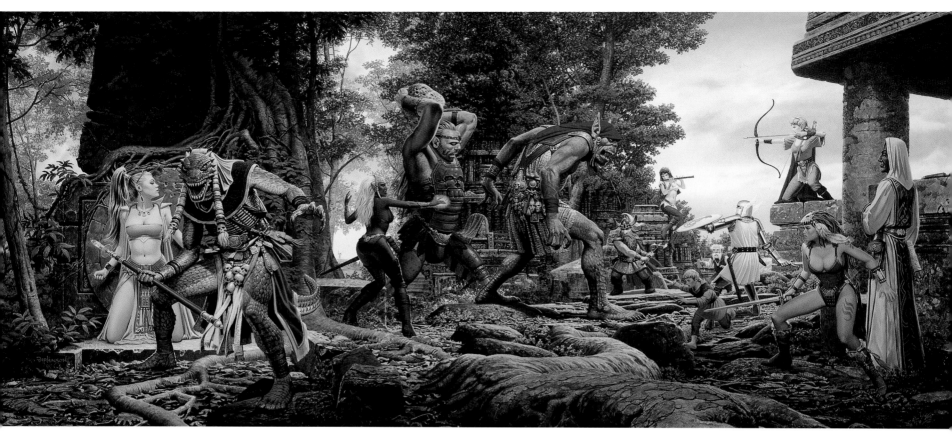

The Ruins of Kunark

61 × 152.5 cm (24 × 60 in)
Oil on masonite, 1999

"This painting is the second instalment in my series of EverQuest box covers. These are always challenging because of what I have to fit into them. They are also published as three separate panels on the EverQuest box. The left third of the art is the cover and the other two thirds are the inside panels. The assignment is to produce a piece of art that works as a whole, but also works with just the left third showing. I needed to fit at least 13 figures in combat into the scene and to show as many full figures as possible so they could be taken out of the image and used separately later. The scene takes place in a jungle through which the viewer needed to be able to see an elfland fortress."

Keith used his computer in the early stages to aid him with this compositional complexity. Detailed rough drawings of the figures were scanned onto separate layers in Photoshop where it was easier to resize them and move them around until they fit into the chosen composition, saving a tremendous amount of time.

"When I had something that worked in rough form it was printed out and refined with pencil. I then photographed models and began drawing the individual figures on separate pieces of paper. Once they had all been redrawn, I did the same with the background. The sketches were assembled in Photoshop, printed and transferred to a board for painting.

"My art is intended to appeal to people, not to offend. I try to keep it 'PG' rated and stay away from things that I find personally distasteful. I thought I was doing the same with this piece, but found that it did stir up quite a controversy among the EverQuest players who posted their opinions on the game's message boards. Opinion was equally divided between those who liked it and those who objected to the placement of the blue lizard's staff and his hand in relation to the woman behind him.

"They saw the staff as little more than a phallic symbol and the placement of his hand over her crotch as symbolic sexual domination. Ironically I had originally intended the staff and his hand to be placed higher, but lowered it because the game's producer and I decided we wanted to be able to see the woman's navel."

A pencil sketch for the background of *The Ruins of Kunark* which was then scanned in to the computer to be worked on in Photoshop.

Into the woods

"After five years at TSR, I set up a studio in downtown Lake Geneva with a fellow artist, Larry Elmore. Across the street was what turned out to be my favorite stretch of woods, and I shot countless rolls of film throughout the next year there. Those pictures have been the basis for the backgrounds in several of my paintings. I use reference like that frequently, and with that in mind take enough pictures to keep Eastman Kodak in the film business by myself. Collecting a good reference library is an important and ongoing process.

"A year later Larry and I went our separate ways. I moved to Pennsylvania with my wife Mary and our two boys, Nick and Zach, and Larry took his family back to Kentucky. By then I was working for the New York publishing industry, painting covers for some of the best-selling authors in the fantasy field.

"Five years later I started work on my collectable card game. I called it 'Guardians.' This project took me into the realm of game design for the first time, as well as the more familiar territory of developing the look of the product. I spent two years working on Guardians and enjoyed every minute. I also had the opportunity to have some of the best fantasy artists in the world illustrate my characters. After this, I ventured into the computer game market and produced the box art for EverQuest. At the time I took the assignment I had no idea it would be such a hit, but it was up my alley and sounded like a fun project so I did it. To this point, I've done four Everquest boxes, and a couple of magazine covers, one of which was for *TV Guide*. These also opened the door to other computer-game commissions and I spend half my time now working in that industry."

Research

Each project Keith takes is different, but his approach to all of them is similar. The first step is always to research the product his art will package. In the case of a book commission Keith will spend a couple of days reading the manuscript, taking notes and sometimes quickly sketching out ideas that occur to him. It is important to him to get a feel for the story and see what emotion it evokes. Whatever it may be, communicating this on the cover is his goal.

"If the manuscript is not available, or if there is not time to read it, I will get an art suggestion from the art director," he says. "This is a short description of a scene that the publishers feel will appeal to their target

Wizard's Keep
25.5 × 20.5 cm (10 × 8 in)
Pencil on paper, 2001
Keith provided the cover and six interior illustrations for Terry
Goodkind's novella *Debt of Bones* (Gollancz). "This was the first interior
illustration, so I wanted it to set the scene for the reader. A sense of
grand scale was important and the low point of view I used accentuated
the castle's size. The birds are also a gauge of scale, but, more
importantly, they bring motion to the otherwise static architecture."

The Hand of Chaos
76 × 122 cm (30 × 48 in)
Oil and acrylic on masonite, 1992
The cover for *The Hand of Chaos* by Margaret Weis and Tracy Hickman
(Bantam), this is an interesting experiment with opposites. "The
foreground and the background are as different as I could possibly make
them. The background, painted with acrylics in warm colors, is an arid
wasteland and is focused on static architecture. The foreground,
painted in oils, is cool and damp with lush vegetation and is concerned
with organic life and movement. With these criteria as ground rules,
I set out to make them work in the same painting. For such an
odd mix, it went together fairly easily."

Keith's preliminary pencil sketch for *Demorgan's First Spell* in which he worked out the composition of the piece.

Demorgan's First Spell
91.5 × 61 cm (36 × 24 in)
Oil on masonite, 1997

Demorgan's First Spell is from the fantasy novel Keith is working on, in which Demorgan is one of the main characters. "This particular scene happens before my story takes place and is a crucial event in shaping her character. I tried to show vulnerability and uncertainty in her, but also the determination to try something new and dangerous. I wanted her to be a character the viewer could empathize with, and also admire."

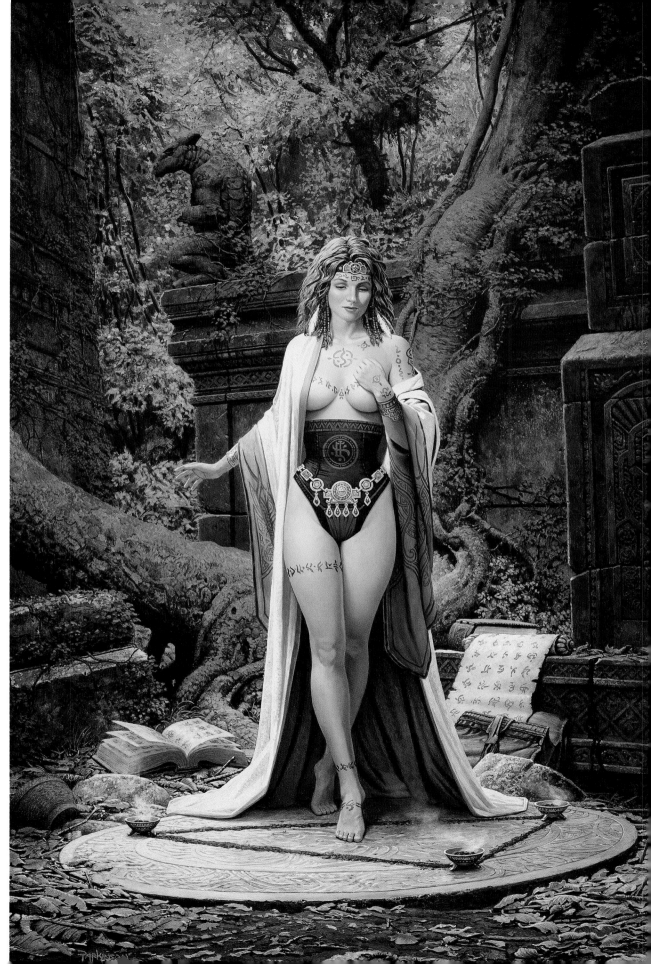

audience. However, when I'm working from an art suggestion I often call the author to talk about the book and get a better feel for the tone of the story. This helps me to decide if a specific scene will convey the essence of the book or if a more general approach is preferable.

"The next step is thumbnails. I like to do 40 to 50 composition roughs measuring only about 1–2 in [2.5–5 cm]. These are quick black-and-white abstract sketches, and doing all of them may take no more than an hour. Usually four or five of them catch my interest and show potential of acting as the foundation for a cover. This step is critical for creating dynamic compositions. If the composition doesn't work in black-and-white, chances are good it won't work in color either.

"Once the composition idea is established, I begin plugging in the elements of the illustration—figures, landscape, architecture and so on. Some of the composition roughs fall by the wayside at this point, and others get refined. This step usually takes quite a bit longer than the first one. After all, this is where all of the tough decisions must be made. The composition sketches are a great jumping-off point, but capturing the right flow of figure through background happens here. I typically do several variations of each composition with figures and background elements added. From these I choose four or five again to develop into more finished

sketches. Usually only three of them actually make it to a finished sketch. These drawings are scanned and emailed to the art director."

Reference

"Once a decision on the sketches is made, I make final adjustments if necessary and start looking at reference seriously. Previously, details were not important enough to be drawn, but in preparation for painting the necessary reference must be gathered. This may mean scheduling a photography session with a model, taking pictures of landscapes and animals or just doing some more research.

"Taking your own photographs is very important. Seeing the magic in a landscape is the first step in capturing it. While as a painter I ultimately prefer a human interpretation of the scene, photographs are a tool that, if used with discretion, are invaluable. Tracing a reference shot is a bad idea, though. It's much better to use the information the photographs have to offer as a supplement to your imagination and see where you end up. Photographing models for figure reference is no different. It is a tool to reach an end, not the end itself.

"Once I have collected all the reference I will need, the next step is to prepare the board. I paint on ¼ in [6 millimeter] masonite, which I prefer to canvas

Soul of the Fire
56 × 101.5 cm (22 × 40 in)
Oil on masonite, 1998
"This was a wraparound cover for Terry Goodkind's novel of the same name (Tor Books). The criteria for this series of book covers are different from most. The illustration appears in a band across the middle of the book with type above and below it, so I don't need to leave dead areas in the painting to accommodate type. Painting landscapes has always been something I enjoy and this was no exception."

because I like its rigidity. First I use an electric palm sander and take off any oily finish or dirt that may be there, then I apply a coat of gesso with a roller and smooth it out carefully. When it's dry, I lightly sand it again with the electric sander and give it another coat of gesso. This process is repeated until the surface is perfect, which usually means three applications. After the last coat, I use a hand sander to smooth the surface and allow it to sit overnight in order to harden the white ground thoroughly.

"Once the board is ready I transfer my sketch to it with an artograph. This machine projects the image onto the gessoed masonite panel and I trace over it lightly with an HB pencil. I repeatedly check my reference both during this process and afterward to refine the drawing, and the pencil work almost becomes an underpainting. Once I'm satisfied with the sketch, I spray fix it to keep it from smearing when the paint is applied."

Time to paint

"Then it's time to paint, although in reality I have begun the painting process long before I sit down to apply the first stroke. This is not some mutant power that I've derived from reading too many science fiction novels—it occurs because I use a controlled palette. This means I buy empty paint tubes and fill them with colors I mix myself that correspond to precise tonal values. For example, I have a row of ten tubes of red oil paint that vary in value from one to ten, the value of the color

meaning how dark or light it is. I have the full spectrum of color premixed in tubes this way. The extra effort at this point allows a more focused approach to the actual painting later on.

"The way I see a scene is in three dimensions. Of course I only have two dimensions to work with, so there is a certain amount of fooling the eye that must take place. I need to create depth, and I do it by controlling the values of the colors in the painting. I start with the horizon line if I'm painting a landscape. Because of recession, the tonal value range there is more compressed than anywhere else in the painting so for that area I'll use light to midtone colors. Since the values are already correct straight out of the tubes I've premixed, I can focus all of my attention on the color. It's a left-brain approach, logical and straightforward, and it works.

"After the paint is mixed, I add medium to it. Most of the time I mix my own medium of half paint thinner, half linseed oil and a couple of drops of cobalt drier, though sometimes, when I need an undercoat that is very tough, I use liquin instead. This is an alkyd resin that makes oil paint virtually indestructible. However, while it is convenient, it often fails to give me the right paint consistency or dries too quickly, so my own medium is usually a better choice.

"I mix my paint on a glass palette with a palette knife. While I use a wide variety of brushes and the palette knife to apply the paint, most of the work is done with round and flat sables.

"I begin at the back of the scene. In a landscape, this point is the horizon line. Since all of the shadows in the painting are based on the sky color, the sky is first. From the horizon line I work my way towards the viewer. As the scene expands into the foreground the value range widens and depth is created.

"I like to mix the paint soft enough to go onto the board smoothly while retaining its opacity. I try to render the area I'm working on with one coat, then move on to the next part of the painting. Sometimes I'll need to go back and glaze over an area later to adjust the color or value, or I'll even repaint an area that doesn't quite work with the rest of the piece. The toughest part of this whole equation, though, is getting the skin tones right. I'll frequently need more than one coat to get close to what I saw in my mind's eye at the outset.

"This is fundamentally the way I approach all cover commissions. For computer games, I read game briefs, look at screen shots and at other developmental sketches if they exist, and sometimes even visit the computer game company to see just what they have up and running in house.

"Inevitably, there are occasions when the publishers request changes in the art after it's finished. One practical reason for a straightforward approach to painting is that any alterations will blend seamlessly into the original work if there are fewer steps to duplicate to match what is already there. The changes need to be painted in the same way as the original work; although a different process or palette may appear the same to the human eye it will be read differently on film."

Still climbing

"Thus far I have discussed my commissioned works, which represent 95 percent of what I have done to date. This leaves 5 percent unaccounted for.

"These few paintings are what happens when an artist has time to ponder the unknowable, reflect on his life, contemplate the order of the universe or ruminate about what was for lunch—all those things that translate into sitting with a blank stare, pretending to look out of a window. Maybe it's the muse making an appearance, or maybe it's just too many jalapeño peppers talking, but either way, it's where my best ideas come from. While the muse is sometimes vapor through my fingers, occasionally she sneaks up on me and drops the bones of a painting right in my lap. When this happens, I sketch. It doesn't matter what I may be working on, or not working on, I stop and put the idea down on paper before it decides to wander away. I don't refine these drawings, but I do save them with the hopes that I will have time to paint them some day. Periodically, I do. *North Watch* is an example.

"I think the best art comes from within. It is a product of what we see, hear, learn and feel. The act of painting is not a collaborative process; it is a singular voyage of discovery. Once the discovery is made and the art is finished, though, listening to constructive criticism is also essential. It is an important part of climbing that ladder I spoke of earlier.

"Creating art as we climb is a journey on many levels, but the part that gets me out of bed in the morning is seeing where the muse leads. Sometimes it is a Byzantine path she leads me down, but I follow. Sometimes I brood about it, sometimes I ponder it, and sometimes I just stare out the window. But in the end, I paint. After all, it is what we artists do."

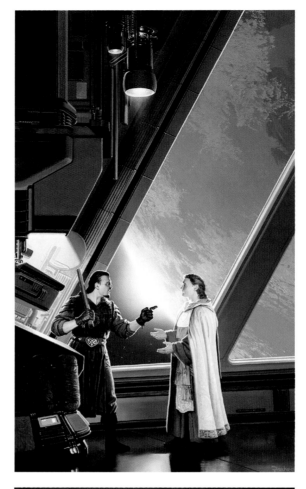

Earthfall
76 × 45.5 cm (30 × 18 in)
Mixed media on masonite, 1994
The vivid background of the planet below flooding through the dramatically positioned diagonal windows adds to the sense of conflict between the two characters in the foreground while also leaving sufficient space for the inevitable lettering. This was the cover for *Earthfall* by Orson Scott Card (Tor Books).

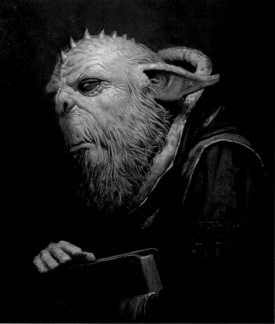

Tulak
25.5 × 20.5 cm (10 × 8 in)
Oil on masonite, 1998
This is the second of two pieces of art showcased here that are based on Keith's own fantasy world. "For years I have been writing my own fantasy novel, painting and drawing the people and places. I enjoy the process of world building, both in the writing and the painting. Eventually I expect the project will see print, but realistically it will not be soon. Tulak is a wizard of sorts, and not one to be trifled with."

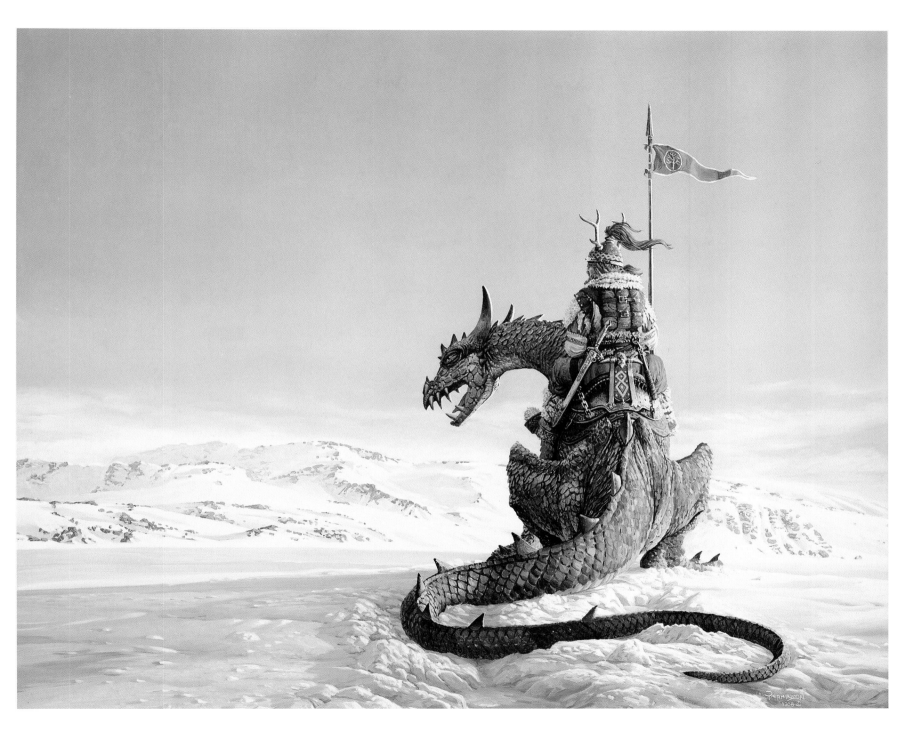

North Watch
61 × 76 cm (24 × 30 in)
Oil on masonite, 1988
This striking painting is a clear example of the strengths of keeping an image simple, an approach that Keith can find difficult to adhere to but nevertheless fully understands.

"The object here was to pull the viewer into the world and let them wonder what is going on, dreaming up their own story to explain it. I've used a number of devices to do that. The subjects are looking further into the picture, which immediately causes us to ponder what they are looking for. They are obviously there for a reason. The figures' body language is purposeful, and gives the impression that they are standing guard, or watching much as a policeman does when he is waiting for speeders on the highway. The banner bears a white tree on a field of green, which any Tolkien fan will know I intended to be the white tree of Gondor. My watcher is a Tolkienesque Ranger. Rangers watch over the wild lands and protect the people living there. What is he looking for and who is he protecting? You tell me."

ANNE SUDWORTH

"I think it was always taken for granted that I'd be an artist when I grew up, and I was lucky enough to have parents who didn't mind what I did as long as I was happy."

Anyone who has ever caught a glimpse of strange shapes briefly animated in the sea of night by the beam of car headlights will be struck by the pictures created by British artist Anne Sudworth. Her eerily glowing trees positively encourage the imagining of things fantastic, of worlds unseen but near at hand.

Anne has been drawing and painting all her life. According to her mother, she was drawing from the moment she could hold a crayon. Her creative energy was not confined just to drawing or painting but also encompassed designing patterns and costumes, building structures, sculpting—anything where she could create a collection of shapes and colors she found pleasing, utilizing whatever materials she could lay her hands on.

"I think it was always taken for granted that I'd be an artist when I grew up, and I was lucky enough to have parents who didn't mind what I did as long as I was happy," she says. "I do remember a couple of lectures from family friends on how difficult it would be to make a living as an artist."

Anne says she did not have any formal training, although she did endure a brief stint on a fine art degree course. This may sound contradictory but further discussion shows the statement to be true. Like many students entering a higher education course in art in the expectation of being supported and shown techniques, she quickly discovered that she would only be taught what the tutors felt appropriate, based on their particular definitions of art.

"There was a general difference of opinion between the lecturers and myself as to what I should be painting and I ended up taking no part in the course at all. I had imagined I would develop my own ideas with occasional help from the tutors, but found a narrow-minded and restrictive environment where much of the work seemed the same. Any individuality was lost or swamped, too heavily influenced by the tutors' own ideas."

Art for art's sake

Although it is an area within which she works, Anne is still disturbed by the arrogance and snobbery associated with the fine art field and ashamed at the elitist attitudes held by some—the feeling that fine art is in some way superior to all other fields of art. It was this view that was promoted in her fine art course and it was one of the many things that discouraged her from following through her formal art studies.

"Fine art itself is a much-misunderstood term. It simply means art for art's sake—a piece of work done for itself, which when it comes down to it is the simplest option, with no one to please but the artist. Where is the superiority in that? I don't believe that there are any clearly defined areas in art; all fields cross at some point. If you have an ability and desire to create then you're an

Sanctuary 1994
62 × 53.5 cm (24½ × 21 in)
Pastel on Ingres board
Sanctuary is based on a picture that Anne used to love as a child. "The picture was in one of my father's books. I think it showed a cairn, a pile of rocks that fellwalkers use to identify paths. I always envisaged it as a huge, towering mass of stone with a tiny impenetrable fortress or castle standing on top."

BIOGRAPHY

Anne Sudworth was born in Lancashire in the early 1960s. She has been drawing and painting since childhood. Her first ambition was to own a horse; her second was to be an artist.

Before becoming a professional artist she had a number of other jobs including working with racehorses, modelling and working in a clothes shop, while continuing to paint in her spare time. Her earliest commissions were equestrian scenes and portraits. However, she did not feel that these pictures were her true work and spent much of her time developing her own more imaginative paintings.

In 1993 she presented her landmark exhibition *Visions and Views*. It was her first solo exhibition and met with great success. Other major solo shows followed, including the highly acclaimed *Dreams and Whispers* show in 1997 and *The Dark Side* in 1998.

She has since exhibited widely, with work in many international collections. She is perhaps best known for her Earth Light Trees, an ongoing series of paintings that represent a central theme in her work. The book *Enchanted World, the Art of Anne Sudworth* was published by Paper Tiger in 1999.

Anne's website can be seen at www.annesudworth.co.uk

Ash Trees at Long Meg
73.5 × 56 cm (29 × 22 in)
Pastel on Ingres board, 2001
This painting shows part of a stone circle called Long Meg and her Daughters. "Inside the circle are two of the most wonderful ash trees that I have ever seen—great, huge old trees with enormous branches and gnarled roots. I wanted to capture the mood and atmosphere of the place; there is something very awesome about stone circles in moonlight."

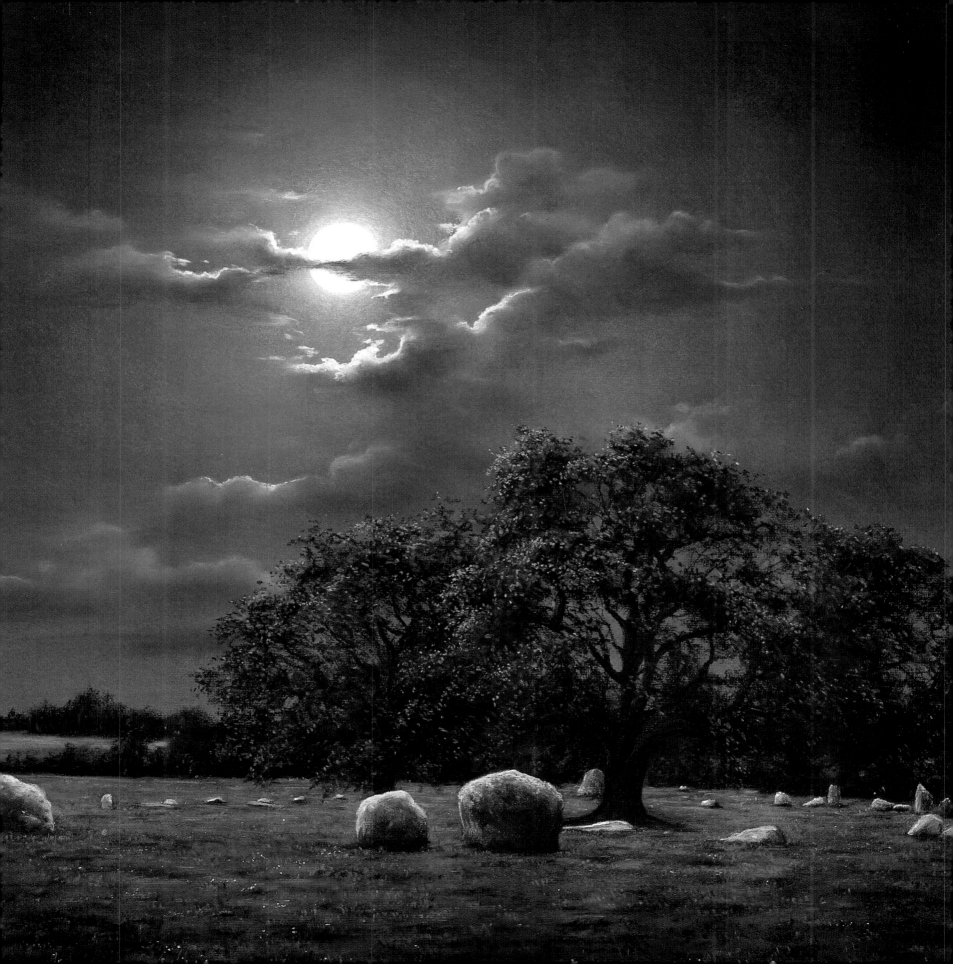

artist. This was sadly not the view of the fine art tutors, whose distress was compounded when they discovered I was mixing with the fashion students, who were much more fun.

"It took me a very short time to realize that art college was not for me. For a while I made early-morning excursions into college to sign the register, leaving hastily by the fire exit to return to my flat to work on my own. I had a great time socially and made some wonderful friends but as far as my work was concerned it was a mistake which I quickly rectified. For some people I'm sure art college is a wonderful and enlightening place but it was definitely not right for me. My work developed without the aid of formal training but with the invaluable help of many wonderful people, places and experiences. I have been very fortunate to have known so many people who have supported, encouraged and inspired my endeavors."

Anne continued to paint while earning money in a number of other jobs which included working with racehorses, modelling and working in a shop, never envisaging she would eventually earn enough money from art to buy her own horses or even art materials. Her early career as an artist was painting equestrian scenes, which allowed her to combine her great love of horses and art. But this phase was short-lived as Anne soon came to the realization she wished to work with other subject matter.

Visions and views

"My true art remained in the background for a while, but it was becoming clearer and stronger in my mind and drawing me in all sorts of new and interesting directions," Anne says. "I had taken part in a few group shows and I'd had a couple of small solo exhibitions, then in 1993 I had my first major solo show, called *Visions and Views*. The title was chosen because this exhibition was to show both my ordinary landscapes and my more visionary scenes. The show was a success and I have since managed to make a living selling my paintings.

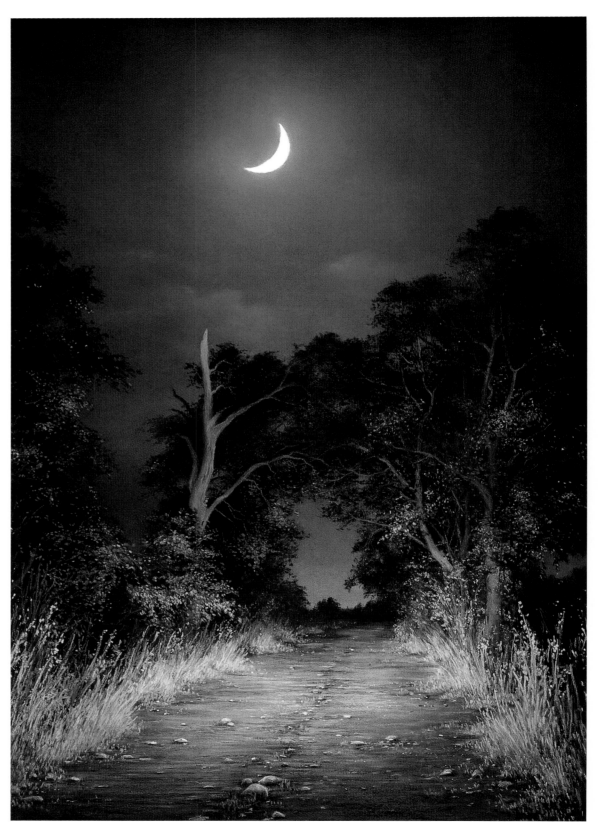

Ghost
73.5 × 56 cm (29 × 22 in)
Pastel on Ingres board, 1998
"The title refers to the ghost of the dead tree on the left of the picture, though there are other ghosts along the path. I wanted to show it standing proud. Even though its natural life has ceased, it still continues to be part of the copse. The waxing moon signifies the birth of a new life cycle."

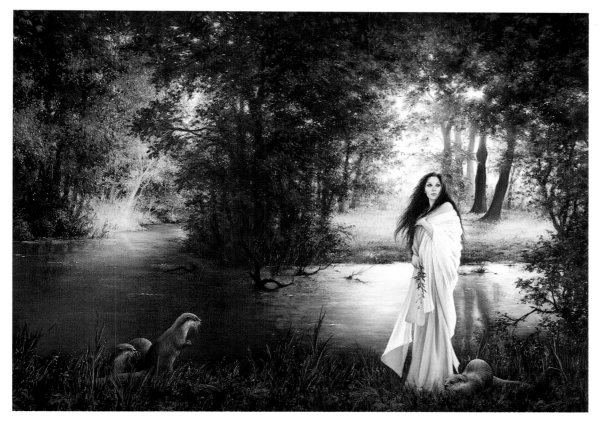

"I now tend to have one major exhibition every 12–18 months and a couple of smaller shows in between. These shows are not normally set out with a specific theme in mind; I tend just to work on whatever is in my head at the time. However, within a few months of a show I will generally get to know which pieces of work or particular themes are going to dominate and the show will then develop around them. Working for a major exhibition does mean you already have certain ideas and themes in your head and that show will obviously be a development and an exploration of these ideas. The other shows will simply consist of a mixture of work on different themes and from different times. I don't always release a picture for sale as soon as I've finished it, so a show might not contain all my most recent paintings.

"My work has certain general underlying themes, although I'm constantly exploring different ideas and striving to find that elusive Something. I have always loved fairy tales and legends, in fact anything magical or make-believe. As a child I was often told I had a too-vivid imagination. I used to see things in my head and try to put them down on paper to make them real. I suppose that's what I still do today, though the work has taken on a more central role in my life. Fairy tales led to an exploration of Celtic mythology and folklore as well as more classical literature.

"I also grew up with a great love of nature, especially the wild countryside of places such as the Lake District. As a child I spent a great deal of time there and it's a place that has had a lasting effect upon my work. Much of my inspiration as an adult stems from these early passions, though the ideas for my work seem to derive from all sorts of experiences: dreams, legends, mysticism, nature.

"Much of my work contains overtones of magic and ancient beliefs. I like to explore the idea that the earth has a darker, more mysterious, less controllable side, but perhaps one of which our ancestors were more aware. This is probably most evident in my Earth Light Tree pictures, an ongoing series of paintings which has become a central theme in my work. These pictures all show imaginary scenes in which trees or woodlands glow with their own earth light and life force, symbolizing the power and magic which the earth holds. Nature and its strange unseen forces have become an important, if not obsessive, theme in my paintings. Nighttime, and particularly moonlight, is also an important element. The dark has always been a haven for the imagination, where the unknown and the fantastic can become believable and where we can and often do visualize things that might or might not exist."

Daughter of The River
76 × 112 cm (30 × 44 in)
Pastel and Conté crayon on Ingres board, 1999
This work was the cover for *Crown of Silence* by Storm Constantine (Gollancz). "There is something particularly special about early-morning light—it makes everything so radiant and fresh. In this painting I tried to capture that feeling. I wanted the whole picture to suggest a harmony between people, animals and landscape.

"I loved working on the otters. They were considered to be very special animals in Celtic mythology—said to be keepers of knowledge and lore. My partner and I spent some time at an otter sanctuary so I could study them before starting the painting. I worked on the picture for about four weeks or so. I don't do many book covers but every so often it provides a refreshing change."

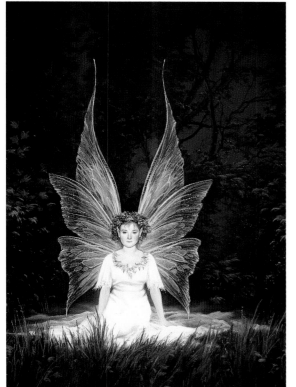

Breath of the Bright Fey
84 × 67 cm (33 × 26½ in)
Pastel and Conté crayon on Ingres board, 1998
"I wanted the fairy to appear very translucent and ethereal yet at the same time remain solid and real. She is a guardian of the forest and sits among her trees in the long grasses. She is wearing a crown of hawthorn, which is considered to be a very powerful and magical tree. It is said that nothing bad can live in a hawthorn."

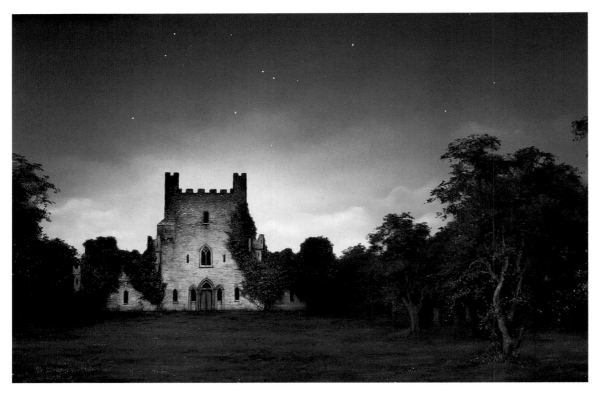

magical, but I also find that the act of making a mark is in itself magical—the act of creating something that previously didn't exist and is now real."

Passion for pastel

"I have experimented with as many different materials as possible, often attempting to mix different media, though not always with success. I particularly liked incorporating objects such as petals or leaves in my work. I used to work mostly in oil or watercolor, but I discovered pastel some years ago when I was given a small box of assorted colors. Once discovered, pastel had a very strange effect on me and I just couldn't leave it alone. I had used oil pastel before but these pastels are completely different. They are basically pure pigment held together with a bit of gum and are exceedingly messy, a bit like soft chalk.

"Pastel is a wonderful medium, very direct and personal, almost like cutting out the middle man—you don't need any implement to apply it, just your fingers. I tend to use my pastel very extravagantly. I seem to go through huge amounts for every piece of work I do, constantly breaking them to obtain a finer edge. The first thing I do when using a new pastel is remove the wrapper and snap it in half.

"I initially started using Canson Ingres paper, choosing a pale blue or gray, but as the paper color never showed through in my paintings this began to seem rather pointless. I now always work on large Ingres boards, usually a warm white or ivory and preferably with a very fine texture. I find that as my work can be quite large the board gives a more stable surface than paper, while the fine texture allows me more detail.

"I have to admit that I have never read a book on the use of pastel. I enjoy experimenting and discovering things for myself. I have been told that I don't use pastel in the correct way, but I don't believe that there is a correct way—you should be able to take a medium and use it as you please.

"I simply love it and use it for almost all of my work. I sometimes wonder if I'll get bored with pastel and move onto something else, although I can't see that happening at the moment. I find that the creative process in general can be a rather unpredictable one, sometimes pleasant, sometimes stressful and occasionally downright traumatic. But it is compulsive. It's something I have to do and if I didn't make a living out of my work I would just have to earn money from another job and paint in any spare time remaining in my day. My work is an extension of myself. It's something that has come from within me that I've managed to control and capture and mix with things around me, either physical or spiritual."

The Sleeping Castle
56 x 91.5 cm (22 x 36 in)
Pastel on Ingres board, 1998
"I used Leap Castle in Ireland for the basic shape of the building. I wanted to paint a very fairy-tale kind of castle and decided to surround it with a thick forest. Many of the trees are based on the silver birch. I always feel it's a fairy-tale tree, often known as the Lady of the Forest."

Making marks

"I love drawing. I have built up a body of many sketches and observational pieces of work over the years that I regularly use for reference. These drawings are never really done with a specific painting in mind, but observing things in real life makes it so much easier to create them from the imagination. If you particularly love something, whether it be real or imaginary, then you find that you are constantly observing or searching for it anyway.

"When I am starting a new piece of work I very rarely do studies beforehand. In the rare cases that I do they tend to be so rough as to be legible only to myself. I never do detailed preliminary drawings. I just scribble down some basic shapes and shadows on any bit of paper that's handy. If anything is going to develop or change I would rather it did so on the actual piece of work. More often than not I just start on a painting and see how it goes. I always begin very loosely, adding detail only gradually.

"Most pieces of work take between three and four weeks to complete, though some of the larger pieces can take six to eight weeks. I tend to enjoy having a painting around for a few weeks. It becomes part of your life, part of your surroundings, though it's constantly being changed. I enjoy its physical presence and I even enjoy the mess. I paint what to me is visionary, fantastical or

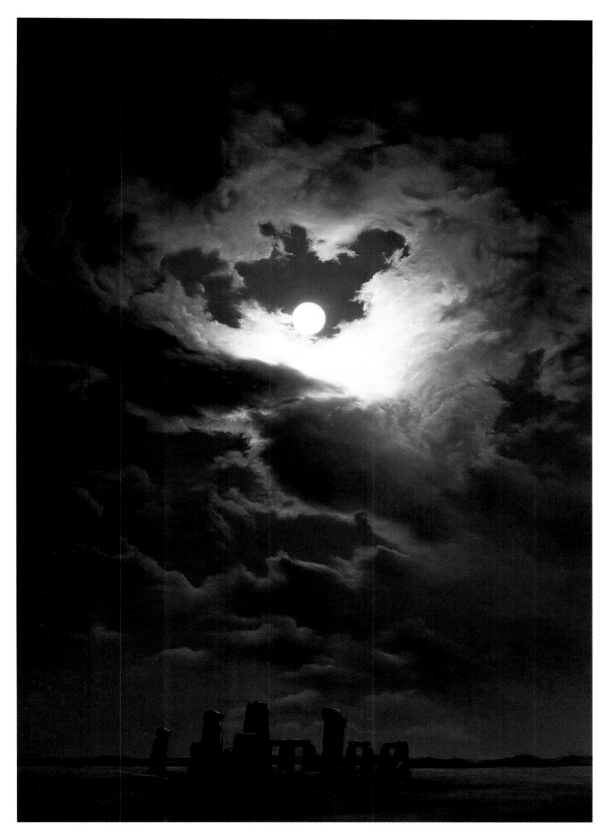

White Goddess
100.5 × 73.5 cm (39½ × 29 in)
Pastel on Ingres board, 2001
This picture, like *Giant's Dance,* is a moonlight scene, but Anne feels they
are completely different in mood. Whereas *Giant's Dance* is calm and
still, this picture has a far more brooding atmosphere and a much wilder
feel. The ancient, mighty stone circle is almost overwhelmed by the
majestic moonlit cloudscape, reminding us that no matter how
impressive mankind's achievements, they are only a tiny part of an all-
encompassing natural world.

White Goddess

"I have always been fascinated by moonlight and often
walk at night, especially on the hills and in woodland.
I love wild places and at night they seem to have a
particularly magical feel. I've painted moonlight many
times, but for me *White Goddess* is a special picture. This is
partly because it is a picture of moonlight and partly
because it depicts the very ancient and wonderful site of
Stonehenge. But it is also special because it was such a
struggle to get started on the piece. I'd had the idea for
this painting for quite a while but every time I started a
piece of work it would evolve into something entirely
different or another idea would come along and supplant
it. It seemed as if the picture just wasn't going to
happen, then all of a sudden I started to work on it and
everything fell into place.

"I began the same way that I always begin a new piece
of work. I take a large piece of Ingres board and draw a
rough boundary. I occasionally cut the boards down to a
specific size, but generally I leave them big because a
piece of work can often develop beyond its intended
boundary—a lesson I've learnt the hard way. My
boundary usually consists of a very loosely scribbled line
to show the basic shape within which I wish to work, but
as *White Goddess* is a large painting almost all of the board
was used anyway.

"I spent about two or three weeks working on the
moon and the sky, which were to be the main part of the
picture. The moon in its various phases represents many
different things but for this picture I had already decided
on a full moon rather than a waxing or waning one. I

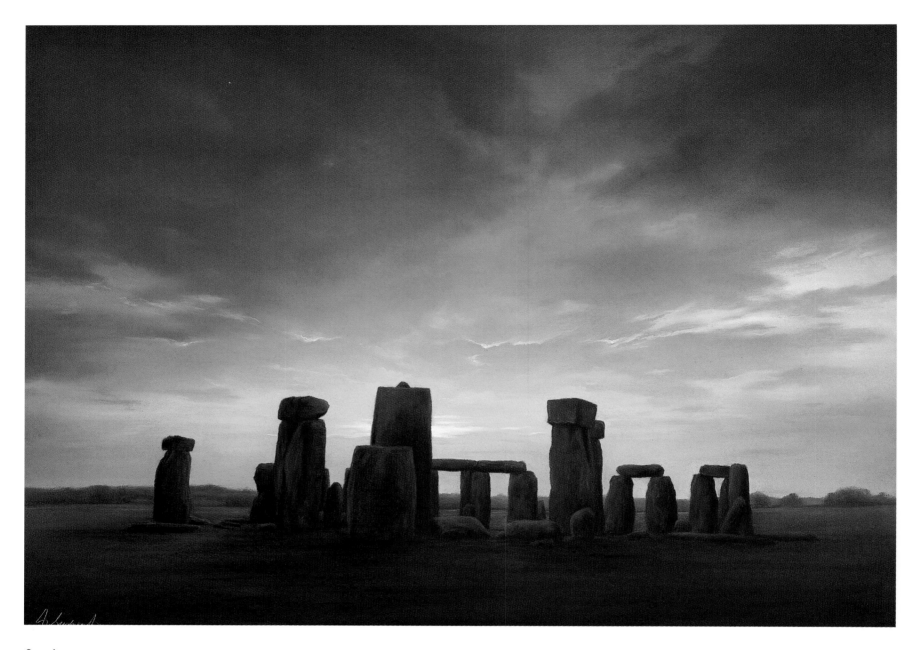

Stonehenge
66 × 80 cm (26 × 31½ in)
Pastel on Ingres board, 1999
Stonehenge as many wish to see it, the megaliths lit by the rays of the
early-morning sun. The first light of the new day also emphasizes their
mystery and beauty. Anne decided to show the sun just rising behind
the heel stone as a complete contrast to the scenes in *Giant's
Dance* and *White Goddess*. Here she wanted the atmosphere
to be warmer and softer.

Giant's Dance
66 × 45.5 cm (26 × 18 in)
Pastel on Ingres board, 1998

This is the first picture of Anne's Stone Temple Trilogy. This series of paintings portrayed three of her favorite ancient sites, each with the moon in a different phase, each with a different mood. As in *White Goddess*, the giant stones are only a small part of this nocturnal scene, although this time clearly silhouetted against the moon-drenched skyscape. The halo of the waxing moon and the sparkling of stars create a sense of calm.

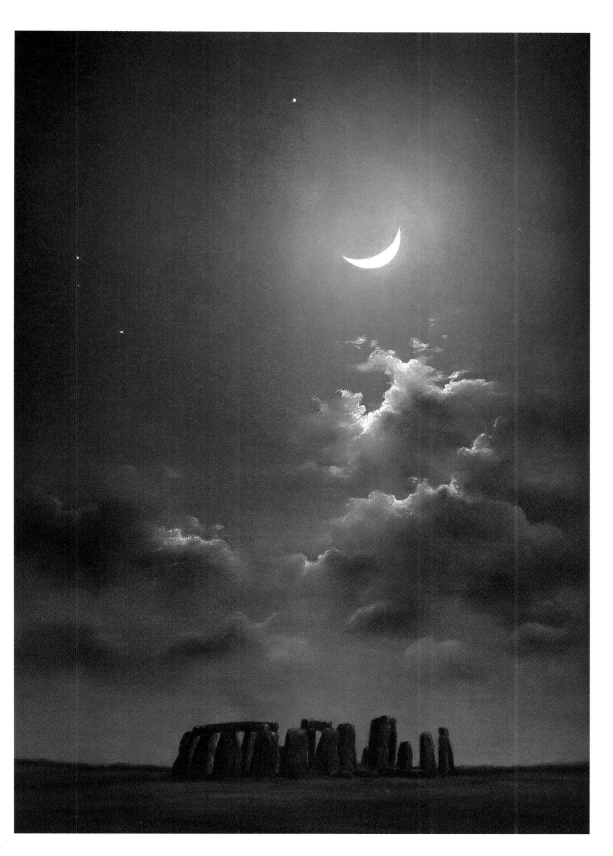

wanted there to be only a suggestion of land at the bottom so that although Stonehenge is a magnificent place, it's hardly discernible there in the gloom. Stonehenge is so awesome that its presence could never be diminished, however basic or small its reproduction. Like the moon, it just has something special."

Stay Not on the Precipice

"The title of *Stay Not on the Precipice* comes from the Chaldean Oracles of Zoroaster: "Stay not on the precipice with dross of matter for there is a place for thine image in a realm ever splendid." Basically this means "Don't be afraid of dying for there is something else." Indeed the whole idea of this picture is about life, death and the transition to that 'something else.'

"I used quite a lot of symbolism in the picture, both in the choice of subject matter and the color. I wanted the clouds to dominate the whole composition. Clouds have always been a symbol of the division between this world and the next. In many myths and legends they were said to conceal the gods and provide a barrier between the mortal world and the otherworld. In autumn, especially around the old Celtic festival of Samhain, the land is often covered in mist and cloud. Traditionally this was believed to be the time when the veil was thinnest between this world and the next and spirits were thought to be able to cross back to this world hidden in clouds.

"The whole of the picture is green apart from some small patches of blue and yellow. Green is a color associated with death. In this case the death is very much a transitional thing—a journey. I wanted the clouds to be vast and heavy but not completely solid, so there are gaps of blue sky and rays of light between them. It is a layer, but one that can be penetrated. It is a rather moody picture and the clouds seem to be rolling inexorably towards the viewer much as death approaches us all. But I don't think it's a depressing picture—in fact I remember feeling exceptionally happy when I painted it. It's fairly small compared to some of my other pieces and didn't take too long to complete. But that's because I worked solidly on it, hardly stopping at all as I was completely absorbed by it and nothing could distract me from it until it was finished."

Earth Light Trees

"Although the picture shown in this book bears the title *Earth Light Trees,* it is only one of a large number of paintings to which I give the same name. The idea of earth light is an old one. It's part of an ancient belief in the earth's power and energy. The light would glow from a particularly special or sacred place, sometimes signifying the presence of a powerful force or perhaps a spirit or guardian. The light might come from within a tree, a stone, a stream or a cave.

"Trees have always been very special to me, with or without earth light—they have a magic all of their own. I originally did a couple of paintings of trees in which I tried to capture the idea of the light coming from within them. This has since developed into the most central part of my work and is a subject that I'm constantly exploring.

"I try to imagine all kinds of trees with this strange earth light emanating from their trunks or from the ground around them. Often when I look at trees I try to imagine the light and shade reversed, so that the dark under part of the tree is white light and the tops of the branches are left in darkness.

"Sometimes I will depict a group of trees with the light flowing from them, as in *The Fairy Wood,* or in other works a solitary tree illuminates the ground and landscape around it as in *The Snow Tree* and *Inifri Duir.* In this picture I wanted to paint a row of trees, all glowing with the light, their branches bending towards each other to make a tunnel that draws the viewer in. At first I had intended having the two trees in the foreground level with each other, making an arch. But after I had worked on the picture for a bit I decided it didn't seem right—it didn't have sufficient depth and it looked too contrived. I did a quick sketch with a biro and some oil pastel to see what it would look like with one tree dropped back.

Stay Not on the Precipice
51 × 66 cm (20 × 26 in)
Pastel on Ingres paper, 1993
Powerful cloudscapes feature as often as night-shrouded trees in Anne's work. In this heavily symbolic picture they totally obscure the horizon of the world, their melancholic mood lifted only by the occasional patches of pale blue sky and a promise of light beyond the gloom.

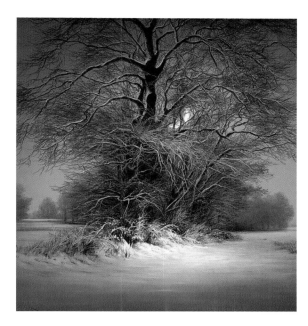

The Snow Tree
68.5 × 63.5 cm (27 × 25 in)
Pastel on Ingres board, 2001
"This picture took quite a long time to complete but I enjoyed every moment I spent working on it. I wanted to portray the hushed stillness of a snowy night contrasting with the warm glow of earth light coming from the tree and illuminating the ground around it. I hoped to create a very magical atmosphere, with almost a suggestion of fairyland."

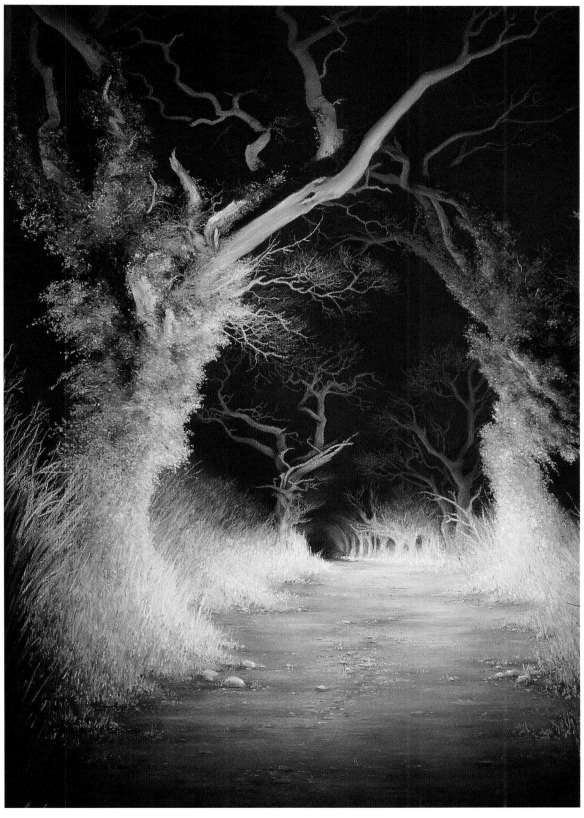

Earth Light Trees
86.5 × 63.5 cm (34 × 25 in)
Pastel on Ingres board, 1995–6
Anne is probably best known for her "Earth Light Trees." Although this picture bears the title it is only one of an ongoing series of paintings which represent a central theme in her work.

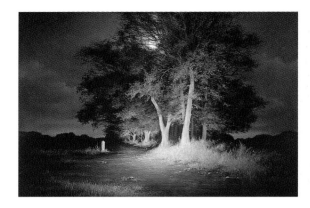

The Fairy Wood
53.5 × 73.5 cm (21 × 29 in)
Pastel on Ingres board, 1997
"I placed my imaginary wood in the center of the picture to isolate it from the rest of the landscape. The earth light comes from the wood, illuminating its surroundings. The post on the left signifies a magical boundary and gives balance to the composition."

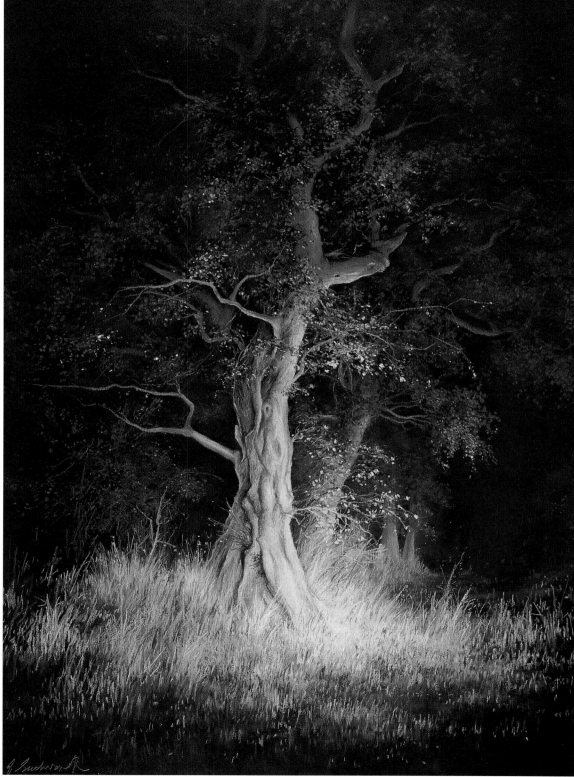

Inifri Duir
68.5 × 51 cm (27 × 20 in)
Pastel on Ingres board, 1999
"Inifri Duir is the name of an oak tree spirit. The oak tree has always been associated with strength and traditionally the door to a house was made of oak. In fact, the word door is thought to be derived from Duir, an ancient name for oak.

"I wanted the light to be very golden and vibrant and to emphasize this I kept the whole of the background in darkness. Without wishing to make the tree look human, I painted it leaning over with branches like outstretched limbs."

This had a much better feel and gave the picture the depth I wanted.

"I often include a stony path in my pictures as they signify all sorts of things. Life is made up of the paths we choose or do not choose. Paths can symbolize a journey, a choice or direction or simply a way through. They also show the presence in the landscape of someone or something else that has travelled that way before."

The Last House

"I don't think that I could ever part with *The Last House*. It is based on a wonderful old farmhouse that I used to explore with my sister. It had been empty for quite some time and was partly boarded up, but we often managed to get inside—though we never disturbed anything. It was so beautiful, with an old cobbled courtyard and all its original exteriors. Inside the house the ceilings were very low with huge beams across them. It was quite ghostly but not at all scary. There was always a wonderful atmosphere around the place, eerie but pleasant. The farm came up for sale a few years ago and we did make enquiries with a view to buying it, but it had been sold almost immediately.

"I called the picture *The Last House* for two reasons: it was a house that I always wanted and has now gone and it was the last house in its country lane. Traditionally the last house was always the home of the wise woman of the village. Like *Stay Not on the Precipice,* it's not a very big picture, but for me it will always be a powerful image. I still wish I had managed to buy the house.

"The picture itself isn't so much about a true representation of the farmhouse. It's more about my feelings for it and perhaps my subconscious view of it. To someone else the farmhouse might not even be recognizable in the picture. But that's what painting is about—making marks that convey more than what is real or can be seen."

The Last House
66 × 48 cm (26 × 19 in)
Pastel on Ingres paper, 1995
Drawing on fond memories of a favorite place from childhood, Anne chose a greenish hue to evoke the ghostly feelings she experienced while exploring this old, partially boarded-up farmhouse. Although dark, the picture is not foreboding as the moon casts its gentle light across still clouds and the darkened house at the edge of the slumbering village.

JUDITH CLUTE

"As I work on a painting I get tentative ideas for a title, but as a painting can evolve beyond my initial expectations I wait until the end before making any decision."

As an inexperienced teenager, going off for a couple of brief but formative moments of art study in the Canadian Rockies during the summers of 1960 and '61, Judith Clute revelled in a powerful sense of exhilaration. She had left behind the familiar world of her normal life in downtown Toronto and for a few weeks immersed herself in the scale of the great outdoors. "I was in Banff, Alberta, and I'd never seen anything like those beautiful mountains," she says. "I felt uplifted by the glory of it all."

This place lifted her spirits and being happy fuelled her creative instincts. She painted canvas after canvas. In fact, her industry won her a place as an apprentice for the next two years with the Belgian artists Charles Stegeman and Françoise André, who at that time had an extraordinary studio on a steep hillside in the British Properties in Vancouver, Canada.

Immersion

Judith immersed herself once again in an exotic environment different from her home base, this time with two other students, Pamela Zoline and Peter Wilson, and they found themselves in a learning situation that was quite special. Their teachers had radical ideas about art schools, based primarily on the assumption that art as such could not be taught. Refusing to impart technical skills, they wanted their students to be working for High Art ideals and to learn that when the artist was motivated to do the art the rest would then fall in place.

Judith admits that she loved all that high-flown stuff and still thinks, albeit in a more down-to-earth way, that it holds true, but it was heavy going at the time. She was once working on a painting when her teachers came up to her and asked questions about what she was doing and why. She babbled some pretentious stuff and then was horrified to realize that this was a test and they had taped her response. When she heard her recorded words she realized without being told that she had made some serious wrong steps and set about trying to think more clearly. She was learning to be self-critical, to look at what she was doing from the outside,

an important artist's tool, and this, coupled with the ability to make up her own projects, was what she gained from the apprenticeship.

There was another aspect to this learning situation as the teachers lived in a big house with their two young children and the students living in were expected to help with the chores and childcare. "But I loved it," says Judith. "I didn't mind doing menial work and the kids were fun to draw. I was in overdrive anyway with energy to spare, absorbing too much and going in every which direction. The reward was that the studio was stocked with a good range of art books and I studied everything I could, discovering things I had not yet encountered, such as the International Gothic of the mid-15th century from which I still draw inspiration.

"In the National Gallery in London there's a painting by Uccello called *The Rout of San Romano,* which is on the cusp, leaning back to decorative International Gothic and forward to the new perspectives of the Renaissance. I first studied this painting in a book in the Stegemans' studio. The central battle scene is composed in handsome overlaps. I borrowed from this in 1994 in my painting

BIOGRAPHY

Judith was born in 1942 in Edmonton, Alberta, and grew up in Toronto. She had no siblings but was surrounded by close friends who were refugees from Estonia, Latvia, Poland and Germany. She remembers the world outside her chosen circle as a grey place not to her liking.

She finished secondary school in 1961 and attended evening art classes at the Artist's Workshop in Toronto. This led to two summer courses at the Banff School of Fine Art. Her lecturers liked her art so much they offered her an apprenticeship, which she accepted.

In 1968 she moved to London and settled in Camden Town. It was at this point that Judith started to develop the fantasy elements of her work.

Her work has been exhibited regularly since 1970 in solo and group shows as well as in many art shows at sci-fi conventions worldwide.

Her pictures have appeared as cover illustrations for, among others, the Women's Press, Serconia Press and Liverpool University Press.

She has also illustrated stories in magazines such as *New Worlds, Cipher, Interzone, Strange Plasma* and *Attitude.*

She still lives in Camden Town with her partner, John Clute. Her work can be seen on her website, www.judithclute.co.uk

An early stage of *Slippage,* which was subsequently overpainted while the work was in progress.

Slippage
30.5 × 30.5 cm (12 × 12 in)
Oil on canvas, 1998
Slippage is a good example of Judith realizing at a late stage of the picture that she wants an entirely different feel to the piece. In this case a far darker image was overpainted. This process of last-minute alterations can sometimes retard the completion of a painting by years.

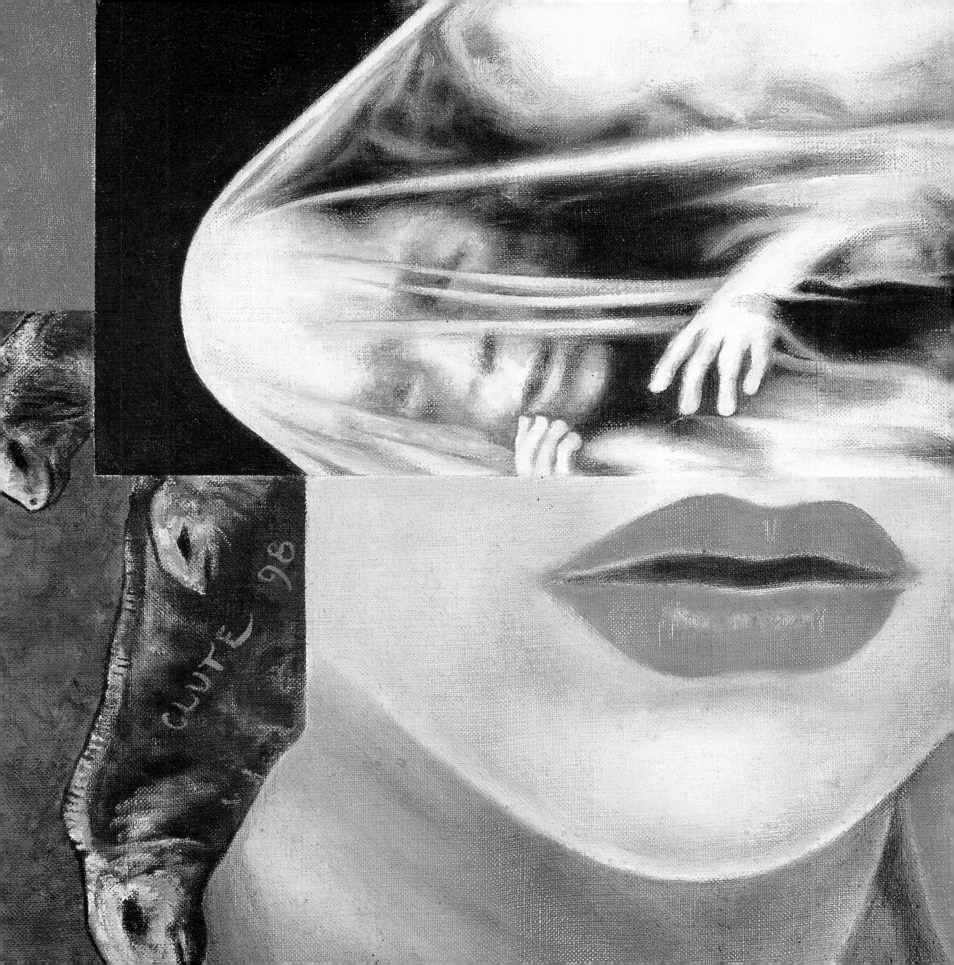
CLUTE 96

Footpads of Darwin to make a background of young noblemen in armor moving across my canvas. But that was a later concern. Back in the early 1960s I wasn't ready for that."

Although there was much inspiration to be found in the library, her teachers held her back from immediately appropriating the techniques that she admired. She was told that much as she was fascinated by the utter strangeness of the Belgian Surrealist René Magritte, it would be cheating for a student to take on the outside trappings of such a individual artist before she had found her own voice.

Theater

"In 1965, shortly after we got married, I went with John Clute to the Colorado Mountains, where he was teaching a summer creative writing course at Geraldine Price's Aspen Workshop while I worked in the attached art school," Judith says. "The landscape was magical and I think finer at that time of year than it would have been during the ski season. You could still take the ski lift up to heights 10,000 feet [3000 m] above sea level and wander in alpine meadows, looking at the majestic grandeur of mountains all around. It was like bathing in that first excitement I felt back in Banff, Alberta.

"Perhaps it was the thin air of the high altitude, but I was in crisis with my art. I felt I needed to include people and urban concerns along with this easy delight in landscapes. By chance David Hockney came on a visit to Aspen at this moment."

Seeing Hockney in the flesh made her pull out the catalogs of his past shows which were in the common room and she gave his work special attention. "Here was an artist I could really admire," she says. "Hockney was not doing chocolate-box landscape pictures; he had just the right mix for the times. He was a romantic who had a way of being odd and surprising and who painted his friends in wonderfully unreal theatrical backdrops such as the California swimming-pool culture. I didn't have anything like those stories to tell, and truthfully I was made slightly uneasy by the theater-set aspect. But I liked the people orientation in all his work. I would do people paintings too, only in mine I would focus on people as icon. By that I meant I would try to paint a person as caught in a special moment and make that person seem to stand for something larger, while remaining just short of being symbolic."

Hockney's work changed Judith. She learnt to analyze what was there in front of her and could see that there was real creative magic implicit in his paintings. She felt that one of the reasons was that he reinvented the composition every time. "As it was a sense of magic in a

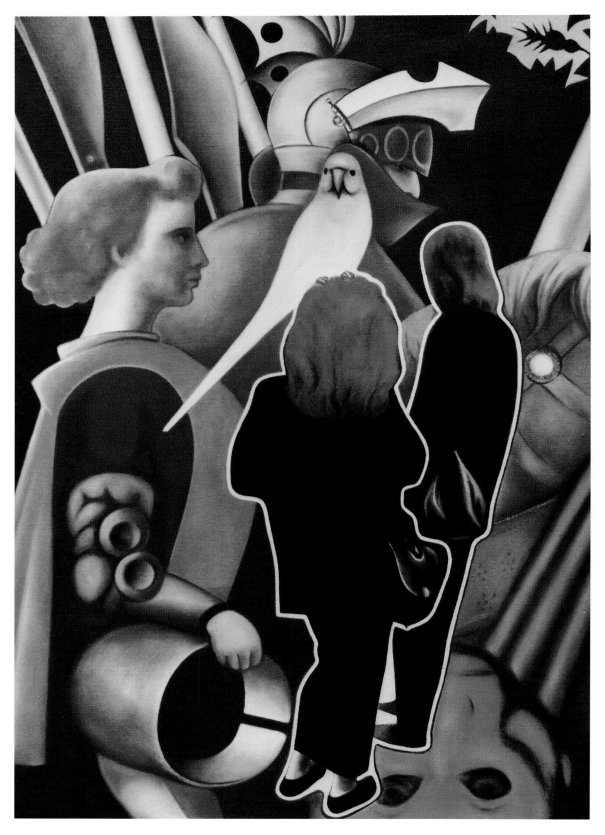

Footpads of Darwin
71 × 51 cm (28 × 20 in)
Oil on canvas, 1994
In the background is Judith's version of Uccello's warriors from *The Rout of San Romano*; the foreground is dominated by a couple of Camden Town women levitating from the base, but the red-faced monkey is the structural pivot for the painting. Its eyes and those of the parakeet look right out at us, reminding us that we are in an uneasy relationship with the animal world. The lances effectively create a swirling motion in a counter-clockwise direction, making a vortex focused on to it.

painting I was trying to achieve, I decided to make paintings which combine the things of this world that intrigue me most: people and their artifacts, and small rations of gorgeous landscape." She decided to mix all this approach into Hockney-type magic paintings, each being different from the one before, and see where this led her.

Perspective

Judith feels she finally hit her stride after she settled in London, when she exhibited her work in a two-person show with Pamela Zoline at the New Arts Lab in 1970. She had been studying one of her favorite Surrealists, Max Ernst. Looking deeply at his work had made her stop and rethink yet again. She could see in this an echo of the Hockney magic she had noticed when she came up with a manifesto for her future work, but this time the input was causing a form of deconstruction. She had stopped stretching canvases and using oils and instead painted with a limited acrylic palette of ochres, black, white and touches of blue on ordinary hardboards. The images were diagrammatic and related to human accomplishment.

"I was building on the liberating decision not to use conventional perspective or treat the painting as a theater picture," she says. "I was laying patterns across the surface of the boards, each of them 24 by 48 inches [60.5 × 122 cm], and attempting to paint like an Australian Aborigine, decorating ritual images on tree bark. One of the paintings even had a quote from that source, white squiggly creatures drawn on a red ochre background, but that was laid on top of a diagram for pistons in a car. There was also a mixing of disparate images such as an Inuit rendering of a raven, circuitry charts, a giant stapler, and a pair of pictures showing how

the bones of the mouth of a boa constrictor can open and re-hinge to take in something huge. This juxtaposition of unlikely elements I think I owe to Max Ernst and it allowed me to move away from landscapes while at the same time incorporating them."

With the decision to work against perspective effected, Judith was painting with a happiness similar to that which she had felt in the mountains of Banff, but raised a notch by the experience of several years. She had laid to rest worries of accommodating the urban. "At last I could see how to paint as a city person with dreams. I can't really express the concept clearly in words. That's why I paint."

Confusion

Judith enjoys pushing to the limits of convention and arranging compositions of elements that really should not go together—which is a good excuse when once in a while a painting goes completely off the rails. Of course, this can also be offered as an explanation for the successful paintings. Most of her paintings over the last 30 years have involved schemes of complex mixing. "I try to accommodate an inordinate range of things and I've got a strange way of composing," she says. "I like to defy gravity with objects that float off at angles. I love angles and overlaps and I often work hidden triangles into my compositions. I also place breathing spaces where conventional composition wouldn't allow them to be—little free spaces as a balance to areas of frantic overactivity." Examples of these angles, overlaps and breathing spaces are quite clear in *Footpads of Darwin*.

"Sometimes there are diagonals which, to use a gravity metaphor, bear some pretty heavy stress-bearing loads. In the really busy compositions my range of

Diorama of the Christian and the Lion
45.5 × 96.5 cm (18 × 38 in)
Oil on canvas, 1978
This painting is composed of four panels which can be taken in all at once by the viewer or studied more slowly and read from left to right. Judith hopes that it works both ways. The left panel is her reworking of an 18th-century Rajasthan hunting scene, brutal but rendered with a poetic light touch. The next comes from the early stages of the Italian Renaissance, borrowed from a part of *The Resurrection* by Guido Reni. The third is a fictional image of Judith intended as a reflection of what the viewer sees in the picture and the fourth is a growing plant, a moment of stability in the swirls and rhythms of the other parts of the painting which also represents our future.

"When I decided to paint pictures of people and their artifacts in 1965, thinking to give up the easy pleasures of beautiful landscape, I still found I was on a road that would come by a different route back to the aesthetics of beauty and epiphany. I think I got there in this painting."

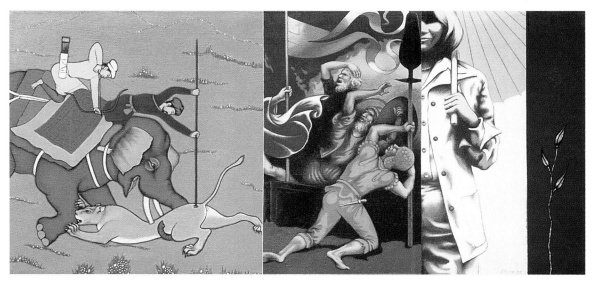

Scree Beach
58.5 × 101.5 cm (23 × 40 in)
Oil and collage on canvas, 1993
This painting was prompted by the epiphanous response Judith experienced upon seeing Vezelay, an ancient Romanesque monastery in central France. The resulting work has a Romanesque woman with huge feet and small hands holding a strange version of a lion, a repeated image of a self-portrait by the Expressionist painter Max Beckman wearing a monkey mask and holding a trumpet with his feet, a collaged rendering of the cogs and wheels of a clock, and a 'scree' of letters lying at the base of the painting. "I don't know whether this painting works in relation to the original intention, but I know I had a lot of fun in creating it and I'm proud of some of the delicate balances of the composition."

Look at the Evidence
48 × 14 cm (19 × 5½ in)
Ink on paper, 1994
The title came to Judith's partner, John Clute, while he was looking at the piece. It was also just right as a title for a new collection of essays and reviews which he had just assembled (*Look at the Evidence* by John Clute, Liverpool University Press, 1996). The original ink drawing was stolen from an exhibition at Lauderdale House in London, which was a double blow as there was a sold sticker alongside it at the time. Fortunately the buyer agreed that if Judith reconstructed a copy she would still buy it.

John Clute

Look
at the
Evidence

ESSAYS & REVIEWS

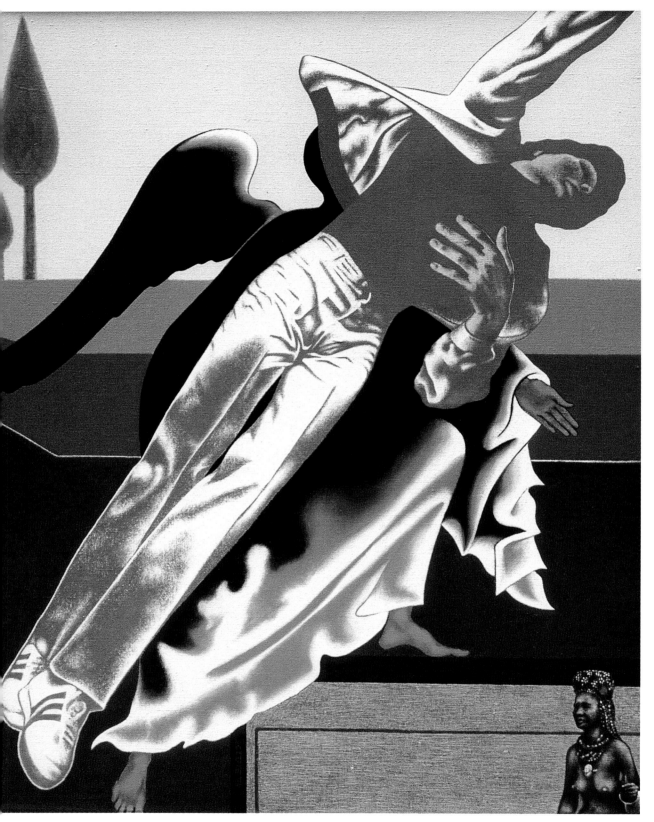

Scheherazade
61 × 48 cm (24 × 19 in)
Oil and acrylic on canvas, 1979
The figures overlap each other, both in their ways looking like angels. The man floating with his jacket out like a wing was painted in acrylic, while the rest was executed in oil. "Although we were living in very cramped accommodation and I don't know how we coped with the smell, I just needed to get back to the sensuousness of oil paint after a period of exclusively using acrylics because of our restricted working space. Much smaller, down in that lower right corner, there is an African woman who could be our storyteller, Scheherazade."

colors tends to be kept down to a close harmonic register, or even a monochrome. Then there are other paintings which look like graphics pure and simple. I'm attempting to push the edges of definition in terms of my approach, which can confuse some people. I have been told my work looks as if I'm a frustrated graphic artist or technical illustrator by people who don't seem to understand that oils would be the last choice of medium for either graphics or technical illustration. I'm doing exactly what I mean to."

Magic box

"I have always felt edgy trying to describe how things come about in my paintings and about that side of the creative drive. It's as if I shouldn't peek inside the magic box because maybe opening it will cause that cache of unending ideas to be suddenly emptied. I have been really lucky in this respect so far in that I always have one painting, sometimes two, on the go. I absolutely love painting. I'd feel devastated if the inspiration dried up and I had nothing to work on.

"I set a clean white prepared canvas on my easel and look at it for a while. I don't make a mark on it until I've planned out a whole composition. The first area to go on the canvas is my main point of interest, which is never directly in the center. All the rest of the structural stuff will work around it, so placing this focal point off-center will keep the piece precariously unbalanced. I avoid composing pictures with objects that are of similar size. They should ideally be in relationships that are graceful or unusual, though the graceful relationships are often sacrificed because I'm pushing more and more for the unusual."

Judith also approaches sketching in a way that is different from the norm. She will often take scissors to magazines and cut out random images and shapes to block in areas of the pictures she is concentrating on. Then she will add charcoal sketches where she needs to

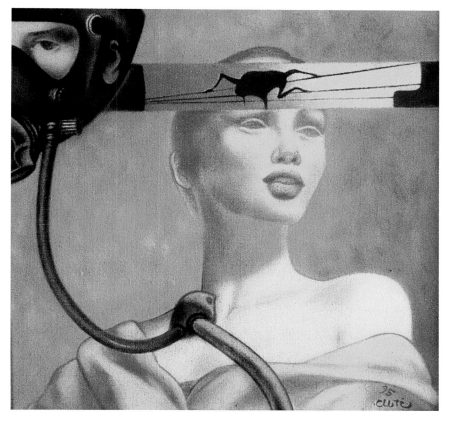

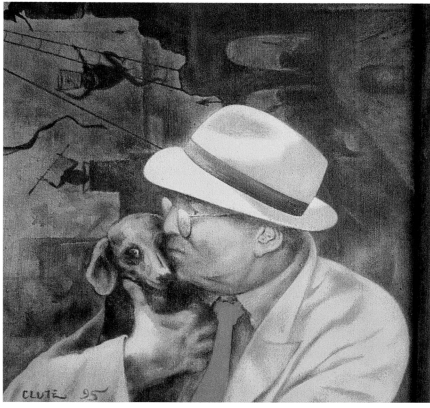

Progress of Anansi #1
30.5 × 30.5 cm (12 × 12 in)
Oil on canvas, 1995
This painting is in a direct line from the moment back in 1965 when Judith decided her direction was to be people-oriented, unusual, magical paintings. "I'm especially proud of the band of strangeness going across the woman's forehead. The image came from the upper right-hand part of Pieter Brueghel's *The Dulle Griet,* or *Mad Meg,* where strange froglike creatures climb up ladders to the crow's nest of a ship. Transposed into my picture, this looks rather like a spider working its way along a web. Anansi is a trickster in the form of a spider in West African and Caribbean folklore and so, Anansi dominating, the plot is up to the viewer."

Progress of Anansi #4
30.5 × 30.5 cm (12 × 12 in)
Oil on canvas, 1995
This painting takes another slice from Brueghel's *Mad Meg.* The dog's apprehensive expression and the man's obvious discomfort with his environment pose questions. "If these are speculations posed by the painting, then that's the subject of the painting. Questions, not answers."

work out the details of a form, pasting them on the magazine color pieces or vice versa. For this purpose she accumulates files of clippings from the popular press in the tradition of the painter Seurat. Sometimes she drops an image from a height to see if it will land in an interesting way, perhaps backwards or upside down.

Judgements

In the turmoil of preparation before painting, Judith says she has large-scale fuzzy ideas, such as mankind's uneasy relationship with the animal world, what emotions might be felt just before death or what an alien might see walking down a street on Earth. Sometimes she might want just to make a kind of dance statement. In the sketching process she might shift from one broad category to another or end up somewhere quite

unexpected. "All this randomness is part of the fun of the way I work," she says, "but I am quite firm about there being an important moment to trust instinct, to know when I should jump. It's all about making the right judgements." At last, when everything is as right in the sketch as it is going to be, Judith makes a tracing with a grid—a very old-fashioned way of transferring a drawing to canvas.

Years ago Judith used to begin by applying midtones in turpentine wash, while working down to dark and up to light. Now she can hold the values and relationships in her head and start immediately with undiluted paint. In her words, she has had experience enough to cope with the intrusion of adjacent white areas. Indeed, white is sometimes part of the composition. "I'm not too bothered if I have to repaint and repaint again to adjust

the tones," she says. "You do what you have to in getting the picture right." She also notes that sometimes she has almost finished a painting exactly as she has designed it only to realize that a favorite part has to be done away with and repainted with something else. It is for this reason that some of her paintings take a few years to complete.

Letters

Judith has accepted commissions for illustrations now and then, squeezing this work in between the ongoing easel paintings. For one story, *Learning the Language* by Martha Hood, published in *Interzone 42,* December 1990, the title translated literally into the content of the illustration. Learning language comes to all children in time; the difficult part for some is learning to read a

The Sacrifice
101.5 × 152.5 cm (40 × 60 in)
Oil on canvas, 1978
The title may refer to a sacrificial goat, or to the mother holding the sign that reads "we need homes now." The idea came from Judith's wish to paint a completely changed version of an oriental cherry blossom painting. The perspective flooring floats intrusively into the animals and sets up a zigzag movement, angling into the top left corner where a woman in an evening dress floats, hands covering her eyes. "I wanted a structure that would in a jagged way move across a portion of the picture plane, leaving graceful empty spaces." Again we see, in the woman's floating evening dress, Judith's fondness for decorative play with fabrics and formalized figures.

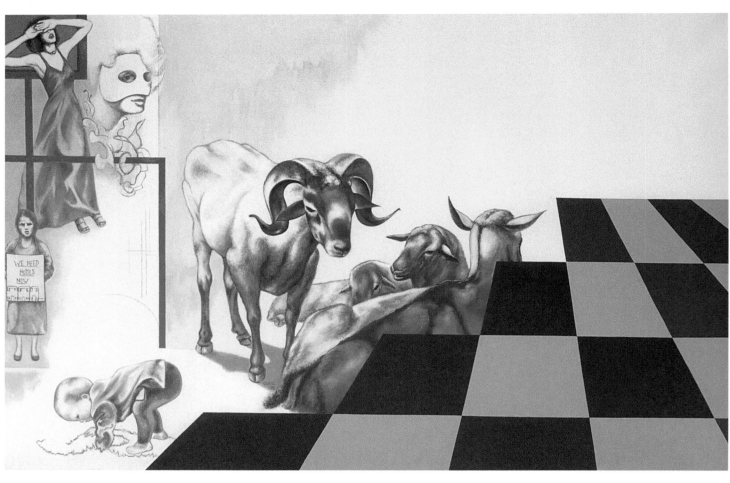

Learning the Language
18 × 12.5 cm (7 × 5 in)
Watercolor, collage and Letraset on paper, 1990
This was the image that started Judith using letter forms in her pictures. A simple but effective design with strong movement that echoes the shape of the letter Z, it was commissioned for a story called *Learning the Language* by Martha Hood, published in *Interzone 42*, December 1990, and literally interprets the title of the story it was illustrating.

Will You Join the Dance?
61 × 45.5 cm (24 × 18 in)
Oil on canvas, 2001
Here a distorted self-portrait is shared with a lizard. The proximity of the two emphasizes the similarity of shape and suggests a sense of connectedness even with something as extreme as a reptile. After all, we all grew up in the same biosphere.

Marrying Out
86.5 × 101.5 cm (34 × 40 in)
Oil on canvas, 1995

The black lines sectioning the picture were appropriated from a René Magritte painting called *On the Threshold of Liberty*. Three of the men wear the same Inuit shaman mask and the odd man out—a rendering of Dan Leno, star of the golden age of music hall—is dressed as a bridegroom. In another segment of the painting the women stand, one of whom might be his bride.

"The men have fully painted faces under the masks, dating from the first stage of this painting, based as it was then on a photograph I had taken in Camden Town of people waiting at a bus stop. The monochrome masks provide the focus and embody a sense of transformation. The hinged hands coming out from the edges relate to the adjacent feathers. I especially like the little open doors in the forehead for the spirit to come out."

written representation of the language. This inspired Judith. "I began creating letter collages. *Learning the Language* started by cutting the letter Z from a rectangle of watercolor texture as the basis of the composition. Then I collaged a woman's arm and thighs in such a way that we can feel the implied form rushing down to the lower left where the direction hits closure, XYZ. I enjoyed this composition as the viewer's focus is encouraged to rush around within the rectangle, striking edges only to bound back into the picture's action in an echo of the letter form.

"As I did these several letter collages, I started to become fascinated by the shape of the letters as graphic form, especially the lowercase letter "a." Then one morning I was suddenly struck by the typography of the banner of our newspaper as it lay on the breakfast table and saw that therein was a perfect graphic shape. I cut out and enlarged the letter "a" and have since painted its shape into several paintings. It has recently occurred to me that by a stretch of the imagination it can even be seen as a shorthand stylized eye under a brow. I suspect there are hints of that in *Will You Join the Dance?* I hadn't seen it quite that way when I painted it, having used this letter as a symbol for language itself, but it's nice when your paintings offer you new clues, even after their completion."

Finding the title

"As I work on a painting I get tentative ideas for a title, but as a painting can evolve beyond my initial expectations I wait until the end before making any decision. It would be a shame to trap the emergence of a picture by an ill-conceived title—that would be the tail wagging the dog. I also like the way Paul Klee encouraged his friends to suggest titles for his finished pictures. I get those around, usually John but once Chip Delany, to offer suggestions. Not all are used but many provide me with new perspective, giving indications as to my intention.

"The main thing I feel to be important is that the title should give further clues for the viewer as to interpretations of the picture, offering a freedom to roam in the imagination. The title should be less a description of the piece and more a part of the process of stimulation a picture can provide for the viewer.

"*Will You Join the Dance?* is a pretty weird painting which is given further ambiguity by the title. The human face, which is a distortion of mine, and the lizard head are in very close conjunction so that they bear a family resemblance. Perhaps the title says we're all in it together, or maybe the letters "a" have just waltzed out from the word 'dance.'"

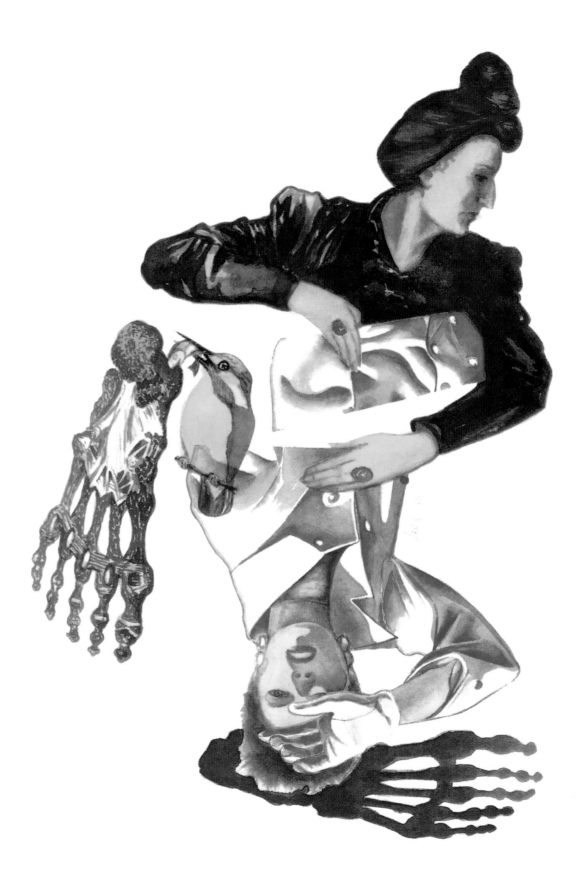

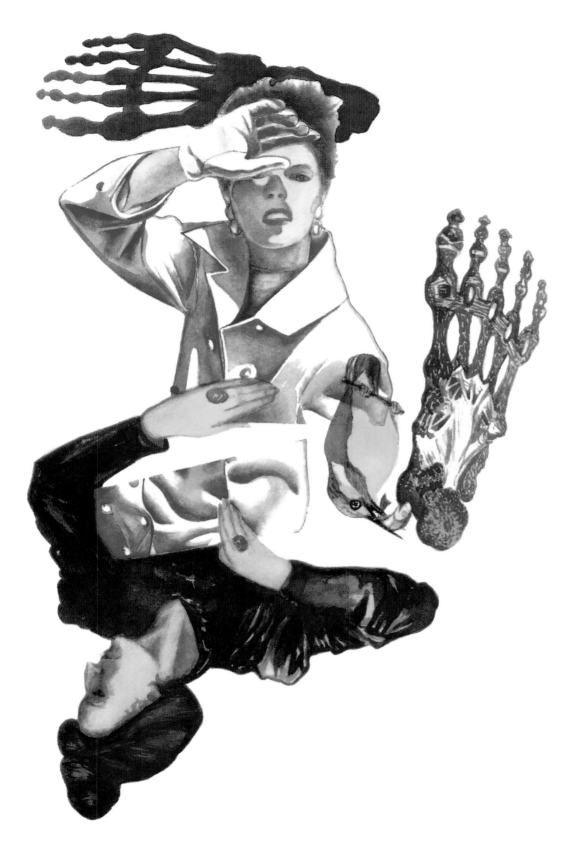

Urban dreaming

"It seems odd to me now, looking back from my vantage point of 60 calendar years over a full life devoted to art, to see that I have not shifted that much from my original intentions. I still have wild enthusiasms much as I had when I was in the Canadian Rockies and I still tend to the pretentious as I did when I was an apprentice in Vancouver.

"When I am asked why and what I'm doing in art, I admit that I earnestly want to make pictures that hover between everyday reality and somewhere entirely new. It's that balance between reticence and saying too much in a painting that has always intrigued me, those qualities that drew me to the work of Max Ernst and René Magritte. The Surrealists were always trying to expose the invisible, the realms of the subconscious, the transitory moments of dream and that's exactly what I've always painted: people in urban dreams."

Winging it
23 × 33 cm (9 × 13 in)
Watercolor on paper, 1999
The inspiration for this picture came from playing cards and Judith's desire to produce a painting which could work both ways up. The sharp-edged elbows allow a strong shape that can be mirrored effectively. The rings on the fingers draw attention to the hands and painting the fingers held close together allows a resemblance to wings. The effectiveness of the composition is heightened by the skeletal feet, which help to spin the composition around in a jerky, circular fashion. They also bring a fantastical, otherworldly feel to the picture.

"I like my subjects to be decked out in fanciful clothing. The folds and undulations of fabric with light and shade in my paintings are usually a part of the musical effect and encourage the viewer's eye to slide across the surface of the painting."

JOHN HARRIS

"When I was a child I spent hours with my head in the grass imagining that I was too small to see over it. I used to watch the tiny creatures living their lives in between gargantuan trunks of grass and wonder what it would be like to be their size."

Anyone with an interest in stargazing will soon discover that the star at the curve of the Plough's handle appears to be two stars—but one of them is in fact not a star at all but the Andromeda Galaxy, our nearest galactic neighbor, billions of stars so distant that a single, nearer star outshines their combined luminosity. This understanding is more than likely to change the star-gazer's perspective of scale and their sense of place in the universe entirely and forever.

The pictures of John Harris suggest he has also confronted such revelations. His work is defined by images of vast spaces and artifacts so huge they reduce any people in the picture to mere dots within the composition. Indeed, so enormous are these ancient decaying machines in comparison to the inhabitants of the pictures that one imagines they can never truly get a sense of their purpose and just have to accept them as an unknowable part of their world. The mind-numbing scale suggested by these images forces the viewer to confront the insignificant minuteness of everything that mankind has discovered or built when placed in the context of the universe; our mightiest achievements would be lost in a tiny blur in a corner of one of John's canvases. There are several causes for this obsession.

A matter of perspective

"When I was a child I spent hours with my head in the grass imagining that I was too small to see over it. I used to watch the tiny creatures living their lives in between gargantuan trunks of grass and wonder what it would be like to be their size," says John. "Physical aberration though it was, it left me with a peculiar sense of what was big and what was small.

"I also remember seeing aircraft flying overhead and having a problem trying to get a proper sense of their size; I imagined them to be the same scale as model planes flying just above my head. There was obviously something in my perceptual makeup that made it difficult for me to get a grip on what was big or small and it's probably from this that the ability to visualize scale came. This struggle to get these relative sizes correct in the ordinary world got to the point where I could go out into the evening to look at the Milky Way and visualize it not just as a sky full of stars but as a disc going upwards for 100,000 light years away from me so that it went off the board in terms of the human scale.

"I would spend hours every night looking at the sky, and I remember quite consciously struggling to see the scale. In my early adolescence I became familiar with the visionary space art of Chesney Bonestell, whose paintings, produced decades before a camera was launched into space and everyone saw the beauty of the solar system, graphically depicted scenes we now take for granted; of the moon, various planetary bodies, space rockets and space stations in high orbit over the Earth. It was inspirational stuff, and I felt I'd found a kindred spirit. It was only recently that I discovered that Bonestell worked like a scientist with his pictures. I had assumed he had shared this kind of innate, poetic perception about what things looked like and it was done by instinct, but apparently he didn't—he built models, stuck them in dark rooms and lit them with the logic of astronomy.

"The feeling of space developed into very much more focused ideas and theories and it's very difficult for me to separate what was my work as an artist and what was triggered by getting deeply involved in meditation in the 1960s and '70s. My interest in meditation grew from a couple of experiences of lucid dreaming."

The wall

"I suffered a bit from vertigo when I was a child, and later, in my twenties, I started having lucid dreams of being in high places. On one of these occasions I dreamt that I was walking along the top of a colossally tall wall, many hundreds of feet high but only about 12 inches [30 cm] wide. I suddenly became aware that I was dreaming, and this produced a tremendous thrill because I realized this was a opportunity to overcome something. I knew I couldn't hurt myself if I fell, so I turned at right angles to the wall and made a decision to test what happened if I stepped off. It was so real that I partly expected to fall, yet because I sensed I was dreaming

BIOGRAPHY

John Harris was born in London in 1948. He enrolled at Luton Technical College in 1964 at the age of 16 and completed an art foundation course. He subsequently went on to Exeter College of Art and Design, Devon, in 1967 and graduated in Painting and Fine Art in 1970.

After several years abroad studying yoga and meditation, he returned to Exeter and began painting science-fiction imagery in 1977.

After joining the Young Artists Agency at the end of that year, he was commissioned by Pierrot Publishing to produce the pictures that were to become Mass: The Art of John Harris, published by Paper Tiger in 2001.

In 1984, the year of his first one-man show, he was invited by NASA to join their art program and record a launch of the Shuttle. This painting is now part of the Smithsonian Collection.

Since then he has produced over 500 book covers and in recent years has executed a number of large canvases for the giant cruise liners of the Royal Caribbean fleet.

He is married with two children and lives in Devon.

A number of John's paintings can be seen on the website www.alisoneldred.com

The Wall
152.5 × 122 cm (60 × 48 in)
Oil on hardboard, 1979
This was the starting point of John's journey into the realms of science fiction. It came from drawing sessions with an architect and expressed a particularly gothic mood. "This started life as an enormous 3 by 4 foot [0.9 × 1.2 m] charcoal drawing and my feelings about the void, represented by the gap between the two parts of the wall, clearly express my fears of the plunge into a large area of darkness."

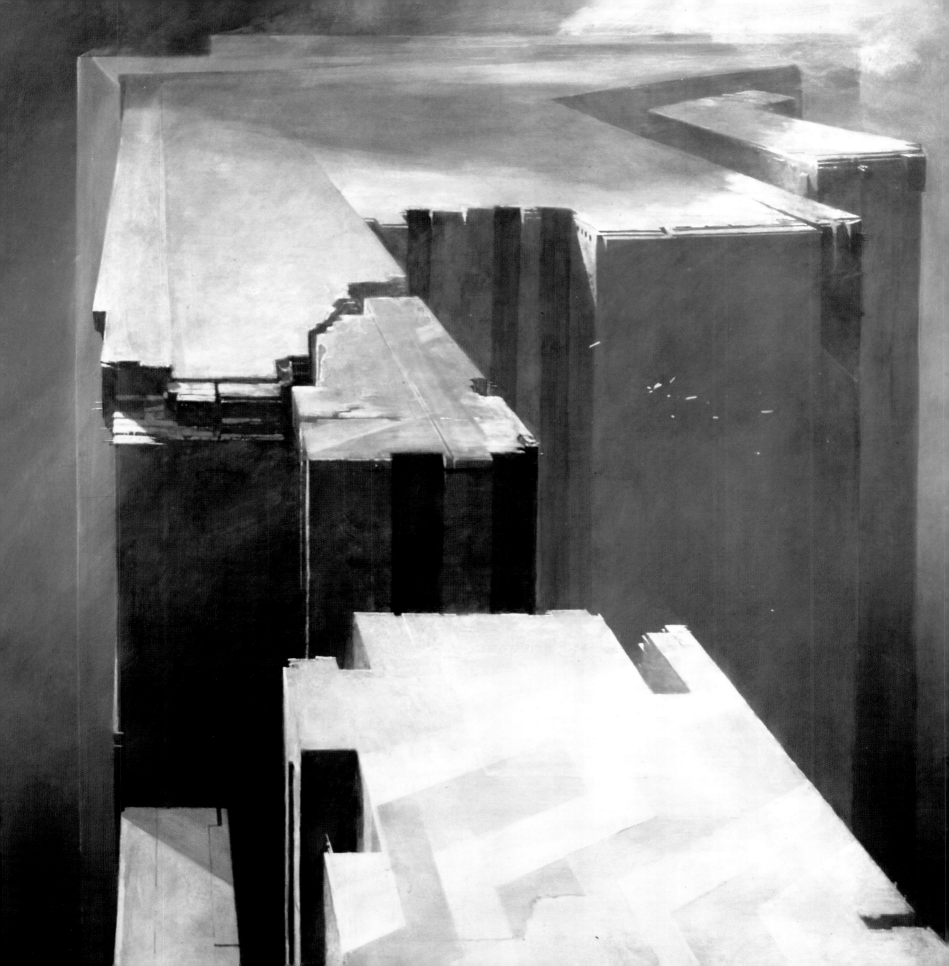

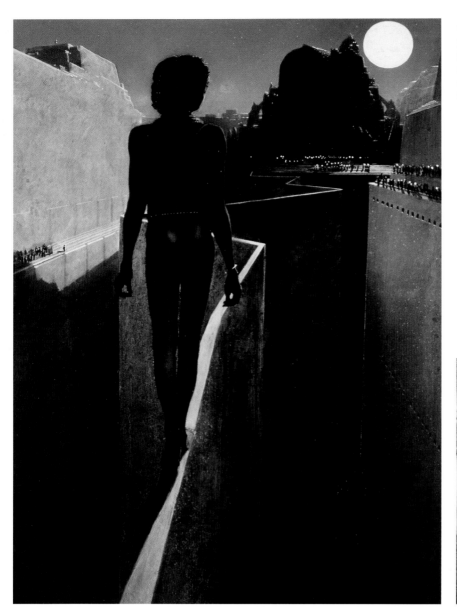

The Girl on the Wall
35.5 × 25.5 cm (14 × 10 in)
Shellac ink on paper, 1979
Although this seems to be another vertiginous nightmare, the picture serves a different purpose. It attempts to evoke curiosity about the unseen parts of the city by asking, "What sort of culture would build such an impossible structure?"

Tightrope
26.5 × 13 cm (10½ × 5 in)
Conté crayon on paper, 1989
A rough sketch for an advertising company produced ten years after *The Wall* is still using the sense of vertigo for visual impact.

I felt that it wouldn't be quite like that. I stayed exactly where I was and I was able to turn in mid-air and see the wall where I had been standing, then turn back and look across the wood around the wall and down to the ground. As I looked down I slowly descended to the ground below and then walked through the wood before waking up. From this point onward the fear of vertigo lost its grip on me, and I think that from then on the will to do such pictures as *The Girl on the Wall* and many other images that invoke vertigo was undermined and my agenda changed.

"Having gone through this huge range of variations on a theme of dealing with the fear of falling and vastness

and all such things, I had now got to the point where the sheer scale of space and time filled me with a sense of joy. I was completely at home with such concepts and I related deeply to the idea contained in the words 'We are stardust,' sung by Crosby Stills & Nash in their chart-topping version of Joni Mitchell's song 'Woodstock.' These words encapsulate the wonder of the universe succinctly, since all the heavy elements found in our biosphere could only have come from the hearts of ancient, exploding stars. Without the deaths of these stars in the unimaginable past there would be no carbon on this planet to facilitate the evolution of life. That is where we come from, that's our home and actually these

pictures for me were like portals, they were ways of connecting with feelings of that joy. It was fortunate I later met my agent, Alison Eldred, and found I could earn money from painting such images.

"The whole of my career as a painter of this kind of picture was motivated to capture that joy and was not so much concerned with the contents as with the atmosphere they conveyed; atmosphere was everything. In essence any good art should have this as its goal, but then of course you get involved in color, in texture and in composition and inevitably become interested in taking it as far as it will go, which leads to the realm of art for its own sake. I would ultimately define art as an attempt to

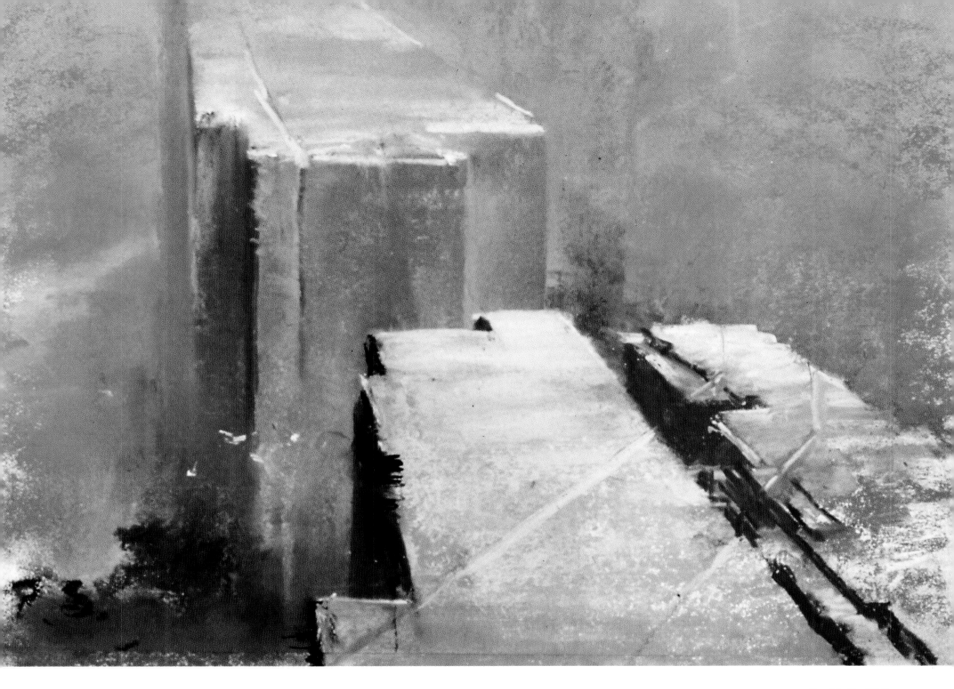

Fire: On the Wall
25.5 × 20.5 cm (10 × 8 in)
Pastel on paper, 1999

John feels this is a watershed picture. He chose to return to the imagery of *The Wall* and to employ virtually
the same vantage point, but then created an entirely different feeling by the use of light. This came about as a
result of his decision to leave behind the seclusion of his life and his growing sense of peace after getting
married and having a family. "It was returning to the same place and seeing it in an entirely different
way, this time as one of warmth and welcome."

express that which cannot be expressed in any other way and the urgency to communicate it probably one of the deepest urgencies in human spirit. Because we are otherwise utterly alone in that void."

Drowning

Thankfully for admirers of John's work, his school art teacher directed him away from a career in the Royal Air Force toward art studies and a pre-diploma course at Luton Technical College, where he studied for 18 months under the tutelage of Anthony Slinn. This in turn led him to Exeter College of Art and Design in Devon. There were two prime reasons to eschew art study in London: the first was to avoid the influence of the prevailing pop art trend and the second was John's desire to paint landscapes. This passion for landscapes still comes through very strongly in John's non-science-fiction-orientated work for various journals and travel books.

"My time at art school was pretty confused," says John. "At that stage I hadn't really focused on what moved me and I practically drowned in a sea of constantly changing possibilities. I learned very little craft except in the realm of drawing. This involved a robust and vigorous method of erasing and rebuilding, often on a large scale, but it was only after I had learned to meditate in my final year that it developed into a way of searching for the right image.

"It was as a result of the meditation that the images which define my work started to arise. There were many very clear images inside my head that wouldn't leave me alone until I had painted them; I had to get them out in order to be free of them. This was the motivation.

"Later, images came from just doing the preliminary charcoal drawings. I did a huge number of these drawings, which were often almost cryptographic; they would trigger off a feeling that would remind me of that sense of vast space, and then I would get a crystallization of an image within a very short period of time. Once that had happened I could not really do anything until I had actually recreated it in front of me."

Picture-making

"Picture-making starts with the vaguest of feelings. My nature is rather serious and a bit romantic in the Victorian sense of the word, so when I'm confronted by the empty canvas or sheet of white paper there is an urgency to introduce an atmosphere of mystery. Inevitably, the medium that I'm working with—usually something soft and malleable like charcoal or pastel—creates textures which, like the frottage techniques of the Surrealists, hints at forms and definitions of space.

"From there, whatever my mind is currently absorbed with kicks in and tries to consolidate the marks in front

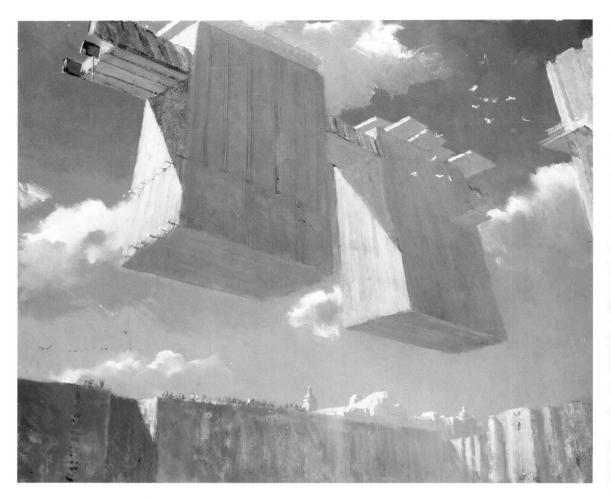

of me into something more tangible. But there is always a urge in me to keep it vague, without losing the satisfaction of expression. This is tricky. The painting that follows is really the battle to keep that balance between these extremes. It is a battle that I usually feel I lose.

"At the beginning of my career I employed a wholly inappropriate technique using shellac inks. They were unsuitable because they are so fragile, and I often destroyed the most promising images in the process of working. Also, they are highly fugitive pigments, meaning they fade over time, so not much survives. Then I progressed to acrylics which are much more effective as, if you're quick enough, you can work on top of previous work without losing what's underneath. I now work almost exclusively in oils, because of their malleability. Usually I start with a neutral midtone gray and then work outwards towards the extremes of light and dark. That way I can keep control over the tone of the picture. The introduction of color is a purely emotional choice and I don't know myself what determines it, except feeling."

The Building of Atlantis
76 × 91.5 cm (30 × 36 in)
Oil on hardboard, 1990
John regrets that he did not leave this piece until he had better painting skills and feels that it is quite crudely executed in some respects. He wanted to create the paradox of the immensely heavy imbued with a quality of great lightness. The title alludes to the many theories people have of the mysterious sciences the Atlanteans may have possessed. "The emotional paradox for me," John says, "was to take something as crude and coarse and brutal as blocks of concrete, make them as light as air and float them in bright sunshine."

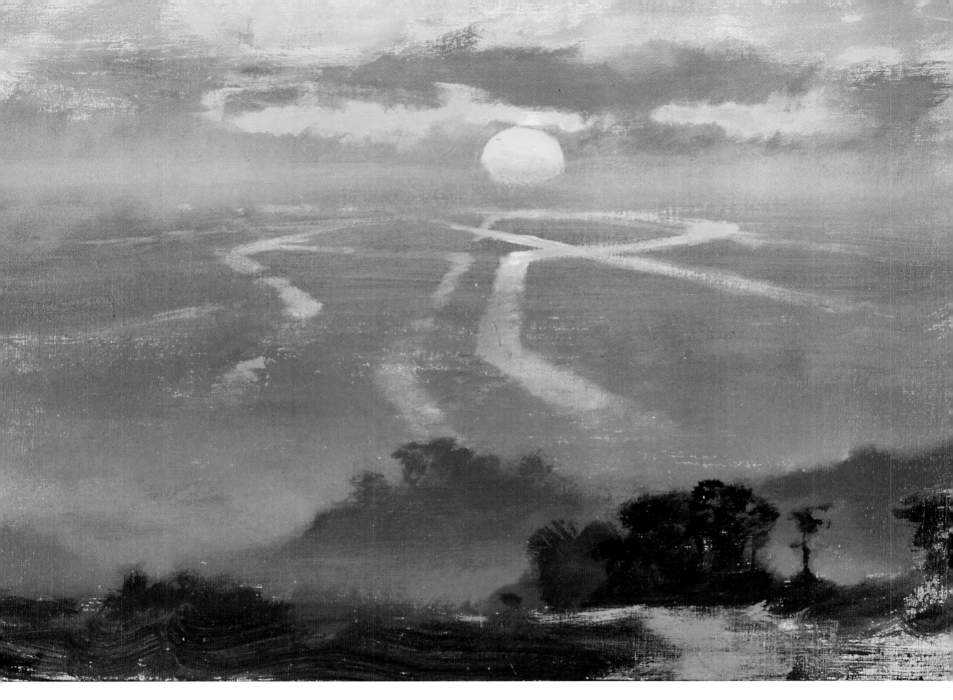

The lines

"As a student, I had had many a discussion with my tutor
about ways in which I could deal with large areas of
open surfaces in such a way that the viewer's eye didn't
get lost in them. I was always looking for methods to
describe these planes in exciting and dynamic ways. In
the early 1970s I spent a lot of time at airports, and
they seemed to be in many ways the epitome of what I
was looking for. Their vast open acres of concrete,
drawn out by the arcane calligraphy of runways criss-
crossing each other and written over by taxiing lines and
parking bays, held a real magic for me. The spirit of the
horizon is a constant presence in places of departure
anyway, but those lines drew it to my attention with
great force."

The Nazca Lines, created in times long forgotten on
the high deserts of Peru, were natural subjects for the art
of John Harris. The purpose of these lines can only be
guessed at and many have offered suggestions, the most
exotic being those of Erik von Daniken who argues they
were created by or for extraterrestrials, possibly as a
landing strip. Whatever their purpose, it is clear that they
can only be read as coherent designs from far above the
ground, something the people that created them could

The View from Above 1 *(detail)*
Oil on canvas, 1989
These pictures represent to John the odd coincidences and significances that have a far greater meaning than we can ever understand from just a cursory glance. Sand was mixed with the paint to give a particularly effective extra texture to the painting.

The View from Above 2
91.5 × 152.5 cm (36 × 60 in)
Oil on canvas, 1989
John's early admiration for the visionary space paintings of Chesley Bonestell are echoed in these paintings of the Nazca Lines.

John's swift, assured strokes of Conté crayon, here in a preliminary sketch for *Ringworld,* are often as effective as the finished painting.

Ringworld
16.5 × 25.5 cm (6½ × 10 in)
Oil on canvas, 1996
Larry Niven's huge artificial habitat surrounding a entire star as described in *Ringworld* (Little, Brown) was perfect material for John, whose science fiction work often centers on the unimaginable differences in scale to be found both within and without our tiny biosphere.

not possibly have done. The scale and mystery of these lines drew John like a magnet.

"When I saw the photos of the Nazca Lines I thought them the most beautiful calligraphy I had ever seen," says John. "But the images lacked a relationship with the horizon and many of my pictures of them have been attempts to supply that. I know this is very abstract stuff, but there is real poetry in it and I haven't even scratched the surface yet. The lines are a calligraphy of intent, vectors of desire whose goal is the horizon, the perfect metaphor for the unknown. Although I see the paintings of the lines as inadequate descriptions of this, they are, for me, some of the more significant images that I have produced, because of the potential development springing out of them."

Space
"Producing images that have been commissioned for the specific purpose of book-cover art brings all sorts of dangers. The ideas that interest me are often very subtle and even abstract, and while science fiction superficially offers a chance to paint what excites me most, the genre also demands a pedantic description of spaceships and architecture. If I want to express any of the feelings important to me I have to allow them to be watered down by the practical demands of book-cover art. I find that ideas that would be better reserved for less illustrative treatment get hi-jacked by the viewer's attention being focused on the spaceships rather than the feeling the picture conveys. Nevertheless, there are some images which have somehow managed to survive this process of compromise, although I can't pin down why.

"*The Currents of Space* is a good example of this. Once again, the horizon has a big part to play. The image of a structure so big that its far end is below the horizon, yet it towers above the viewer, stretches my imagination to its limit, which is always a fun place to be. Even if I had absolute freedom to produce any image I wanted, I would not have created anything different. *Ringworld* similarly has a resonance for me, although more abstract. I think this is an image more to do with the vastness of time than of space. I wanted the structure to look as though it had seen empires rise and fall but after all this had remained intact. I tried to induce a sense of 'booming,' echoing endlessly through the rings in the wake of the ship. There is a loneliness implicit in this which I have always felt when confronted by the past. When you consider how short a time humankind has been around, galactically speaking, it would seem unlikely that our tenure would coincide with another race in the same tiny fraction of space available to our exploration—so far!"

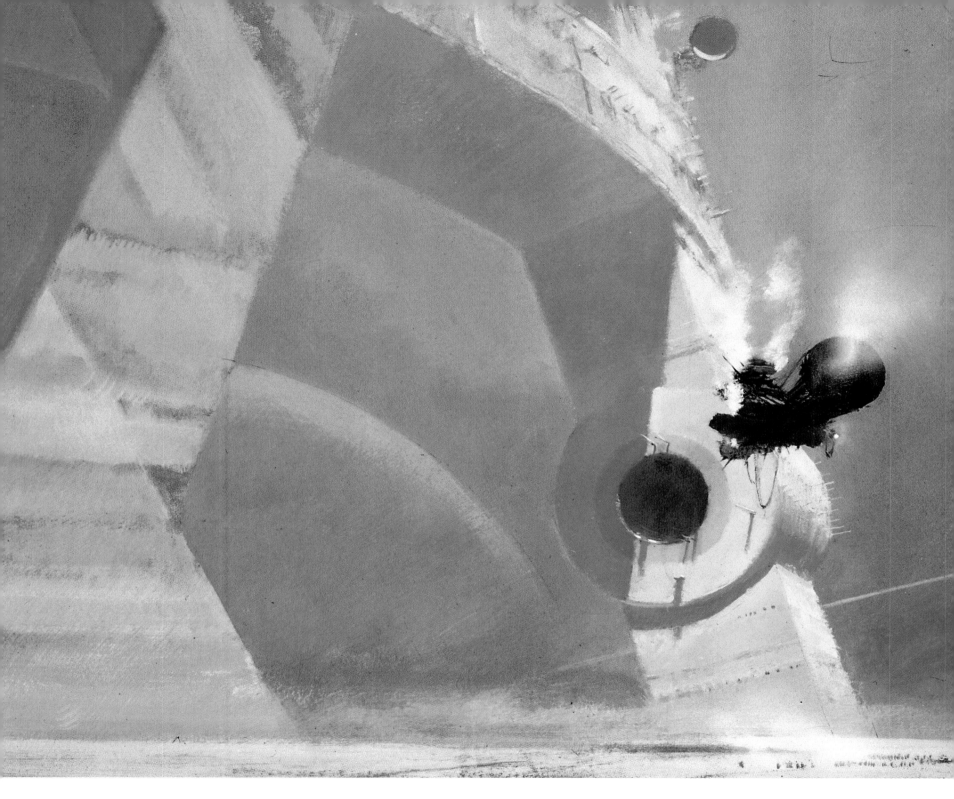

The Currents of Space
30.5 × 51 cm (12 × 20 in)
Acrylic on board, 1992

Isaac Asimov's vision in *The Currents of Space* (HarperCollins) is another that is found only in science fiction. The structure is so large that its supporting legs straddle the horizon, reducing the creatures on the plain to the size of ants. John has deliberately stretched the perspective to emphasize the scale of the structure and slightly curved the horizon to hint at the distances involved.

Sector General
45.5 × 25.5 cm (18 × 10 in)
Oil on canvas, 1999
This painting was the cover art for *Sector General* by James White (Tor Books). Regardless of the technology needed to build such futuristic structures, everything in John's imaginary universe has a rugged, industrial, thoroughly used look to it.

Alien Emergencies
73.5 × 48 cm (29 × 19 in)
Oil on canvas, 2001
Striking angles, unusual perspectives and dramatic use of light and shade allow John to interpret even the tightest of briefs with sufficient creativity to keep the frustrations of illustrations at arm's length. This was the cover for *Alien Emergencies* by James White (Tor Books).

The Building of Babylon
56 × 12.5 cm (22 × 5 in)
Conté crayon preliminary sketch.

Starwolves: Tactical Error
76 × 51 cm (30 × 20 in)
Acrylic on board, 1990
Of this commission for the book of the same title by Thorarinn Gunnarsson (Warner Books), John says, "I realized while working on the painting that there was a much better way of doing this image but that it wouldn't be acceptable as a book cover."

Tactical Error
122 × 92 cm (48 × 36 in)
Conté crayon on paper, 1990
A reinterpretation of the painting that John felt had been flawed by the compromises made at the insistence of the publishers (*left*). "Having finished the artwork I took a huge piece of paper and filled it with the image, adjusting it until I had a more satisfactory composition. The smudge of smoke provided a more effective focal point than the darting starship of the original painting."

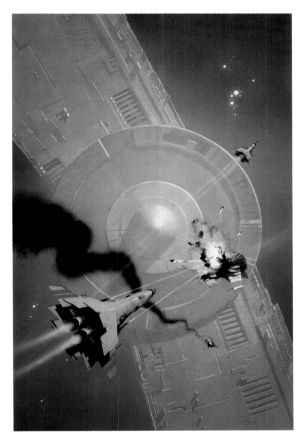

The Building of Babylon
56 × 12.5 cm (22 × 5 in)
Acrylic on paper, 1985
In this color sketch, created as a proposal for a picture for the advertising group Imagination, John used the old science fiction idea that although a planet's surface may look natural, all manner of artificial constructs may lurk just beneath the surface—another of John's reminders that nothing is skin deep and that only by scratching through the surface can the true nature of things be revealed.

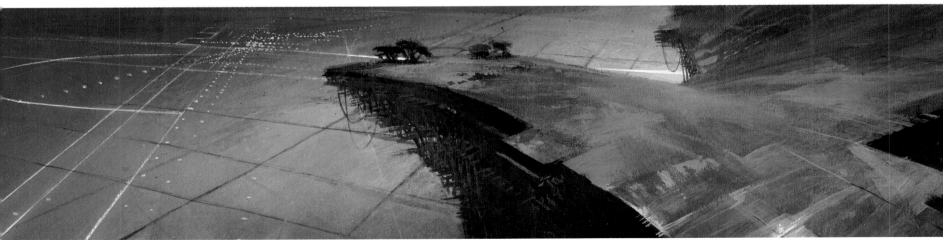

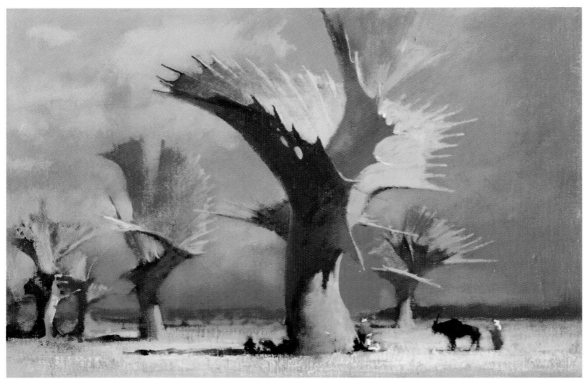

Fire

John traces the origins of *Fire*, also called *The Rite of the Hidden Sun*, right back to the first images he produced in the 1970s. He had been commissioned to do a series of pictures around the theme of vastness, and produced 25 paintings for a book that was never published in its intended form. However, over time the paintings were used in one way or another by advertisers and science fiction editors and they were eventually collected, with many more, in the book *Mass: The Art of John Harris*, published in 2000 by Paper Tiger.

"Among these paintings was an image which had a qualitative difference," says John. "This was *The Girl on the Wall*. While I was working on this picture, I felt as if I had found a physical place, a reality that was very much like home. The city surrounding the girl, visible in the moonlight, had for me a tangible spirit of place. The pressures of work made me move on and for a time I left the thing alone, but a few years ago it surfaced again very clearly. Enough, in fact, for me to start producing a lot of images and ideas relating directly to this 'place.'

"They evolved into the idea of a journeyman artist, who, rather like the Orientalists of Victorian England, travels to an unknown region and records what he sees in drawings and paintings. The substance of the project is a description of the *City of Fire,* the goal of his wanderings. What sets the city apart from any other is that it is built

Fire: Herdsmen in the Arantoga Grove
25.5 × 39.5 cm (10 × 15½ in)
Oil on canvas, 1999
This painting is another example of the contrasts John enjoys using in his art. The huge plants are the only reservoirs of water in the barren wilderness.

Fire: The Grand Gallery
30.5 × 48 cm (12 × 19 in)
Oil on canvas, 1999
Once again John explores the theme of the void, of deep dark spaces, although this time viewed from within the pit. The shadows cast by the grille provide a striking visual arrangement and suggest the whole scene is enclosed while at the same time allowing shadows and light to convey the scale of the gallery.

Fire: Clearing the Lower Sink

20.5 × 34 cm (8 × 13½ in)

Conté crayon on paper, 1999

Including an ellipse in a picture often defeats less accomplished artists as this shape often plays tricks with perspective, making it difficult to use effectively in composition. John has never been interested in truly mathematical/technical drawings where these shapes often occur but has always loved the idea of being able to draw a perfect ellipse freehand because of the challenge it presents for a draughtsman.

Fire: The Big Sink

24 × 29 cm (9½ × 11½ in)

Conté crayon on paper, 1999

The gaping mouth of this huge sink brings to mind John's old obsession with plunging down into bottomless depths. "I also just liked the idea of such colossal structures having these rather banal titles."

within the crater of an active volcano. Although the images mostly concern themselves with the look of the place, the real story lies in the secret of its location and how a culture manages to survive and actually thrive in such circumstances. Hanging off the walls of the crater, the buildings have echoes of a number of cultures around the globe—in Tibet, Peru, Persia and Mexico, for example. But these are surface appearances hiding labyrinthine tunnels and dizzying chasms within which can occasionally be seen the glow of molten lava. During the artist's stay in the city, a solar eclipse occurs, triggering an eruption. An ancient technology involving a valve system built deep in the mountain is brought into play in conjunction with an extraordinary rite of passage, known as the Rite of the Hidden Sun.

"Developing this idea gave me an opportunity to create a number of images, which resonate quite deeply for me. Vertigo, a sensation which the people seem actively to seek; a sense of ancient culture; the hint of a spiritual technology; the relationship of human culture to the planetary and solar forces, over which man has no apparent control: these and many other issues have given me an endless supply of imagery. Although a book with both text and imagery has been completed in one form, this is an ongoing project which has already lasted more than 20 years, on and off. It's one way to fulfil my own very complicated nature."

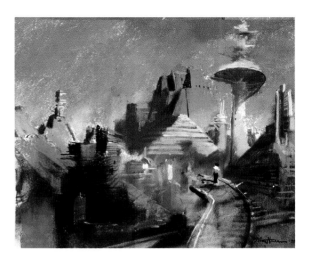

The Other End of Time
20.5 × 25.5 cm (8 × 10 in)
Preliminary pastel sketch.

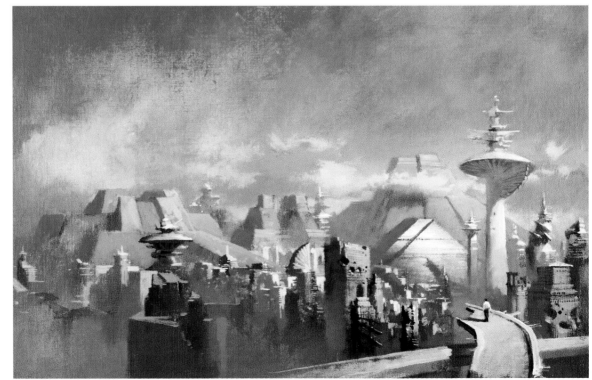

The Other End of Time
33.5 × 55.5 cm (14 × 21 in)
Oil on canvas, 1996
Of this cover for *The Other End of Time* by Frederick Pohl (Tor Books), John says, "I think I overdid the detail here, allowing the whole picture to slip out of focus. I'm not even sure I got this nailed down in the pastel sketch, but restricting the width of the panorama helped to draw attention to the top of the pyramid." This is only a problem when the whole picture is viewed, as here. When it is wrapped around a book, only the right-hand side of the picture is seen.

PHIL HALE

"The act of painting is to bear down on your ideas; the painting itself is a by-product of the real process, it's just a record of what you've done. The work is the tool—what you're actually doing is in your head."

"Artists," says Phil, "and painters in particular, are a part of the history of my family—most recently my grandmother and mother. It's a cliché, but I always knew I was going to be an artist. It didn't seem incomprehensible. It seemed normal."

It is strange, therefore, to discover that an artist apparently rooted so thoroughly in traditional painting should have as his starting point the humble comic book. Most young people so inspired never manage to struggle free from the crippling artistic limitations imposed by drawing simplistic representations of unfeasibly proportioned superbeings to order. The work of Phil Hale should provide a beacon of hope for any young illustrator with such aspirations.

At the age of ten Phil bought a copy of DC Comics' *Swamp Thing,* drawn by the bright new comic artist Berni Wrightson. At this point Wrightson was still developing a highly original style of comic illustration; his choice of subject matter tended to avoid superheroes and therefore the restrictive conventions of that particular stream. Concentrating instead on dark fantasy allowed a moodier expression of shadows, less conventional shapes and most important of all a more relaxed, fluid approach to drawing. Phil spent several years attempting to develop a similar style of his own, discovering in the process the work of Frank Frazetta, a less melodramatic, more refined version of all the things Phil liked in Wrightson's art.

Frazetta's bold and vigorous oil paintings of Conan the Barbarian, the many heroes of Edgar Rice Burroughs and countless dark fantasy covers for EC Comics have been an inspiration to fantasy painters for the last 45 years. For Phil, Frazetta provided a contact point with all aspects of fantasy illustration and as he was now old enough to travel he rapidly explored the available territory.

An influential encounter

"At 16 I met Rick Berry at BosCon, the annual Boston science fiction convention," says Phil. "I had gone with a friend and Rick was exhibiting in the art show. His stuff was so powerful and different from the other work on display. He was a bit of a hippie, very generous, very open. He invited me to his studio. I basically became his apprentice for the next two years. Then we got a studio together on Newbury Street with Richard Salvucci and Thomas Canty.

"I'd do drawings and Rick would do tracing paper amendments over these to show me his approach to musculature and form—one of many overlapping interests we shared. We also painted on each other's pieces regularly. My ego wasn't developed to the point where this sort of stuff was confusing. That happened later. I did some flabby bookcovers just through being too anxious to give the publishers what they wanted.

"Even though Rick was considerably more sophisticated than me, he never patronized me or talked down to me. He was open to many of the things I was into—both in painting and music—and we had an equally strong influence on each other. He gave me a way of thinking about how I could enjoy what I was doing and seeing that it could be real, not just wouldn't-it-be-great-if-I-could-fly stuff. From him I learned that rather than making an image I was refining an idea, developing my skills, moving toward something—something that might not and in fact probably wouldn't happen in that particular painting. I didn't have to know what it was; unless I was a fraud my interest would work toward something good. This was hugely helpful as I was bogged down in determinedly trying to crack all this technical stuff that people like Norman Rockwell and in particular John Singer Sargent had mastered. Rick provided me with an ethical and philosophical approach to structuring my work and helped me understand what art's role is, why some is effective while some is false and why artists can dry up."

Locomotion

"Rick provided me with a love for the reality of how the body worked, the mechanics of how things fitted together and how the muscles were actually doing something, not just displaying themselves. He showed me that people such as Wrightson and even Frazetta have a

BIOGRAPHY

Phil Hale was born in 1963 and raised in Massachusetts, and Nairobi, Kenya.

He became Rick Berry's apprentice at the age of 16 and turned professional at 17. He founded and shared the Newbury Studio with Rick, Thomas Canty and Richard Salvucci in the same year.

Phil moved to England when he was 21 and has since lived in London.

He has designed more than ten frames for racing motorcycles over the last 14 years, the most recent winning its class at the Isle of Man TT three years running.

His clients have included Stephen King, *Playboy* and the National Portrait Gallery.

He won the Gold Award in Editorial Illustration from the Society of Illustrators in 1999 and 2002, both awards being for work published in *Playboy*.

Donald M. Grant has published two collections of his work, *Double Memory: Art and Collaborations* with Rick Berry in 1992 and *Goad: the Many Moods of Phil Hale* in 2001.

Phil lives in London with his partner, Rachel, and their two children, Callum and Avalon.

The Money Shot Is Gone
112 × 157.5 cm (44 × 62 in)
Oil on linen, 2001
Given the opportunity, Phil has a neurotic compulsion to work toward refining the finish to accord with commercial expectations of slickness and detail, even though as he does so he monitors the slow ruining of the painting. "It can be a good idea to make the perfect finish of the piece impossible, for example by using substandard brushes. Then no matter how much I sweat and grunt I can't refine it, so the problem of how to get the painting to please me has to be solved through resources available at the moment." This is one of his personal works.

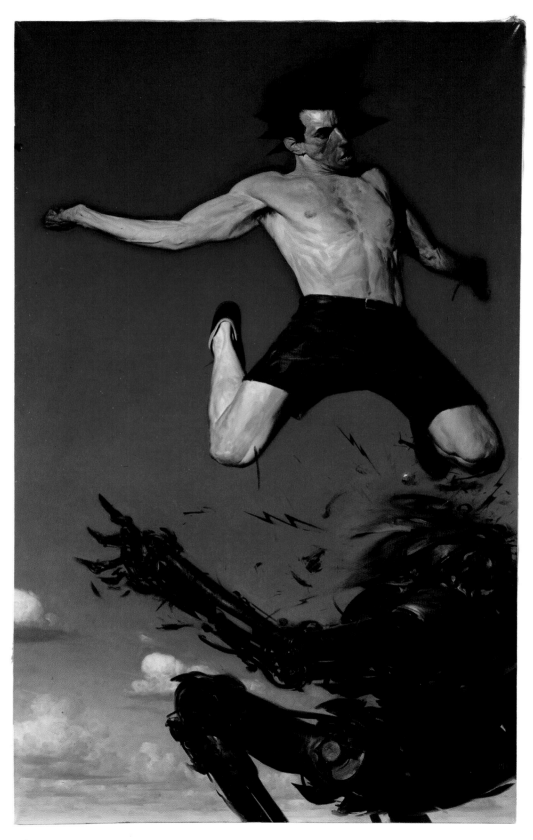

The Poet Must Get His Weeping Done With
178 × 137 cm (70 × 54 in)
Oil on linen, 2000
This character was originally created for Archie Goodwin at Epic Comics. Unfortunately, being only 20 at the time and rather careless with titles, Phil named him Johnny Badhair, and has since found it impossible to relabel him with something wittier. Regardless of this he still loves painting the character. "I think there is a purity there that is very real and enjoyable. It had almost become a graphic project until some nameless accountant squashed it—which is a mystery to me, as I still think it has real potential; an ideal combination of entertainment and voyeurism."

Phil approaches sketching with the same commitment as he brings to his painting. Every mark made in the process is retained; erasures are not an option as Phil feels that drawings should represent the moment of their creation from start to finish and not be tampered with to adjust or correct the final image. If the drawing goes wrong, it is quite easy to start again. In this way they are honest documents of his creative process and not fakes that have been refined until they become idealized and unreal images.

Nothing Tells You What You're Supposed to Make of This
117 × 91.5 cm (46 × 36 in)
Oil on linen, 1997
This is one of ten pieces Phil painted for the rerelease of *The Drawing of the Three* by Stephen King (Donald M. Grant, 1997). "I made a hash of it ten years earlier, and this was a chance to make amends." Phil hopes to get another chance at it in 2007.

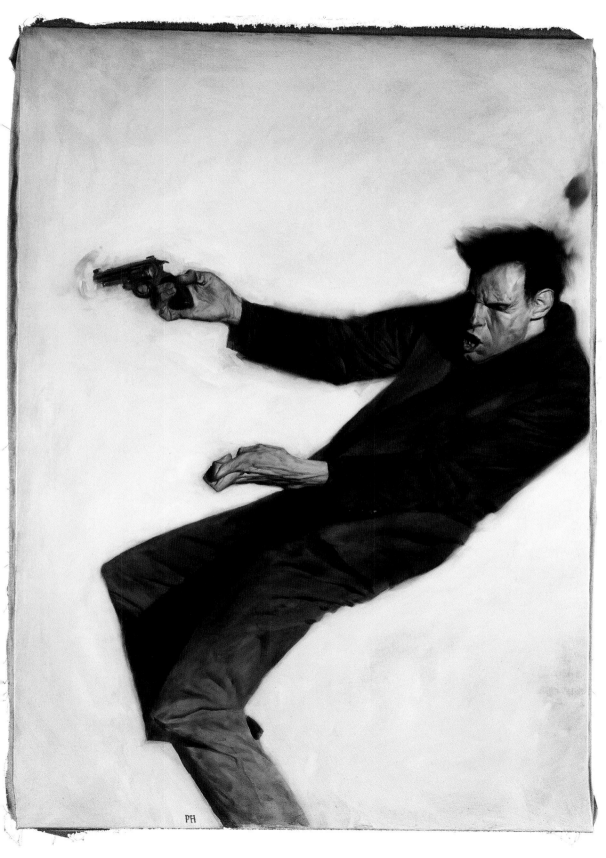

kind of shorthand, an Action Man symbol for musculature which, although dynamic, has a short shelf-life and is less exciting than realistic musculature, which can give the piece a veracity impossible to achieve with that comic compression. Instead of being iconic—an idea—the anatomy actually belongs to that character. When Rick paints an arm it isn't a representation of an arm, it's that person's arm at that moment.

"When a runner sprints, his muscles change their form through flexion, gravity and the impact with the ground, so the mechanics of locomotion distort the leg, often in unexpected, singular ways. Because the triceps in the arm are not being used they go floppy and wobble around. This is the way the human body works in the real world. In order to create honest pictures you shouldn't compromise this by painting what you think is the most graceful, extreme, exquisite, muscular or profound expression of movement; you have to look for something with a particular kind of reality to it. Often it doesn't quite look familiar or right initially but then you will start to recognize it in the sports pages and on TV. You tune into it and it becomes visible.

"The true center of a piece is achieved by removing the image from the ideal. Rick has a particular strength in that he can make this up; having seen these effects, he can remember them and render them. The way in which certain muscles work can be surprising; they look wrong or clumsy in a sense and you have to acclimatize yourself to this. They aren't all neat, orderly, graceful, but this is what gives them believability in a painting."

By-product

"Rick's whole attitude is that artists can't be too specific about what comes out but must just learn to accept what is delivered through their hands. The essence of this philosophy is that the drawings are only tools to move the artist forward.

"I just want to continue to get better at what I do and painting is a no-compromise school of learning. This is particularly so with portraiture; when you make a portrait the act of looking at the subject and transferring the information to paper is like writing down a phone number. If I'm going to learn a face it is the act of scribbling it, seeing the subject and making the line, that fixes in my mind how that face works.

"It is that transference that I remember. When I do a portrait I'll repaint the face five, six or seven times over the original, each time bringing more and more of what I know into the methodology. At the end of this I can paint the entire face in a two-hour period because I have finally memorized it, and understand how to work the paint to bring it forward. The act of painting is to bear down on

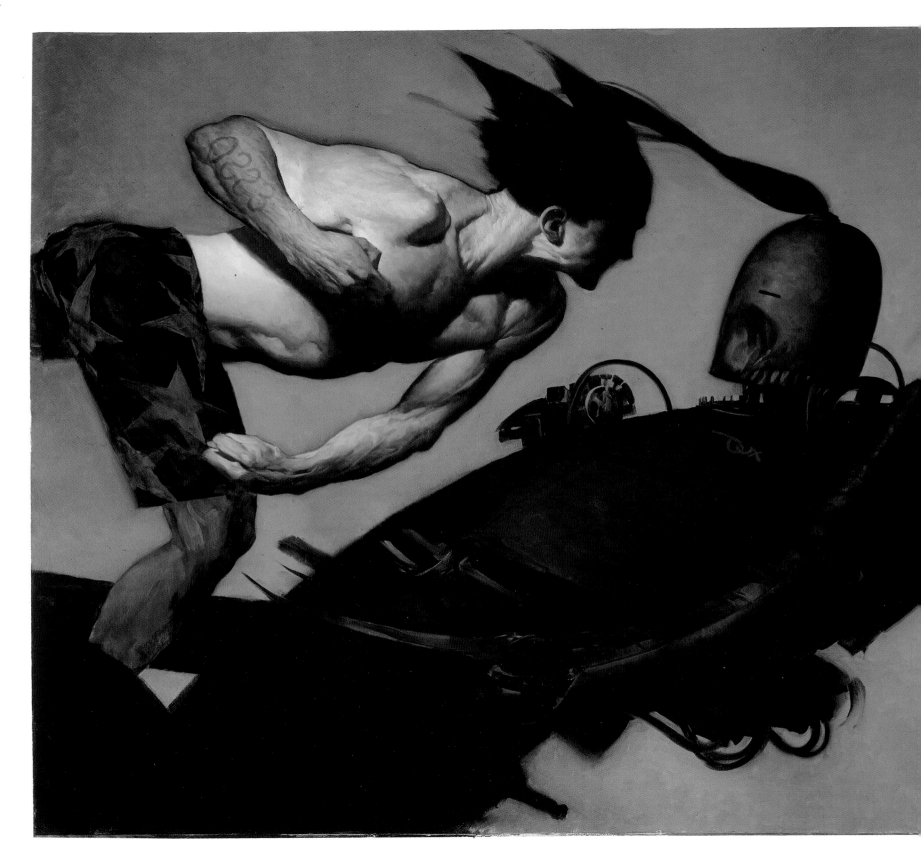

An End to Fidelity
172.5 × 188 cm (68 × 74 in)
Oil on linen, 2001
This large personal work was painted quickly from a life model. Phil wanted to maintain the dynamics of the Badhair pieces but without using the action-painting, comics form so overtly while still retaining the ferocity and immediacy of that Frazetta-style high energy. "The narrative sense in the Badhair pictures was making the paintings a bit limited and comprehensible so I tried to avoid any sense of what was actually happening in this one. I wanted to concentrate on the act of painting itself and by reducing the focus to a single form avoided diverting my attention to inventing figures and anatomies."

Poorly Casanova
96.5 × 178 cm (38 × 70 in)
Oil on panel, 1992
This personal work is one of Phil's love letters to Frank Frazetta. "The most effective of Frazetta's works still operate outside taste, usefulness or any willingness to please. These have become my goals as well. Of those three, taste is the hardest to circumnavigate. Beyond Frazetta's obvious technical brilliance he brought an authentic anger and violence to a genre based on pretend."

your ideas; the painting itself is a by-product of the real process, it's just a record of what you've done. The work is the tool—what you're actually doing is in your head.

"The beauty of this understanding is that with painting you can solve problems in any way you want to; you can cut off the guy's head, set him on fire, smear and bodge, even solve them graphically. Your only obligation is to make the painting as good as it can be. Most of the time as you are pushing the work, shrivelling in an egocentric furnace, you are asking yourself: how good can I be?"

Illustration

In the case of illustration, Phil feels that obligation to the picture is way down the list. There's the art director to be kept happy, and worse, the picture must suit the text. "I'm not psychologically set up for this. I just couldn't disregard all those pressures," he says. "I was approaching projects with my brains already stalled out and many of my pictures were in a way blank. This was demoralizing, as it made me paint worse. It was all about solving other people's problems and was about the end rather than the means.

"I couldn't do art that way. One of the crucial freedoms of art is to do lousy paintings; they are an inevitable part of working towards a satisfactory resolution. Art directors aren't there to help you with that, they're there to protect their own agenda. Illustrative pictures have to develop in a matter of weeks. Neither my brain nor my art works that way and you can't tell an art director that although the painting is lousy it has helped you come to terms with the limitations of glazing. They don't like it.

"I was painting 7-foot [2.1 m] canvases because I couldn't push my painting on just working within 2 square feet [2 sq m] at a time, yet these large pieces were to be reproduced on comic covers at a fraction of the size. This reduction was great for the final reproduction, but the bottom line was that although I was learning fast I was losing money on every commission.

"These problems were compounded by the fact that with illustration I never knew how good I actually was; each piece was filtered through other people's low-wattage needs and my own apathy. It was a shock to do my first real portrait and find out I wasn't really that good. But facing your limitations lets you start dealing with them. They become a known quantity and you can do something about it."

Kick-start

"I paint because I'm struggling to get better at painting. There is no choice in this, you have to keep improving and to achieve that you have to know when you're

cheating. When you're trying to kick-start a painting you can't see the final picture but experience tells you that if you drop a shadow at a certain point you will start to see dimension. This in turn will point to areas that need highlighting and the painting will start to determine its own development. It is just a mechanical process at this point.

"I'm at my happiest when the feedback loop between me and the painting takes it beyond what I've been capable of doing so far. For a moment the painting exceeds my abilities. But the result is probably not what I expected and as art directors like to know what they are going to get, there is a direct conflict of interest. It was such a relief to accept finally that I wasn't any good at it. It gave me the moral prerogative to try to paint as I wanted to."

Phil's work had first been noticed when he was allowed by Archie Goodwin to do ten pages in the last issue of *Epic Comics*. His Johnny Badhair character showed off his dynamic painting style and oblique sense of humour and led eventually to his working with Stephen King, providing paintings and covers for *The Talisman, Insomnia*

Syack
78.5 × 56 cm (31 × 22 in)
Oil on canvas, 1996
Phil likes this piece even though he considers it a throwaway. "Wash painting using transparent oils really does a lot of your work for you."

and *The Dark Tower: Drawing of Three*. The attention they attracted started the phone calls that led Phil into a brief career in illustration, although he had seized these as opportunities to refine his technique and develop his skills for use in the fine art world. Eventually he hit the jackpot when best-selling author King offered him a 1 percent commission for illustrating *The Dark Tower*, a fee substantial enough for him to avoid work in illustration for four years and find out for the first time what his painting actually amounted to.

"I had got to the point where I asked myself if I had to do illustration because I wasn't good enough to make a living out of art," says Phil. "It wasn't and isn't an easy transition. Illustration rewards expedience but the bad

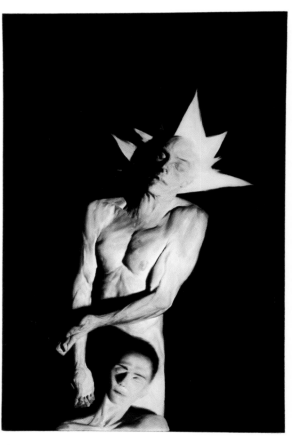

Atomiser
167.5 × 101.5 cm (66 × 40 in)
Oil on canvas, 1996
A cover done for the Michael Moorcock book *The Stealer of Souls* (White Wolf, 1998), this was one of the first paintings Phil did almost entirely with large, coarse brushes. "They made it impossible even to try to work it out through details, which was good. I was learning the difference between painting the appearance of something, and the thing itself. This is a bit of a mongrel, really, but a necessary one. It is a matter of learning in discrete grudging increments."

habits so effective at solving illustration insinuate themselves into your style. The pragmatism of illustration makes it hard to know yourself well. This is particularly insidious if you are getting a slap on the back for your refined technique."

Phil's desire to paint art has led to him turning down lucrative illustration jobs, most recently a job with Marvel Comics to paint a Hulk graphic novel, because he can paint or illustrate but not both. "If I'm going to paint I can't expect to fumble at it like a dilettante or be

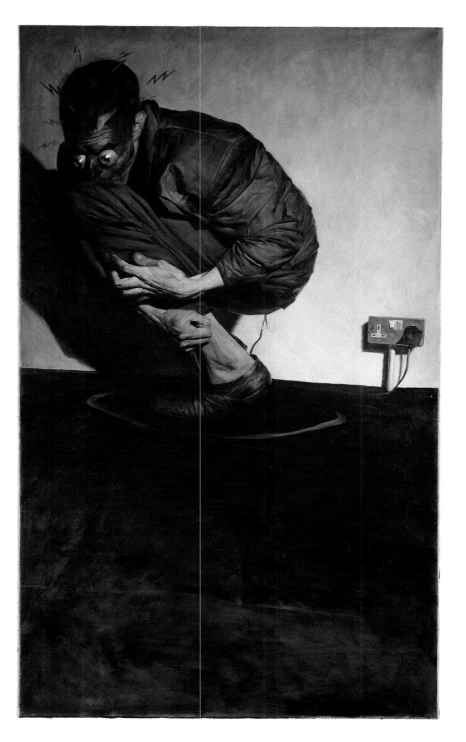

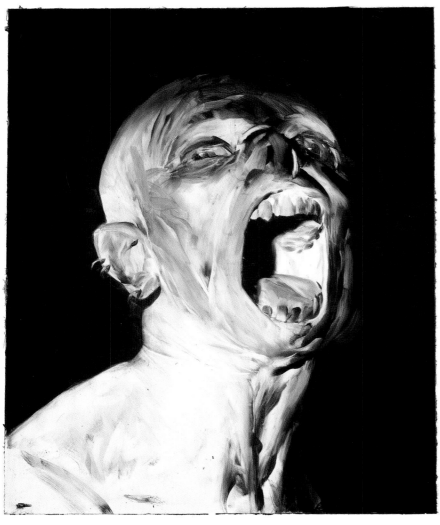

The Anguish of the Night Recedes Before the Slow Bulb of Research
76 × 56 cm (30 × 22 in)
Oil on panel, 1996

Phil sometimes makes his approach to painting sound as if he is just solving a technical problem, or trying to resolve the piece according to some idealized philosophy such as no glazing, no blending or an imperative to complete the whole of the painting in one sitting. "These sound like arbitrary limitations, but they aren't—they facilitate a feeling of something real occurring. A painting where the whole of the surface is completed in a sitting is almost always stronger than something you fuss over. Even if it lacks the finish, the moment has been caught." The swift, assured brushstrokes in this personal work illustrate this principle perfectly.

Debutante
137 × 117 cm (54 × 46 in)
Oil on linen, 1996

Phil is less than satisfied with this little piece of suffering, which is a personal work. "This is a good example of what I mean by fake—weak brushstrokes compromising what could otherwise be a strong piece. I knew better at the time, but didn't have the integrity to act on what I knew. So this happened instead."

arrogant enough to believe I can just wake up one day and do fantastic portraits. You can't just do something facile. You really have to invest yourself in it," he says.

Reading paint

One of the reasons Phil is drawn to portraiture is his love of the paint-handling skills of John Singer Sargent. "In all his work, both portraits and landscapes, he is, by a considerable margin, the extreme of what can be achieved with paint. I learned to paint by looking at the work of artists like Norman Rockwell where you can break the whole process down into a negotiable, comprehensible, repeatable sequence. With Sargent you can't do that.

"I remember looking at a gold chair leg that he had painted; with anyone else you could isolate the pigments and techniques used to build the illusion of metal and shape. But with Sargent, it just looked like gold—you couldn't break it down to its constituent parts. He painted so loosely, openly, but achieved an almost photographic faithfulness. His work stands out so much that in comparison the portraits by most artists look as if they've been laboured by taxidermists. Sargent's look like Polaroids—they're fluid, caught between expressions, fugitive. They happen somewhere but it is not on the picture plane.

"To paint like this is utterly different to 'accountant-style' painting in which everything is reduced to a list. The stuff Sargent does is genuinely sculptural. He uses big brushes, pushing paint around, working the whole surface and the form. He's allowing the paint to do what it wants to, not telling it what to do. He's exploiting the malleability of the medium."

Sharpening the abilities

"If I want to get better at painting, to pursue as a painter whatever I want to pursue, portraiture is the way to go. It is a very efficient sharpener of your abilities, it doesn't tolerate cowardice.

"Illustration is all about appearance—wood and vinyl can be interchangeable. It doesn't matter what you do to

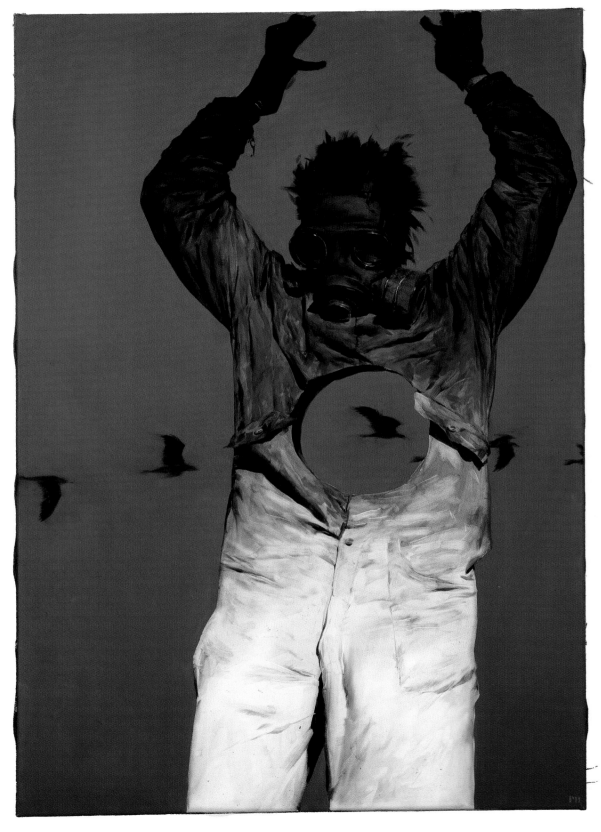

Each Other
106.5 × 76 cm (42 × 30 in)
Oil on linen, 1996
"This was painted to a vague brief from Brom, who was then art-directing at FPG. He let me do anything I wanted and then built the Each Other game and text to support it. More of that, please."

get the end result, particularly when Photoshop and other computer tools are used. With portraiture, it is entirely the way that you do it that matters. You cannot fake it—people aren't stupid, they know the difference even if they can't identify what it is. With good paintings you can see beneath the surface and extract from the painting exactly what the painter put into it."

The size of the painting and demands of the commission are things that attract Phil to portraiture. "They're big paintings and you're expected to spend months on them because the clients are paying a lot of money and the results must be good. The demands of the client are as severe as any in illustration and everyone will know when you've failed. With portraiture you are given the opportunity and responsibility to paint to the best of your abilities. I felt that I had the potential to paint well but it wasn't until I turned to portraiture that I could clearly see where I was weak, tentative or immature."

Computers

Given this almost gladiatorial approach to picture-making it is not surprising that Phil views digital imagery tools with skepticism. He doesn't like the safety net in the form of the Undo command; he feels it bankrupts the whole process. By the same token he doesn't like to use an eraser as he feels a drawing should be an intact document.

"It's the same problem as with multitrack recording. You might think it would give the performer the freedom to cut loose, knowing that it could all be done again if it didn't go well, but this doesn't tend to happen. More often the performance is soft because there is no longer a moment where it absolutely has to be delivered in its entirety. Each element can subsequently be isolated and every mistake made good, so there is no performance, no now, no present. This limits the risk, but I don't think art should succumb to this compromise. The moment should not be avoided because it is too demanding, too unforgiving. I may sound cynical, but most people only see something difficult through when there is no alternative; it is hard to avoid taking the easy, flattering, remunerative choice. Painting, at its best,

An Author's Prayer For Validation Goes Unanswered
188 × 132 cm (74 × 52 in)
Oil on linen, 2001
This personal work is a favourite of Phil's, not least because it was done quickly. "I think it's a bit disorienting and the qualities that make it work are irreducible. I couldn't do a copy of it. I love it when a painting defines a moment—although there is always the risk that the moment is often dull, incompetent, or self-involved. But this one is good. I survived a lot of bad paintings to produce this good one."

doesn't give you the choice; you have to put it on the line and it is obvious when you fail.

"There is a mainstream perception of competence in image-making, often based on a quantifiable technique—with photography, for example, if it's in focus, if the colors are true to life, if its composition conforms to certain expectations, then it is a better photograph. This means that as everyone gets better technically many will start to make the same photograph."

Phil feels the use of Photoshop has similar inherent problems and additionally, as the vast range of tools in this application are so seductive, the final image will always be about 30 percent Photoshop. Simple mathematics therefore suggests that the greatest investment anyone can have in the creation of the work is 70 per cent. Overriding all these objections is the fact that he just likes the physical presence, the painting itself.

Technique

"When I paint I don't worry about the content," Phil says. "My concerns are always to do with working the emotional feel of the piece and the medium (oil) in congruence toward some feeling of rightness, something unexpected that balances craft with intuition to nice effect. The content takes care of itself. The pieces are at their best just as they are finished. Ideally I would use paint that never dried, as paint darkens and dulls as it dries and loses its malleability. Wet paint has an immediacy and fragility that is a good correlation to real life.

"I try to avoid working a brushstroke once it's down. It forces you to consider each stroke as you do it, to get the gesture and the color right, to discipline yourself. You can only get better at it through practice. I learned from studying Sargent's work that if you get the value right, and your drawing is good, you can get away with much looser, faster work, and it will still come together. I also learned to exploit the malleability of the medium.

"When you lay down the brushstroke and leave it, it doesn't need to be softened or blended, or glazed for color or value, or worked. As soon as you mess with it you diminish its strength; it's compromised, acknowledged as a bit partial. It is better to make a clear mistake than bodge it in the hope you can get away with it.

"Painting is commitment and the brushstroke is a document of that commitment. I think it makes a real difference to the integrity of the piece and it is only the integrity that gives the painting its authority. This is the ideal I am always working towards. I'm not saying I can consistently achieve it in my work, but that is because it is nerve-racking. You have to deal directly with how limited you are, and where you need to work harder. It sounds pedantic to think about it so much, but when you

sit down to work you fall into your right-brain groove and you are basically incapable of structuring your behavior. If you are trying to circumvent your bad habits, that needs to happen first.

"Art should work against what is appropriate or agreeable but still work. The artist should make the invisible visible. Generally, people can only accept what they already know. The artist attempts to bring the hidden to the surface in recognizable forms."

Superlegitimate
152.5 × 89 cm (60 × 35 in)
Oil on panel, 1997
"This was another piece for Brom at FPG. I'm driven to extend my technical range because I want to make choices in a painting and discover what can be there, not be backed into a corner through the limitations of my ability. I want to drive it around like a little car."

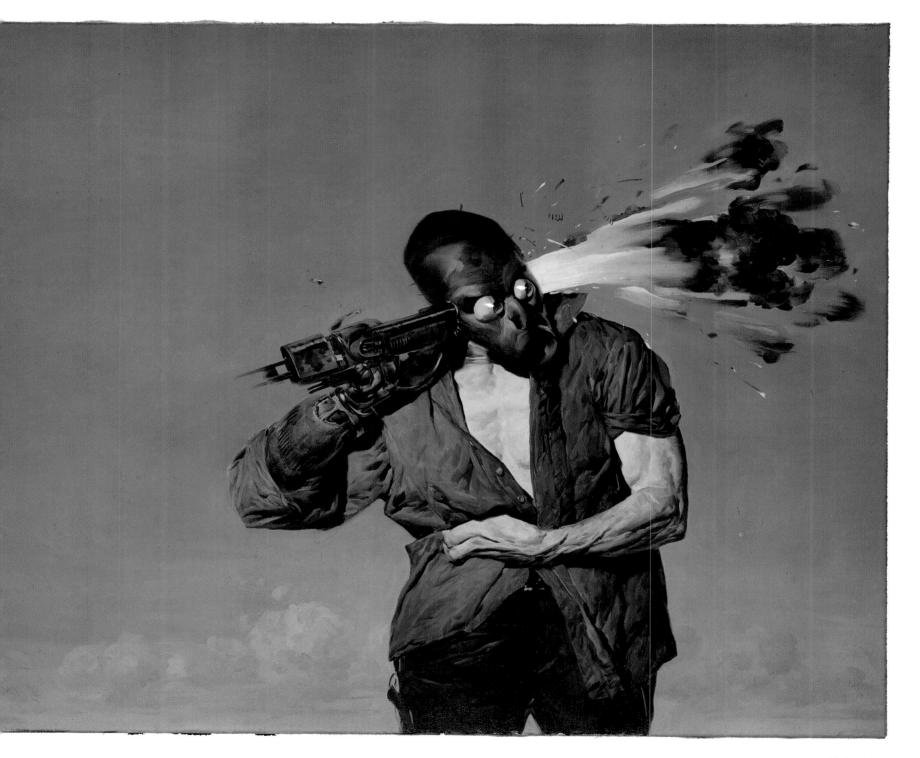

Maintaining
101.5 × 167.5 cm (40 × 66 in)
Oil on panel, 1998
A revisiting of a piece done for Brom, this became a personal work as all the original brushwork was covered.
The character also appears in *Debutante* (see p.71). "In a sense he is there to suffer; his eyes help you to know
this. I'm sure he'll recover some sense of dignity only to have something humiliating reduce him further."

Society Prepares Its Crimes and Criminals Are the Only Instrument Necessary to Execute Them
178 × 66 cm (70 × 26 in)
Oil on linen, 1999
This personal work was one of the first pieces Phil painted from a model and was a breakthrough for him. "I was learning, slowly, that the trappings of fantasy or horror or whatever were irrelevant, that they had nothing to do with the painting."

Promises Lovers Make When It Gets Late
112 × 183 cm (44 × 72 in)
Oil on linen, 2001
This personal work is a repainting of a piece originally done for *Playboy*. Phil felt his painting was a bit flat for the printed version and revised it when he got the original back. "The worst things to find in your work are the tentative, the indecisive or the cowardly. You aren't even learning from it. But the repaint on this one almost made me happy except when I think of what could have happened there. And then I hate myself."

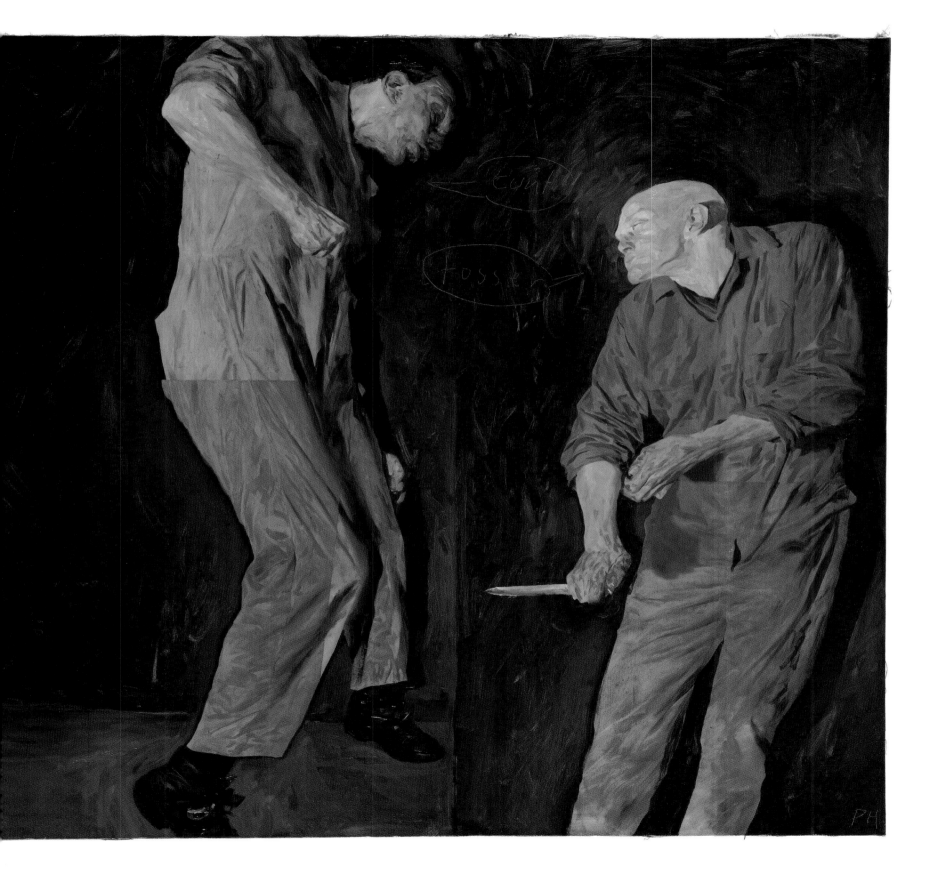

IAN MILLER

"On my sixth birthday I was given a set of 12 colored pencils with a different color at each end. The vivid quality of the colors was quite startling and even now, all these years on, I can still remember the excitement they aroused in me."

For more than 30 years the highly individual images of Ian Miller have kept popping up throughout fantastic media, books and magazines and, in a more stealthy manner, have been hidden within animated films. Ian could be described as a concrete-age Hieronymous Bosch, an artist whose complex and highly detailed images disturb as many viewers as those they give pleasure to; an illustrator of the fairy stories from his head as dark as anything from the Brothers Grimm, meticulous pictures informed by a lifetime of macabre musings.

Even at 55 his childhood is still very much with him and he is not sure where the so-called adult phase of his life replaced the raucous and uncouth adolescent. He chooses to view the whole matter as something of an accommodation of unruly elements and leaves it at that. All that is clear is that the potency of his childhood imagination is still very much present and permeates every level of his work.

The inflatable bra

Ian's mother worked for one of the leading theatrical costumers in London during the early part of the 1950s and right from the outset he was caught up in the most intimate workings of the Illusion Machine. Not many other young boys knew about the inflatable bra worn by a particular Hollywood star, let alone the problems that were caused by its wayward valves. His toy chests overflowed with the castoffs and oddments from a score of film and theatre productions and all these years on he still often wonders what happened to those chests.

"I was mesmerized by the sheer flurry of it all and receptive to everything that was weird and wonderful," he says. "Fact and fiction were very much in contention and strange worlds could still be reached through the backs of cupboards, if you knew where to look. Bubble gum was made from Everglades swamp water and that was a fact.

"On my sixth birthday I was given a set of 12 colored pencils with a different color at each end. The vivid

Message from Mars
38 × 15 cm (15 × 6 in)
Pen and ink, 1984
No Ian Miller essay could be complete without one example of his fastidious attention to detail and his almost obsessive pen-and-ink work. This piece accompanied a story of the same name by J.G. Ballard, published in *Interzone* magazine.

BIOGRAPHY

Ian was born on November 11, 1946, in Ealing, London. He studied at Northwich School of Art between 1963 and 1967. In 1967 he secured a place in the sculpture department at St Martin's School of Art in London. He switched to the painting department in 1968 and graduated in 1970 with a Dip AD/BA in Painting.

After a short sojourn in the north, Ian returned to London and found employment almost immediately as an illustrator. Between 1975 and 1976 he worked for Ralph Bakshi on his feature animation *Wizards*. This gave him an ongoing taste for animation that he still pursues. In the 1980s he worked on a second Bakshi film, *Cool World*. Since then he has done pre-production work on the Dreamworks animated feature *Shrek* and several other proposed features, which sadly never made it to the screen.

His first collection, *Green Dog Trumpet*, was published by Dragon's Dream in 1979. There have been two further collections of his work —*Secret Art* (Dragon's Dream, 1980) and *Ratspike* (Games Workshop Books, 1989). He has also created two graphic novels: *Luck in the Head*, with co-author M. John Harrison (Victor Gollancz, 1991), and *The City* with co-author James Herbert (Pan Macmillan, 1989).

Ian has lectured part-time at Sir John Cass College in London, Brighton School of Art and Horsham School of Art. His work has been widely exhibited for the last 30 years, both as solo exhibitions and in group shows internationally. He has worked as art editor for *Interzone* magazine and as art consultant for Game Workshop Ltd.

He lives in Brighton with his wife Jenny, Winky the one-eyed crow, Riley the cat, Jesper the terrier and son Dan when he's home.

His email address is millpond@waitrose.com

Punch Is Dead (detail)
Montage with pencil, charcoal and watercolor, 1982
Despite the commercial success of Ian's fine line work, by the early 1980s he had begun to feel increasingly frustrated and pigeonholed. He felt he needed to expand, exploit and build on the already sizeable backlog of experimental work and make a wholly different type of statement and mark, which the fine-line style at that time seemed unable to accommodate meaningfully. He was told by some that his "messy stuff" was nothing more than a visual aberration and he would get over it. "Like life, you mean," was his usual reply to this.

quality of the colors was quite startling and even now, all these years on, I can still remember the excitement they aroused in me. Their arrival prompted my 'Ancient Egyptian Phase.' Frontality, hieroglyphic pillars, pyramids and Ancient Egyptians were all that mattered to me. It must have been the desert yellow that started it. But whatever the reason, sand, asps, striped clothing, palm trees and pyramids filled the pages of my drawing books until every single one of those 12 pencils was all used up. That was a very sad day for me, I recall, because it also marked the demise of Joey, my rubber clown hot-water bottle. In a fit of pique, Wink, my brother's crippled crow, savaged Joey and pecked out his eyes. In between the tears, and wishing the foul bird dead, I put the sightless clown into a biscuit tin along with the pencil stumps and buried them in the garden."

Firing the imagination

However, Ian soon found other things to occupy him. "I started lighting fires behind the velvet drapes in the lounge," he says. "This was not an act of vandalism, you understand, but more an attempt to re-enact the tepee-style living of the American Plains Indians. Happily the tepee phase was short-lived and I was soon drawing again; this time anything to do with Red Indians. When I discovered my inability to draw horses that did not look like giant Alsatian dogs I forsook the Plains Indians for the foot-padding Hurons and the backwoods country of James Fenimore Cooper.

"Then I got a set of poster paints in a cardboard box, eight pots of assorted colors with a real paintbrush. Up until this time I had suffered the indignities of globby school powder paint which you mixed and applied with mini yard brushes. For the first time I was able to paint

The Paradise Fence
38 × 30.5 cm (15 × 12 in)
Watercolor and acrylic, 1980
A wire mesh fence marking the estate boundary or an osmotic membrane between two states of mind—the choice is the viewer's. The picture is dissected in this manner because Ian felt there was something moribund about it which no amount of creature detail was going to cure.

Ian's starting point was *The Balcony* by Edouard Manet, in which the image is dissected with a green iron railing. He began with the black rail, then the mesh and finally crude black bars. These were extreme nihilistic marks, the antithesis of the detailed watercolor work behind the mesh providing a dynamic contrast in an attempt to breathe life into it.

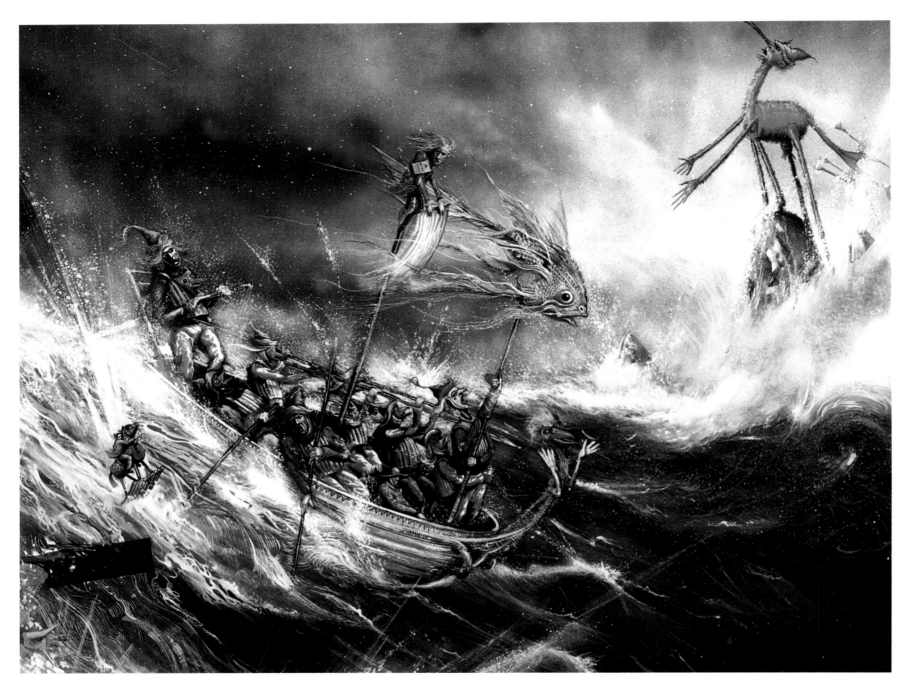

with some degree of precision and I never looked back. After my problem with the Alsatians, I determined there would be no more setbacks where draughtsmanship was concerned. If I couldn't draw it, I put a tree in front of it and have continued to do so ever since.

"I went to the cinema every Saturday afternoon with my mother, sometimes to see films she had helped dress. Bastions and crenellated heaps of every shape and configuration abounded there. Though I knew them in most cases to be little more than structures of canvas and wood, paper cutouts or paintings on glass, it mattered not a jot—I willingly filled them out with substance and imaginings all of my own. Cowboys, Indians, knights and soldiers in redcoats—they were all there, charging about on the silver screen and afterwards around my bedroom walls and across the ceiling, usually in hot pursuit of the fat, green-faced magician from Sinbad the sailor, who frightened me a good deal."

The twitch

"At the age of nine I was enrolled at the Mortbane Academy for Boys near Inverness, a damp, gray granite pile, situated on the shores of a small black-water loch. It was here, while under the influence and tutelage of Mr Beck the art master (known affectionately as Old Dribble to those in his charge), that I determined to become an artist. Mr Beck was a spare-framed man with a livid pallor, spiky gray hair and the blushed nose of an

The Wave
30.5 × 51 cm (12 × 20 in)
Ink and watercolor, 1980
The Wave was commissioned by a friend who suffered from a recurring nightmare about drowning after being engulfed by a large wave. He thought a painting of a large wave might exorcise this horror. "With the words 'a lifeboat of hope on a sea of despair' and my own childhood memories of nearly drowning in a froth of milky white bubbles and turbulent green water, I took my circus of creatures and people to sea."

Luck in the Head
63.5 × 48.5 cm (25 × 19 in)
Acrylic ink and charcoal, 1991
Although it was an extremely labor-intensive affair with 80-plus pages and originals measuring 63.5 x 48.5 cm (25 x 19 in), Ian felt that on a personal and artistic level his graphic novel of the same title, co-authored with M. John Harrison (Gollancz), was one of the most rewarding projects he had worked on to date. It took its inspiration from the book of short stories entitled *Viriconium Nights* by Harrison, an author Ian regards as having immense talent and creative integrity. "Having read and reread the stories, I took a deep breath and ran at it. Dangerous stuff, but it seemed to work."

inveterate drinker, and every boy in the school thought
the world of him.

"I remember doing a wonderful oil painting of a
sunset, a panorama on hardboard in orange, red and
black, a subtle palette knife smear sinking down behind a
flat lamp black roofscape. I thought it was very special,
and so did Mr Beck. He put it up on a easel in front of
the assembled art class and explained why. He told us my
picture was, without fear of contradiction, the worst
painting ever produced in the entire history of art and
would not be, in his opinion, overtaken by anything in
the near, or foreseeable, future. Everyone cheered.

"Mr Beck went on to say that my ability to create such
an unerring visual obscenity was a portentous moment in
both our lives, not to mention those of my classmates,
and that bearing witness to this event was far, far better
than he deserved. In what seemed a brighter vein, he
then told me that the gap between failure and success
was infinitesimal, so small as to be unmeasurable. "Twitch
once, Miller, and you are king of the heap, twitch twice
and you're inconsolably lost." Removing the picture from
the easel, he smiled at me and said, 'Carry on, and
remember the twitch.' I did and still do, frequently."

Etching

"I took up etching in my first year at St Martin's School
of Art in London and flirted on and off with the process
for the next seven years of study. I was wholly intrigued
by the process but eternally frustrated by the difficulties
of securing time on an etching press. The printing
facilities at St Martin's in the late 1960s were by any

measure insubstantial and always heavily oversubscribed.
This was a real shame, because the staff and technicians
were really very good.

"However, after trying out a Rotring Rapidograph
I knew I'd stumbled on the solution to my problem. The
drawing point of the technical pen, although different in
so many ways from that of an etching needle, provided a
precise substitute. Although every image was now a
limited edition of one, it did allow me to create the type
of line work I wanted and, most importantly, when I
wanted. This was sheer joy. Admittedly the unvarying
line quality of these pens imposed limitations, but they
were clean and efficient tools and I found I quickly
compensated for any shortfalls. In fact, building up
surfaces was so much easier and faster that my image
production quadrupled.

"Laying down one pattern of lines on top of another
for so many years in all manner of configurations and
permutations was perhaps the perfect preparation
for understanding and manipulating the layers feature
in Photoshop."

Method and mood

"I start by pencilling in the image. When I've got the
composition I want—and this is sometimes hard won,
with a lot of rubbing out and reworking—I go to stage
two. Depending on my mood, this stage can vary:
sometimes I block in the pencil shapes using watercolor
or acrylic ink washes; on other occasions I ink in all the
basic pencil shapes and then block in with colored washes
afterward.

Killer of Cows *(detail)*
Watercolor and ink, 1980
"I remember, while travelling to Manchester on a steam train in 1952, seeing a herd of headless cows from my carriage window. When I mentioned it to the other occupants of the carriage they just smiled and said such things were commonplace in the North of England." This image appears in *Secret Art* (Dragon's Dream).

"If after this everything still looks sound, I begin the slow trawl of laying down the primary and secondary detail. At this stage I cover the image with movable sheets of paper, leaving only that area of the image I am working on exposed. This window can be no more than 2 inches [5 cm] square at times and allows me to focus totally on the area I'm working on, free from the inevitable distractions of the bigger field. Because most of the vital decisions about the image were made in the primary stages this seldom creates problems. On a purely practical basis it also protects the image from getting greasy as my hand moves back and forward over the surface of the picture. I remove these cover sheets on a regular basis to check on the overall feel of the image.

"Despite the pragmatic approach this process is never a foregone conclusion. At any stage of the work changes can be made, and often are. Areas that have been days in the doing might be reshaped or even scratched out completely. Again, mood dictates how the detail is applied. I will sometimes work through the whole image applying primary and specific types of textures and detail. With other pictures I will build up a single section, creating a salient anchor point in the still-transient field of colored wash and pencil lines.

"Whichever route I take, there must be an overall tension and unity in the finished picture, no matter how contentious, disaffected or anarchic the varied elements in that piece of work might be."

Common roots

"My loose method of working could be described as "run at the wall" style, and it does not always matter how well I see as much as how fast I flick my wrist. Given the obvious restraints and retentive nature of the tight pen style, applying the term "visual constipation" to it helps, if a little crudely, to emphasize and underscore the inherent nature of the process.

"Though diametrically opposed in their methods of application, both styles complement and benefit from the existence of the other. By working loose, I acquire a better understanding of tight and vice versa. This awareness in turn promotes a far more critical and enlightened understanding of the tensions at play in a visual composition. That both spring from a common root and are driven by the need to make images further validates them.

"Some people embrace both forms, others acknowledge only the tight work as valid. The duality is implicit in both forms. Between these two extremes is the work I do on the computer. Again this is a real problem area for some people. As everybody's had the computer-versus-serious-proper-traditional-art debate

Gormenghast
51 × 63.5 cm (20 × 25 in)
Acrylic ink and watercolor, 2000

Mervyn Peake's novel is a subject ideally suited to Ian's meticulous approach, in this instance for a private commission. "This is the most recent of four renderings of Gormenghast Castle, all of which now hang on walls somewhere in the USA. No matter how many times I draw this image—I did the first in 1974—I can always imagine another way of doing it. I'm always conscious of a shortfall, some missed nuance or understated shadow. It is a mound of moods linked umbilically to the characters and if I let go of that idea for a moment I always lose the drawing."

Shown here are Ian's pen-and-ink sketches for Harry Harrison's *Deathworld 1 Fly* (*right*) and *Deathworld 2 MechFly* (*below*) (Orbit). These two drawings give the reader just a hint of the myriad hostile life forms to be encountered by the human colonists within the pages of these books. The planet of the title is crammed with all manner of species deadly to humans, none of them in a rush to be colonized. With such a wide range of flesh-rending nightmares as potential illustrations, Ian must have felt quite spoilt for choice.

I only need to comment, like many others before me, that it's a brilliant creative tool that cannot be denied. I love my Mac and Photoshop and still want to do all the other things with charcoal and paint. For me the eclectic process of using doctrines, methods and styles from as wide a variety of sources as possible underscores all artistic activity.

"No matter how many times you use a particular technique or style of image-making there should always be room to push back the boundaries and through experiment expand your awareness. My experimental work is an open-ended process. For a recent exhibition I constructed an image measuring 6 by 4 feet [1.8 × 1.2 m] on a field made from glued paper and barbed wire. I was very pleased with the result but now have to navigate around it in my front hall—though it is safely encased in a large box!

"Sometimes I describe my imagery as stills from a lost film: mute, frozen fragments, waiting for a lead. I love the idea of fragmentation in all its diversities, and even more the fanciful notion of a metaphysical glue pot somewhere with which to reunite the lost pieces in a new or totally anarchic order. It has been suggested by some that fragmentation is synonymous with modern living, so maybe I'm just a drone of my time."

No constraints

"I am a great advocate of the eclectic process and the use of mixed media in image-making. No artist should be constrained by the appellation painter, sculptor, illustrator, designer and so forth. The constant search for new horizons and innovative vehicles and tools of expression is implicit in the creative process and should never be impeded.

"I am intrigued by the speed values inherent in a visual composition, by their flow and direction. By speed value, I mean the speed at which the eye engages, reacts and travels across, around or through the picture, dictated by the retention or mobility values peculiar to different colors, by a ragged or smooth line or a thick or thin one, by a shape that is regular or amorphous, smooth or textured. Understanding and being able to manipulate these qualities during the picture-making process, or when constructing a three-dimensional form, can mark the difference between creating something great and something very ordinary."

The Joharis Window

"When people ask me what my images are all about, what motivated them and what I am trying to say, I invariably think of the Joharis Window concept when

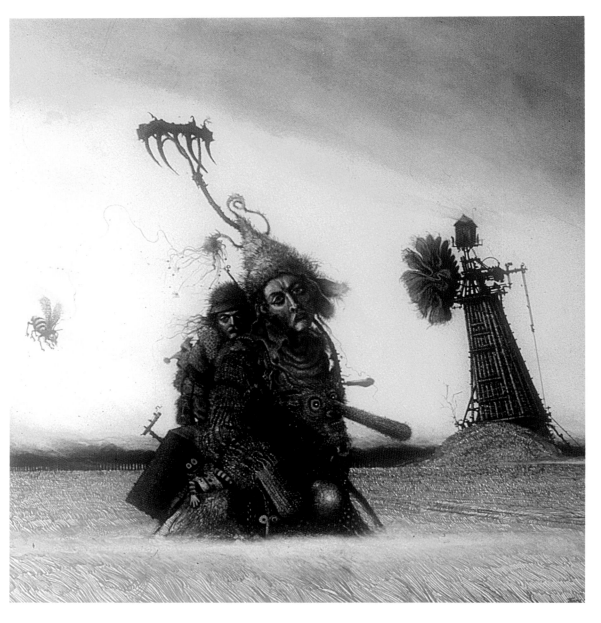

I'm trying to formulate a reply. I explain that the Joharis Window is a window on the world divided up into four parts: the first part is known to yourself and others; the second part is perceived by others but hidden from yourself; the third part is hidden from others but known to yourself; and the fourth part is hidden both from yourself and from others.

"Perplexed by this answer, they will then ask me what lies at the root of my image-making and I say, 'I never wanted to leave Wonderland but that bitch Alice wouldn't let me stay.' Providing the insights that people seem to crave is not easy."

Green Dog Trumpet
20.5 × 20.5 cm (8 × 8 in)
Watercolor and ink, 1974
Ian had always wanted to illustrate a children's book, so he decided to create one of his own. When it was finished he hawked his collection of stories around London in search of a publisher but sadly had no luck. It was finally published in 1979 by Dragon's Dream under the title of *Green Dog Trumpet*.

The Black Seas of Infinity
Watercolor and ink, 2001
14 × 34 cm (5½ × 13½ in)
A commission for the cover of *Black Seas of Infinity: The Best of H. P. Lovecraft* (SFBC) offered perfect subject matter for the imagination of Ian Miller. Lovecraft's ancient pantheon of gods and demons and Ian's darker musings are a match made in heaven or, more likely, in hell. Shown right is Ian's preliminary pen-and-ink sketch.

J. K. POTTER

"I think I was born with a leaning towards the dark side—it didn't come from reading or the movies. My earliest sketches and drawings always had a dark twist to them."

The work of J. K. Potter stands almost alone in this day and age of illustrations created in the virtual studios of computer applications such as Photoshop. His chosen medium is photography and almost all of that is in black and white. "The core of my artistic obsessions and the dominant addiction of my life is film," he says. "There is a certain kind of magic alchemy in those photosensitive silver halide crystals suspended in film emulsion. Crystals reacting to light! What could be more metaphysically symbolic?"

Light

The techniques employed by Potter, many as old as photography itself, are unknown to a generation of kids who have become proficient in the use of computer art programs and are able to employ anything from a huge menu of effects and filters to form the image they have conceived. Any image that can be scanned or digitally photographed can be collaged, modelled and lit without their ever moving from a work station. To many of these people the lengths that Potter goes to in order to obtain the image he wants seem extraordinarily time-consuming and messy.

It is light that is central to the difference between these two media. Light activates the chemicals in the film at the photograph stage and the paper at the printing stage. At both points the amount of light hitting either surface can be controlled, which is necessary to prevent over- or underexposure, but can also produce many other effects. Masks can be used when the printing is done to block the projected light from chosen parts of the print, which then allows multiple images to be combined; blurs can be achieved at either end of the process by merely moving the camera or the paper; and selected parts of the image can be faded by reducing the length of time the light falls from the enlarger on to the printing paper in the darkroom.

All these effects can be achieved by the correct use of a combination of the many filters in Photoshop, but they only happen on the screen of the computer; nothing exists until the print button is hit. It is not physical or

tactile and it does not smell—all parts of the creative process vital to Potter.

Dancing in the dark

'Digital cameras are great but I have to have my fix of film or I become very cranky,' says Potter. 'I use Ilford black-and-white films, which in my opinion are among the finest exports ever manufactured in Britain. All my work is produced using traditional darkroom techniques and all color work is created by hand, using dyes and paints. I love to make a mess, splattering paint and spraying toxic plumes of color from my 1920s antique airbrush, emerging at the end of the day with paint-covered hands. To be honest, one of the main reasons I don't use a computer is that I'm very used to my drill, to what I do and the way I do it.

"When you are printing a photograph there is an image projected in a beam of light, and one of the most exciting and poetic aspects of my creative process is being able to reach out physically into that beam of light and change the image by that action. It's a dance, it's isometric exercise. It's so congruent to my personality and my personal ascetic. I synthesize imagery much as people do with computers and I enjoy the results of both methods. I have collaborated with digital photographers because many of the companies I work for tamper with my work after it's been sent in, often at my suggestion. Digital tools are great for stretching or reformatting an image, but I just prefer creating them the way I always have."

Born in California in 1956, the son of an airman, J. K. Potter spent much of his childhood in the southern United States. At school he earned money from his classmates by drawing macabre death scenes for members of the teaching staff particularly disliked by the pupils. "I think I was born with a leaning towards the dark side—it didn't come from reading or the movies. My earliest sketches and drawings always had a dark twist to them.

I had a very pleasant, almost Bradburyesque, childhood and from the age of 12 was a passionate reader of Ray

BIOGRAPHY

J. K. Potter was born in Riverside, California, in 1956 and subsequently received a peripatetic education in New Jersey, Arkansas, Alabama and Louisiana.

In October 1978 Potter met noted surrealist photographer Clarence John Laughlin at the World Fantasy Convention held in Fort Worth, Texas. This meeting proved to be the most decisive of the artist's career, with Laughlin becoming Potter's most influential mentor.

Potter's first illustrated hardcover book, *Tales of the Werewolf Clan* by H. Warner Munn, was published by Donald M. Grant in 1979. A second volume was published a year later.

In 1984, after working in photolabs and advertising agencies for over ten years, Potter officially became a permanent freelance artist.

In 1985 he illustrated Stephen King's *Skeleton Crew* for Scream Press and in the following years he successfully made the transition from magazine illustrator to mass-market cover artist. This culminated in the publication of two volumes of his work by Paper Tiger, *Horripilations* in 1993 and *Neurotica* in 1996.

Potter's work has appeared in several Hollywood movies, including Brian Yuzna's *Necronomicon* and Randal Kleiser's *Shadow of Doubt*.

After a stint of seven years in rural New England, exploring his Lovecraftian roots, J. K. Potter returned to his true home in New Orleans, Louisiana, in 2001.

Untitled
40.5 × 40.5 cm (16 × 16 in)
Transparent dye and watercolor on sepia-toned black and white print, 2000
Organizing separate photographs of six people into a coherent composition could sometimes be a laborious and painful experience for Potter. For this image each member of the band Fishbone was photographed and distorted individually, with the results then printed and cut out to be assembled against a Californian sunset. The final print was hand-colored using dyes and watercolours. Intended for the Fishbone CD *The Psychotic Friends of Nuttwerx* (Hollywood Records), it became an outtake.

Bradbury. I loved the Joe Mugaini illustrations, which had a profound influence on me." At 15 he found the works of H. P. Lovecraft. "I felt a powerful kinship with Lovecraft, and although I enjoy them less nowadays as an adult I've never forgotten or lost what I soaked up from those books," he says.

Although he was artistically inclined, Potter felt strongly that art was not something that could be taught and was also deterred from formal tuition by his observations of high school art students idling away their time. He briefly took a commercial art course but decided that a practical apprenticeship was the only means to give him the tools and experience he needed to make art.

Apprenticeship

Potter's search for an apprenticeship led him to New York and a brief stint at the offices of Warren Publications, where he worked for a summer as a paste-up artist before returning to Louisiana to take a job at a local photographic laboratory with the intention of learning the art of airbrushing photographs. Unfortunately the resident airbrush artist left immediately and Potter was forced to learn the trade on the job. Fortunately his boss knew as little about the possibilities of airbrush as Potter and although he found the experience a severe learning curve he rose to the challenge and held down the job.

He stayed in this profession for a little over a decade. Everything was done with pencils, paints and dyes and he learned many techniques in the course of removing blemishes and wrinkles and generally touching out any

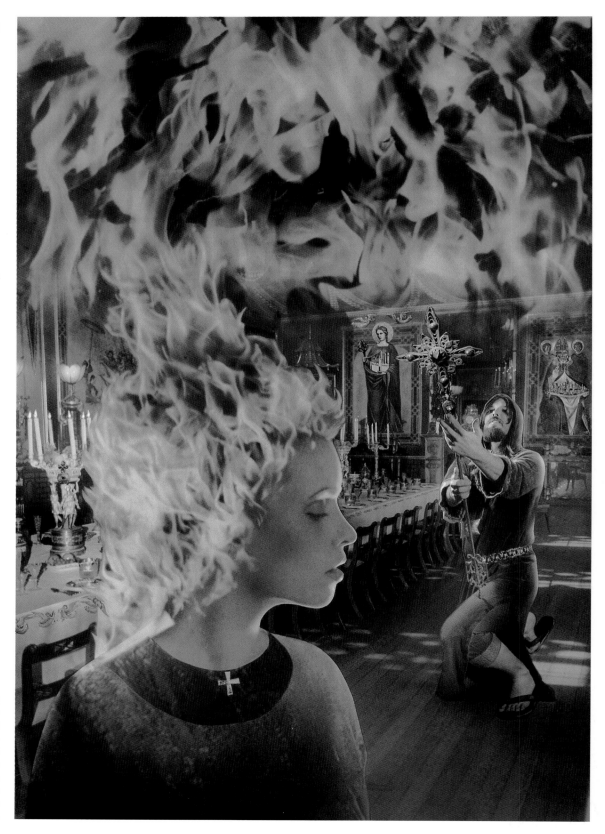

Saint Fire
48.5 × 33 cm (19 × 13 in)
Transparent dye and watercolor on black and white print, 1999
Complicated collage techniques were used to create this image for *Saint Fire* by Tanith Lee (Overlook Press). Unfortunately Potter has chosen furniture and candlesticks from the wrong century—a mistake felt to be so obvious that his artistic licence was revoked and the whole background was omitted from the final cover, which featured just the beautiful girl with the red hair.

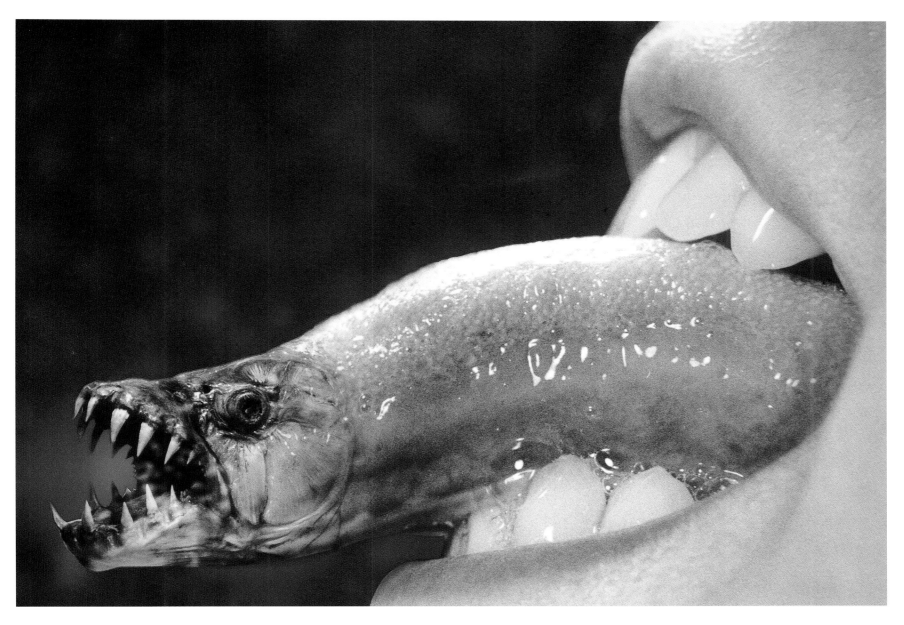

The Fishwife's Acid Tongue
28 × 35.5 cm (11 × 14 in)
Airbrush and dye on black-and-white print, 1997
The inspiration for this visual atrocity, a personal work, came to Potter in a dream. Immediately upon waking he did a quick thumbnail sketch on a pad he keeps by the bed for this purpose. The fish head had been photographed in the window of a taxidermist's shop in Paris ten years earlier.

perceived imperfections from thousands of photographs. About three years into this stint Potter acquired a side job of restoring old, damaged photographs that were precious family heirlooms.

"It was at this point I learned to make a truly excellent copy negative," he says. "I was not only airbrushing the photos but copying the results with a 4-by-5-inch view camera. I had used cameras since I was 12 but they were mostly Polaroids, and this was my first formal introduction to proper photography. The view camera was the traditional tripod-mounted bellows camera where you throw a blanket over your head to allow you to focus the image on the viewing plate." This

skill is still central to the way Potter works. The larger image area on the negative allows the recording of minute detail and is therefore ideal for printing big photographs that are easier to retouch than smaller ones.

Private nightmares

In Potter's spare time he applied this new knowledge to experiments of his own by radically altering the faces and shapes of people and giving them strange hairstyles. It was therapy from the daytime work of touching out all the flaws that customers' vanity would not allow—he went home and created portraits they would have considered nightmares. However, this modest creative

outlet was not sufficient to block out what had become
a dreadfully routine and artistically unsatisfying experience
for Potter, and he left portrait retouching for the world
of advertising.

Unfortunately he found the deceptions of the
advertising world, although much better paid, equally
unsatisfying and he fundamentally disliked the dishonesty
involved. Illustration, however, offered a chance to use
all his skills and viewers of this type of art expected to
be deceived—indeed, convincing images to use as a
platform for their imaginations was what they paid for.
It also allowed Potter to create images that were entirely
his own. Up to this point most of the pictures he had
contributed to had been a group effort, with a chain of
artists involved in each image, and Potter wanted a more
direct relationship with his art and his audience.

"My move toward illustration was a gradual thing,"
he says. "In 1978 I had illustrated two books for the
publisher Donald M. Grant, *Tales of the Werewolf Clan*
Volumes 1 and 2 by H. Warner Munn. In the long period
between these and my next illustrated books I started
attending fantasy conventions and wooed various writers
that I was enamoured with, primarily Ramsey Campbell
and Denis Etchison, and was given work illustrating their
volumes for the late lamented Scream Press, starting
with *The Dark Country* by Denis Etchison. By choosing
writers that I was impressed by and persuading them to
use my work I eventually got a reputation for myself as
an illustrator. These long periods between similar
commissions seems to have been a pattern with me.
My first paperback cover, also *The Dark Country* for
Berkeley Books, was the only paperback cover I did for
the next five years."

The pulps

"I was helped to get by in these lean times by a constant
stream of work from Shawna McCarthy at *Isaac Asimov's*

Faces Under Water
48.5 × 33 cm (19 × 13 in)
Dye and watercolor on sepia-toned black
and white print, 1998
This cover for *Faces Under Water* by Tanith Lee (Overlook Press) was
created from a combination of photographs of a Venetian palazzo, a
room from Louis IV's Palace of Versailles and characters from the New
Orleans Mardi Gras. The mask was photographed with a slide of rippling
water projected onto it. Ripples were blended photographically into
the ceiling of the room to give the mask the appearance of descending from
the water above. All these elements and the collage of cutout human
figures were glued into place when a satisfactory composition had been
established in readiness for coloring.

94

Science Fiction magazine, along with commissions from *Twilight Zone* and *Night Cry*, both dark fantasy horror magazines. This period contained a lot of work but for only small sums of money as I built a reputation, so I subsidised this with freelance work in advertising. This was dropped gradually as I became more self-sufficient as a professional illustrator.

"When I was a young lad I wanted to be like the classic pulp magazine illustrators such as Virgil Finlay or Hans Bok, but I was living in an era when there were no pulps. Looking back now it seems I achieved my desire in these magazines. Well over 100 illustrations were created for Asimov's alone and the deadlines imposed a good discipline on me. The time constraints made some of this work quite horrid but the stream of commissions lasted for four years and allowed me the exposure to get work as a paperback artist.

"I have a love of the grotesque—what other people are revolted by I often find beautiful. I frequently forget this when I am making a picture, creating some juxtaposition of a human body with animal or insect parts that I think is beautiful only to witness revulsion crawl across the faces of some viewers when I show the print. It would be a huge mistake for anyone to assume that I make outlandish horror pictures simply to shock. Many of my most mind-bending pieces have the opposite effect on me. I am actually soothed by the dementedly strange and grotesque."

Dowsing

One of the things that sets Potter's work apart from mainstream photography is that he employs so many darkroom techniques to achieve his pictures that the camera does not take center stage in the process. Neither does an obsession with technique. "The camera is only a machine if it's used like a machine," he says. "I tend to use mine as a dowsing rod. I have very little interest in the specifics of various lenses; all I need to know is that this

Faces Under Water
48.5 × 33 cm (19 × 13 in)
Sepia-toned black-and-white print, 1998
This preliminary composite photograph shows the complicated combination of photographic blending and collage just prior to the coloring of the image.

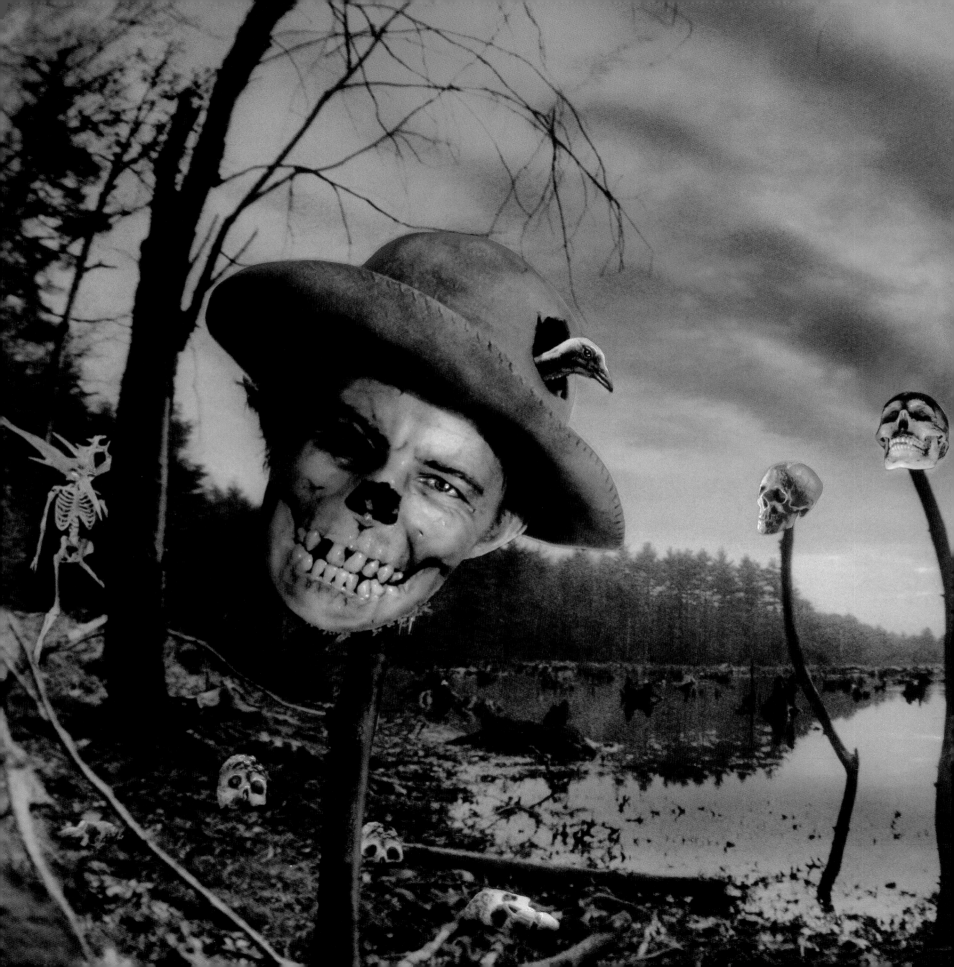

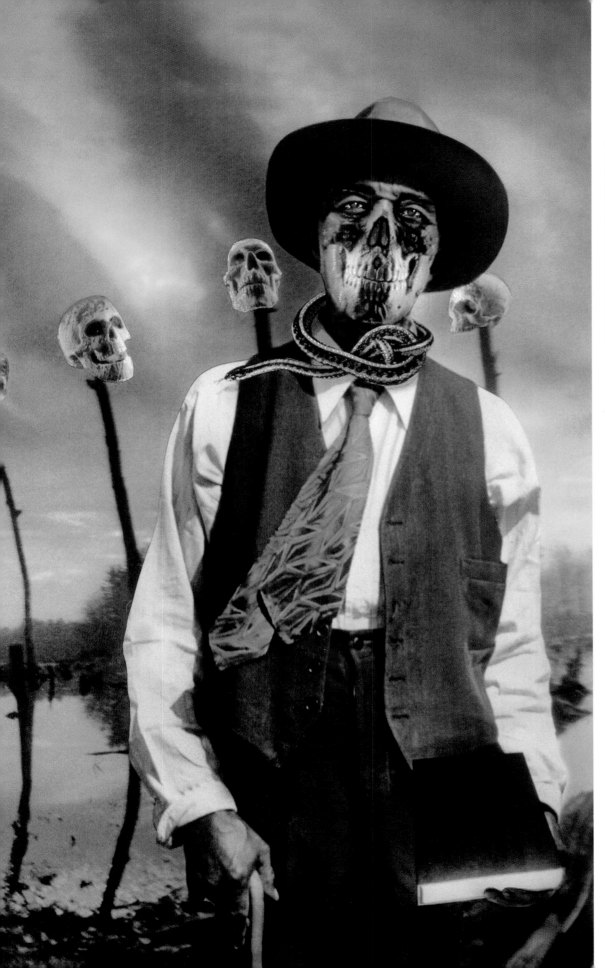

High Cotton
49.5 × 32 cm (19½ × 12½ in)
Transparent dye and watercolor on black-
and-white print, 2000
The background for this cover for *High Cotton* by Joe Lansdale (Golden
Gryphon) was shot in muddy rural Massachusetts, which was a rather
convincing stand-in for Texas. Risking the bites of snakes and insects,
Potter wallowed piglike on his back in mud to obtain the correct angle
for his composition. Returning from this act of trespass without
buckshot wounds inflicted by angry landowners, he used his negative
files of hillbillies and human bones to create the decomposing figures.

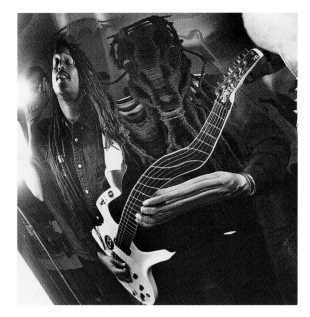

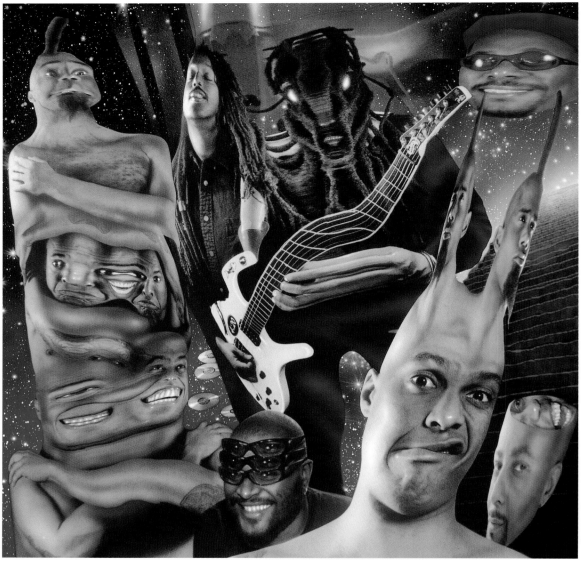

lens sees more than that lens. I'm not absolutely without technical knowledge but it's the ideas that should drive an image forward, the technique should get soaked up in that process. You should learn it and then forget it or at least learn to use it in an intuitive way."

His models are his muse. "Without good models that are appropriate for me I am diminished as an artist. The term model is not only overused, but wholly inadequate. The people I choose to photograph are my collaborators. They are the enablers of my addiction. I select them not for their looks but for their personalities, their gestures, their individuality and their ability to emote for the camera. Beauty is informed by intelligence and one's life experience is often reflected in the eyes. I look for an ability to communicate that transcends the verbal. I love

the language of gesture and the vocabulary of glances. My models speak to the viewer through me and I find that very humanistic. My camera is like a dowsing rod that often seeks out the most extraordinary and interesting people. It acts as a psychic implement."

Fishbone

"When Norwood of the band Fishbone asked me if I was interested in creating images for their upcoming CD *The Psychotic Friends of Nuttwerx,* I jumped at the chance. Not only is Fishbone an extraordinarily multifaceted band with a reservoir of energy that seems positively nuclear in its intensity, but I actually get paid to photograph them! I'm not sure I want the band to find out, but I would be willing to pay them to model for me. I don't usually

make house calls but Hollywood Records' art director made arrangements to fly me direct from Boston to LA to shoot the band. I shipped my equipment to the west coast and followed by United Airlines. Once in California I settled into a suite at a Santa Monica Hotel overlooking the Pacific Ocean. I elected to photograph the band at the hotel because I always find unfamiliar studios sterile and unfriendly. I use bare bones 1950s-style lighting and I can get the same results in a public urinal as I would in a posh studio.

"On the night of the shoot the band all tumbled into my extravagant rent-a-crib and the first improvisational act of the evening was a hasty disconnection of the smoke detectors. It rapidly came to resemble a party rather than a professional photo session, which made

The Universe Is On My Side
40.5 × 40.5 cm (16 × 16in)
Transparent dye and watercolor on sepia-toned black and white print, 2000
Potter created this image for the Fishbone CD *The Psychotic Friends of Nuttwerx* (Hollywood Records). The guitar player's dreadlocks were photographed as reflections in Potter's portable, flexible Mylar mirror. The undulating alien creature thus created was then used to center the piece. "I have long suspected that Stacy T's science fictional guitar stylings have been attracting the attention of visiting extraterrestrials for years," says Potter.

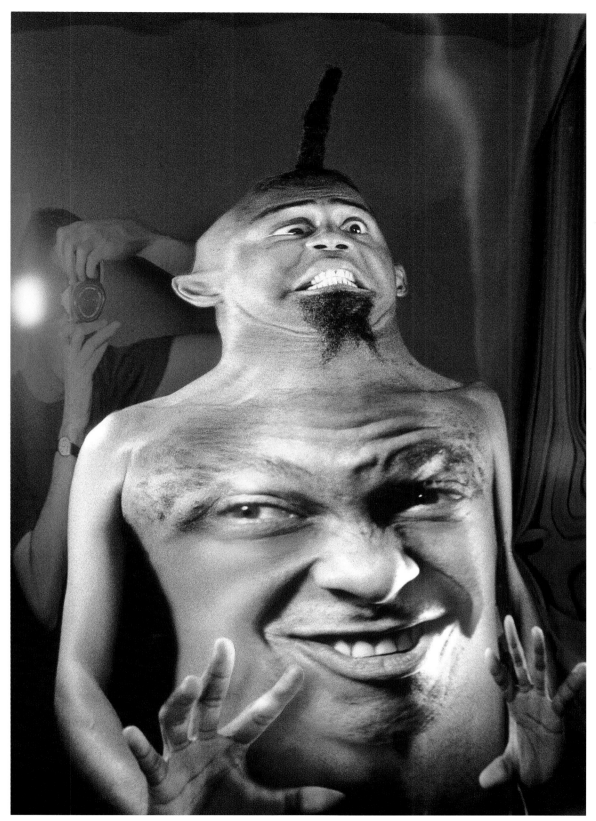

Norwood's Nightmare
51 × 34 cm (20 × 13½ in)
Transparent dye and watercolor on black and white print, 2000
The photographer is caught in the act of creating this nightmare for *The Psychotic Friends of Nuttwerx* CD (Hollywood Records) as a reflection in his Mylar mirror. Potter imagines that if Norwood awoke to find himself in such a predicament his reaction would be exactly as depicted.

me very happy and certainly helped take the pressure off me. Not only is it extremely rare for me to photograph six people in one go, I don't usually have an audience to witness my creative hijinks. Fishbone, however, were the epitome of looseness, with a degenerate sense of humour that I felt instantly at home with. I was totally comfortable and I think this was subsequently reflected in the finished work.

"By the time the session was over every piece of furniture was upside down, take-out Thai food dripped from the lampshades, and at least one band member, who was suspended from a light fixture, had to be cut down and carried to a waiting limo. I have the pictures to prove this but I omitted them from this book out of deference to the band. I love you, Fishbone!"

Mr Filth calling

"Cradle of Filth—the mere name itself conjures up a image in my mind that I don't dare execute on paper. They are a black metal band that has really transcended the genre. Fronted by Byronic lead singer Dani Filth, they produce music that will eat right through your cerebral cortex if you let it. Creating images for the Cradle of Filth CD *Midian* was a rare opportunity for me to indulge my tastes for the darkly gothic extremes. What could be easier?

"The *Midian* cover went through a strange and intense gestation. My first test image, which is really my version of a preliminary sketch, depicted the imaginary gates of the mythical Midian fronted by two images of a young woman with a smiling demonic face looming in the sky above. Now that I look back on it, my first pass on this cover was clearly tepid.

"It was at this point that new art director Mr Filth made his presence felt in a forceful, unambiguous and poetically potent fashion. I remember my infernal fax machine buzzing like a trapped insect in the middle of the night, and my surprise at seeing a long, densely packed letter of impeccable calligraphy appear before my eyes. In all my strange years I have never encountered a data burst as wonderfully impurpled and bizarre as this nocturnal communication. The upshot was that my tentative cover design for *Midian* lacked a certain 'saturation of evil' required by the band. I certainly could see Dani's point.

"Actually, I was having quite a happy summer at the time and it's never easy to distil darkness when one is feeling so bloody pleasant. Dani's letter riffed through a veritable jewel casket of images designed to inflame my imagination, among which were, 'Maggotropolis, demonest, Satanarchists, shapeshitters, transformers, Vigor Mortis, obsidian mirrors, obelisks impaling the starry firmament, little dead riding hoods, raven-winged and missing-limbed Daemonarchectypes all roiling in a stew of succulent wounds.' Of course Mr Filth's suggestions were a bit more precise and coherent than I make them sound but it would be totally irresponsible to print the entire letter here. Needless to say I got an immediate sense of what was required of me and I think I subsequently rose to the challenge. The cover would never have turned out as well as it did without Dani's golgothic prose infusion and I owe him a considerable debt of gratitude for this."

Dues

"When I was 19 years old and working briefly for Warren Publications, a wonderfully wise editor called Bill Dibay told me to pay my dues and not expect the world to be

The Psychotic Friends of Nuttwerx
40.5 × 40.5 cm (16 × 16 in)
Transparent dye and watercolor on sepia-toned black-and-white print, 2000
This was the image chosen as the cover of the Fishbone CD *The Psychotic Friends of Nuttwerx* (Hollywood Records). Throughout his artistic career Potter has repeatedly returned to images of hands disturbingly substituting for various parts of the body—in this case the entire body. So frequently does he explore this particular visual nightmare that it could almost be considered his signature stroke.

Portrait of Dani Filth
35.5 × 28 cm (14 × 11 in)
Transparent dye and watercolor on black-and-white print, 2000
This portrait from the Cradle of Filth CD *Midian* (Music for Nations) is a rare collaboration between Potter and another photographer. British photographer Paul Harries shot the original portrait of Dani Filth to which Potter added his trademark macabre finishing touches.

handed to me on a silver platter. Now that my career is approaching the quarter-century mark, I often think of Bill's words as I am flown here and there on good wages to do CD covers and photoshoots like the ones depicted in these pages.

"I consider myself extremely lucky to have illustrated the work of so many writers I have admired, even idolized, over the years. Authors such as Tanith Lee, Lucius Shepard and Ramsey Campbell have left a powerful imprint on my work. But it's not just luck that has brought me to this place––more than anything, I am a man who has paid his dues and I offer this as advice to any aspiring artist or illustrator.'

Midian
40.5 × 40.5 cm (16 × 16 in)
Transparent dye and watercolor on black-and-white print, 2000
One of Potter's creations for the Cradle of Filth CD *Midian* (Music For Nations), this was a composite image of cemetery photographs and obelisks double-exposed with pictures of fossils and sea creatures. The toothed maw of a gateway is a negative image of the teeth of a large fish called an alligator gar and the model was photographed running from a friend's back yard. Careful blending of several negatives of a white-painted scorpion created the scorpion man, while the mouth of a very angry monkey, photographed at the zoo, gave the demon king a suitable malevolence that was considered missing from the first attempt at this image (*bottom right*).

Inside Midian
45.5 × 35.5 cm (18 × 14 in)
Watercolor on blue-toned black-and-white print, 2000
A photograph of the Père Lachaise cemetery was used as a background for this piece for the Cradle of Filth CD *Midian*, with elements of various other cemeteries in New England and New Orleans added to spice up the visual gumbo. The young woman seen breaching the gates of the city on the CD's cover is now on the inside. Midian, the hidden city of groteques and noble beasts, is the creation of author, playwright, artist and film director Clive Barker, whom Potter greatly admires.

Pagan Savior
61 × 51 cm (24 × 20 in)
Transparent dye and watercolor on black-and-white print, 2000
Another of Potter's images produced for the Cradle of Filth CD *Midian* (Music For Nations). The model painted herself prior to shooting and her horns were airbrushed in later. The eucalyptus and dead roses were stuck onto the print and rephotographed in color, using a technique Potter learned from the work of British artist Patrick Woodruff, renowned for pictures that combine painting, sculpture, dried flowers and all kinds of appropriate "found objects."

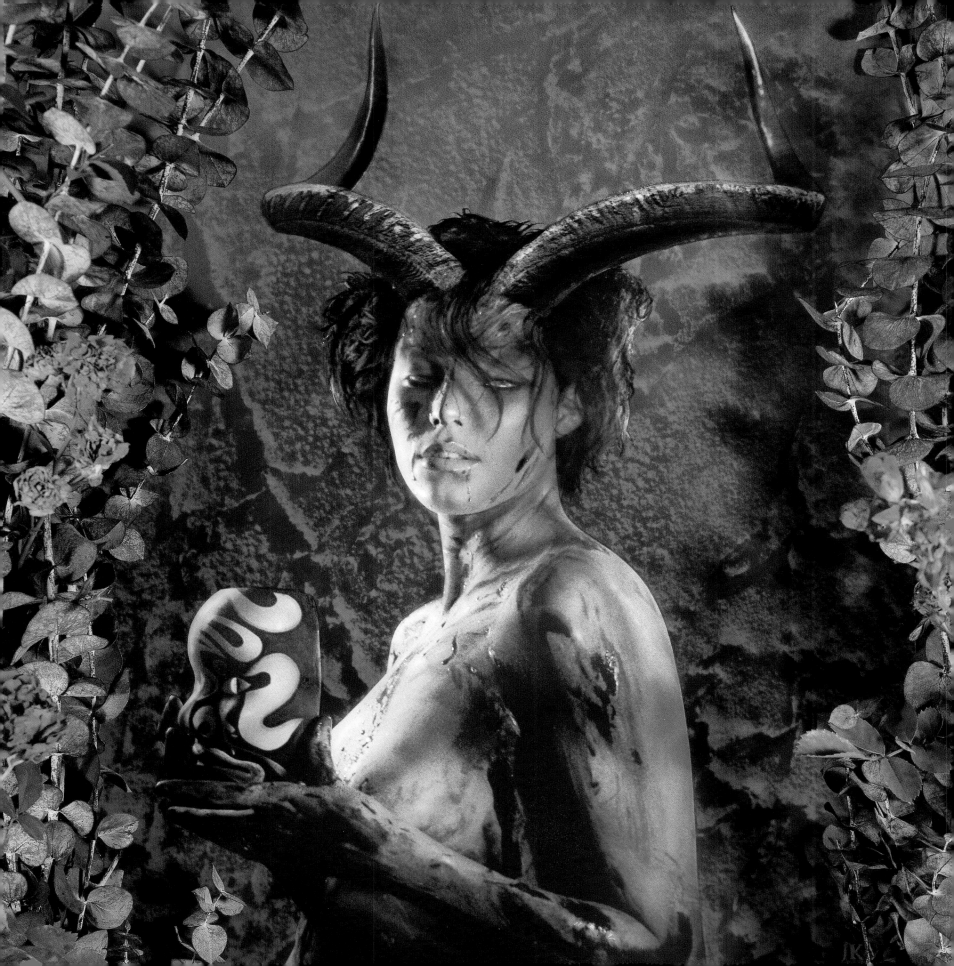

GREG SPALENKA

"During my high school years I continued to read sci fi and fantasy books as well as creating bizarre worlds filled with mythical scenes, Frazetta-like monsters, warriors and nubile women."

The art of Greg Spalenka was borne of two worlds, two sides of his nature competing for and completing his creative vision. One of these worlds is sensual, dark and mysterious, the other spiritual, light and magical. Raised as a Roman Catholic, he was hypnotized by the feeling that came with standing in a large church with glowing stained glass windows, flickering candles and statues of saints who seemed to be looking down at him. "I was enthralled and impressed, but I knew there was a cathedral inside my head, too," he says. "I was able to get glimpses of it now and then and it was magnificent."

As Greg was the eldest of five brothers and sisters, finding space for himself was next to impossible. He used his bed as a workspace to produce drawings called up from his imagination. At the age of 10, upon subscribing to the Science Fiction Book Club, he found his muse in the form of the John Carter of Mars series of novels by Edgar Rice Burroughs, covered by the amazing paintings of Frank Frazetta. Michelangelo, Leonardo da Vinci, Bernini and other classical artists found in the local library had been his only inspiration to date. The vitality and primal powers imbued in Frazetta's pen and ink drawings and paintings caused Greg to study and copy them, in the course of which he realized his own love of the human form.

At this time Rod Serling's long-running dark fantasy show *Night Gallery* began airing on television. This show opened up little windows of insight to the darker side of Greg's vision and many demented and nightmarish images were realized. He created a walk of horrors in the garage with stuffed dummies, shadow plays and his brother in a box like a coffin with ketchup on his face. The local kids were charged a quarter to view this delight.

Intuition

"Something else was happening with my spirit, too," Greg says of this time. "I noticed that during moments of calm and focused attention my intuition would bring forth a gift of insight. I remember one day walking near a large bush in our backyard when I was told intuitively to stop and look at the bush. I faced the bush and allowed myself to take it in. No thinking, just opening my eyes to what's there. Soon the reason for this was made clear. To my surprise I saw wedged in the branches a baseball I had lost weeks before and near it the largest alligator lizard I had ever encountered! What a prize! This intuitive quality would imbue my dreamlike pictures with cryptic images and beings.

"During my high school years I continued to read sci fi and fantasy books as well as creating bizarre worlds filled with mythical scenes, Frazetta-like monsters, warriors and nubile women. Entering a Sci Fi and fantasy art contest one year garnered me an award and a free pass to the San Diego Comic Convention. It was a thrill to see an original Frazetta painting there, but at this time the event was relatively small and seemed to be filled with strange characters, so I left a bit perplexed as to its purpose.

"Soon after high school I enrolled as a full-time student at the Art Center College of Design in Pasadena, California. This school was hard work. In technique, in thinking, in seeing, all parts of my visual vocabulary were expanded. Here my influences expanded greatly too and I learned what it meant to bring 'concept' to a piece of art—not just to tell a story with pictures but to say something in a new and unique way that goes beyond storytelling."

His range of influences now included the Symbolist period with the Pre-Raphaelites Millais, Rossetti, Burne Jones and Holman Hunt, the Decadents and Art Nouveau artists as well as the ethereal qualities of the Pictorialist photographers—Robert Demachy, Julia Margaret Cameron, Jose Ortiz Echagüe, Robert H. Conklin, Fred Holland Day. The social and political commentary from editorial illustrators of the day such as Marshall Arisman, John Collier, Allan Cober, Ralph Steadman and Brad Holland also grabbed his attention. Here he found art with a real purpose to communicate issues about humanity, art that was speaking to thousands, in some case millions, of people.

BIOGRAPHY

Greg Spalenka was born on March 13, 1958 in Arcadia, California.

He graduated with a BFA Illustration from the Art Center College of Design, Pasadena, CA in 1982.

Upon moving to New York City he provided illustrations for many leading magazines, including *Time*, *Newsweek*, *Rolling Stone* and *Playboy*.

His pictures have accompanied many articles in major newspapers across the USA including the *New York Times*, *Los Angeles Times*, *Washington Post*, *Boston Globe*, *San Francisco Examiner* and *Wall Street Journal* and have covered books published by all the major US publishing houses.

Since 1989 his work has been exhibited extensively in the USA and also in Japan in 1992. He has lectured and run workshops in art colleges the length and breadth of the USA since 1987 and currently teaches at four colleges in California.

He has won both the gold and silver Society of Illustration medals.

His website can be seen at www.spalenka.com.

Mind 2000
Mixed media/digital, 2000
What better way to illustrate an article about the attempts to develop intuitive organic computers than to show the white heat of our own electrochemical computer, the brain? This image appeared in *San Francisco Focus* magazine.

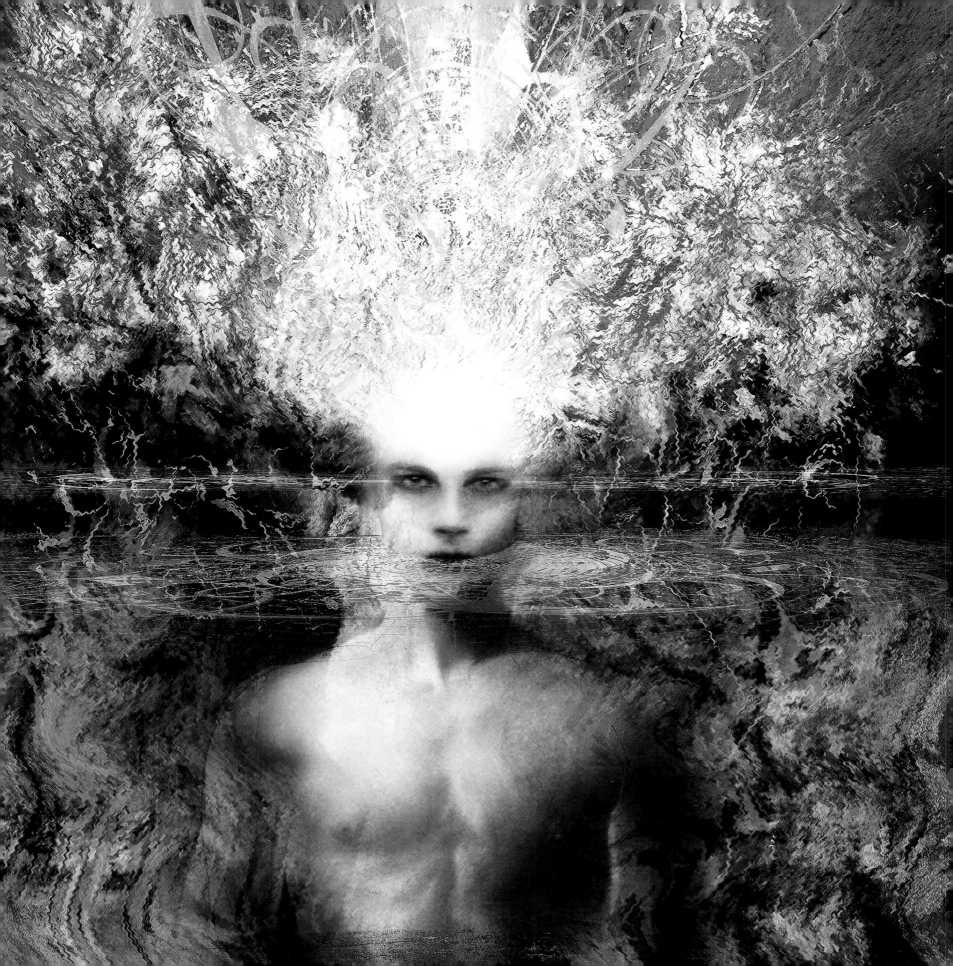

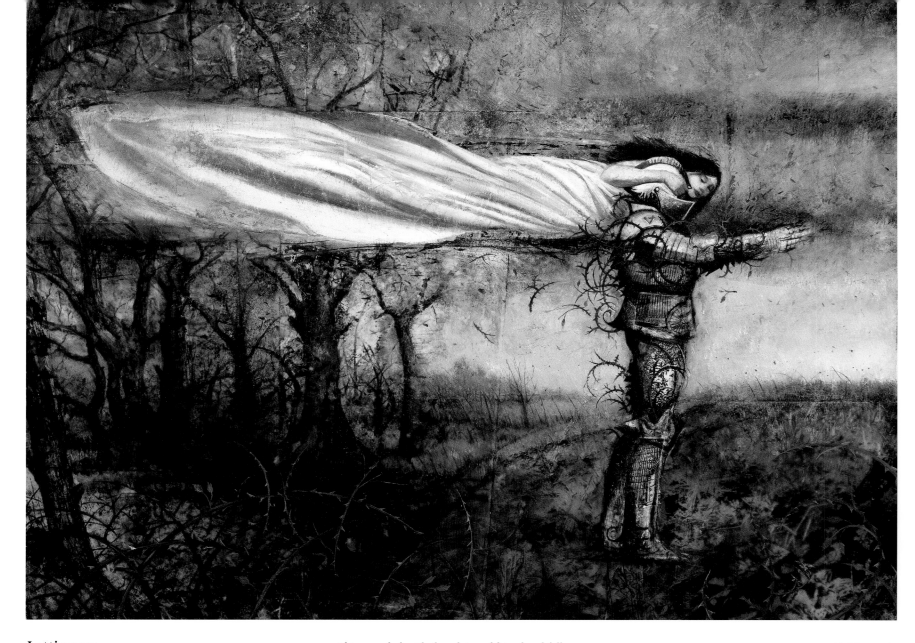

Letting go

A revelatory book Greg read at this time was *The Art Spirit* by Robert Henri, first published in 1923 (reissued in 1984 by Westview Press). A great painter, educator and philosopher, Henri talks about art and the artist's responsibility to it and himself. He expounds upon the student's journey and what it takes to be successful.

"I now recommend this book to all my students," says Greg. "Henri says, 'There are moments in our lives, there are moments in a day, when we seem to see beyond the usual. Such are the moments of our greatest happiness. Such are the moments of our greatest wisdom.' If one could but recall his vision by some sort of sign. It was in this hope that the arts were invented. Signposts on the way to what may be. Signposts toward greater knowledge."

This, coupled with the advice of friend and fellow student Matt Mahurin, proved vital to Greg's progression as an artist. "Matt was an individual with lots of talent and tremendous passion and energy," he says. "He showed me that the concept, the idea behind the art is the foundation, that building a personal vision involves taking risks and that since all art is study don't get too precious with it!

"I had asked Matt to come by and take a look at a class assignment that I was struggling with. When he arrived he proceeded to take my art outside onto the balcony to get a better look at it in the sun. He looked from the art to me and then, saying, 'Sometimes, Spalenka, you just have to know when to let a piece go,' proceeded to toss it out into the street. Voicing expletives, I ran down the stairs to watch in disbelief as cars drove over it. I pulled

Knightengale
23.5 × 33 cm (9 × 13 in)
Mixed media, 1996
The Visions of Vespertina, a collaboration with artist/songwriter Michelle Barnes, was a fusion of music and art which took six years to develop. This picture appears in the booklet accompanying the Celsius Records CD of the same name. It is a combination of drawing, painting and collage: armor, fabric and tree imagery were sealed with acrylic medium which Greg then fingerpainted over. When this work had dried it was severely distressed with sandpaper, sealed and painted over with acrylics. Oils were later applied to add highlights and refine the picture details as a whole.

Thirteen Phantasms
Mixed media/digital, 2002

The small doors into the person's head are a good way of suggesting that the book this image covers is a collection of short stories. The image shown above right was the picture chosen by author James Blaylock to cover the Edgewood Press edition of *Thirteen Phantasms* published in 2000, but Greg continued to work on it, resulting in the other pictures shown here. The image shown right, used as the cover to the 2002 Penguin edition, is the version he prefers. Antique English book plates served as the source for much of the detail in this image and strengthen the Gothic feel Greg was attempting to convey.

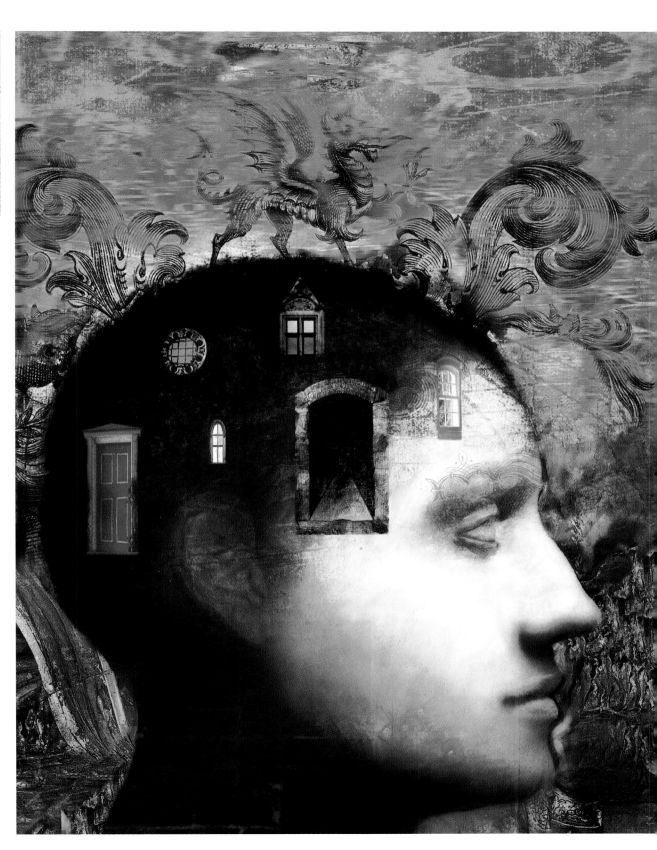

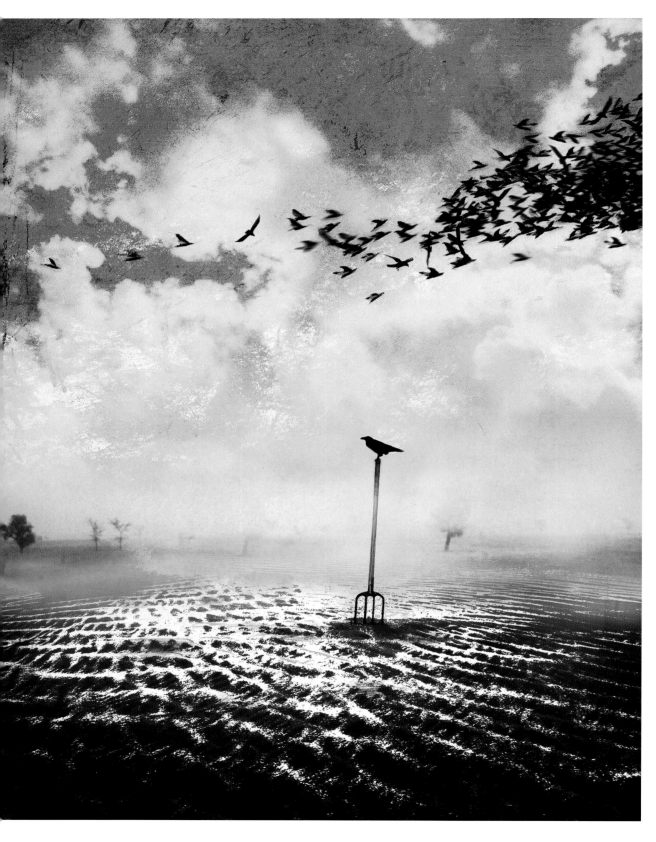

Famine
Mixed media/digital, 2000

When a potato blight wiped out the staple food source in Ireland during 1845–50 the population was totally unprepared and no help came to them. The death toll was huge and there was a massive emigration of the survivors. This picture, painted for an editorial on the Irish Famine in the *Boston Globe*, is heavy with symbolic representations of this disaster. The flock of migrating birds is leaving the barren land that has been desperately worked over by the minority who have remained in the vain hope of somehow growing life-saving food. The hopelessly inadequate fork and single crow are all that is left in this deserted landscape, reminding us of the loss of life during this sad moment in history.

Adventures in Time and Space with Max Merriwell
Mixed media/digital, 2001

In *Adventures in Time and Space with Max Merriwell* by Pat Murphy (Tor Books), a cruise ship passes through the Bermuda Triangle and all sorts of strange things start to happen. Greg's simple cover design effectively conveys the dreamlike strangeness experienced by the characters in the story. The impossibility of a liner hanging upside down over a storm-tossed sea of faces is rather unsettling and the greenish hues add a suitably nightmarish quality to the picture. The viewer can almost feel the panic rising within the ship.

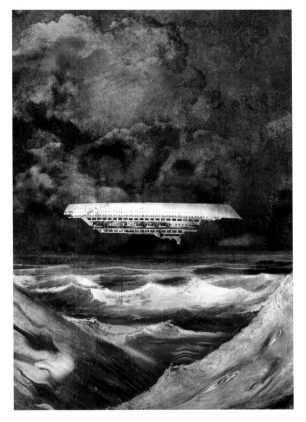

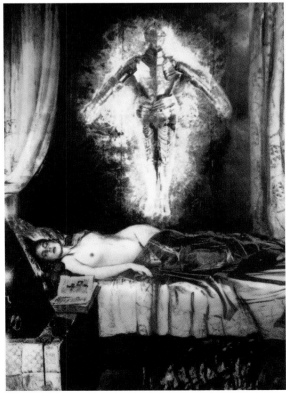

Vespertina's Dream
33 × 28 cm (13 × 11 in)
Mixed media, 1996

Vespertina's story takes place in early 14th-century England, where she is a young mystic. In her visions an enigmatic knight seduces her to follow him to strange and dangerous lands. Drawings and xeroxed photographs were collaged together and then photographed with a Polaroid camera under yellow light. The resulting picture was then scanned into the computer and subtly manipulated. Greg self-published a limited edition version of the *The Visions of Vespertina* in 1997. It was recorded again and repackaged by Celsius Records in 1999. He feels he has yet to realize the full potential of this vision of an illustrated novel with music.

the art from the street. Deep gashes covered part of the surface, new textures came to light and I realized that this treatment had actually improved the piece!

"That experience taught me that sometimes it's a matter of taking a painting to complete destruction to make it work. Allowing the risk factor to enter the equation allowed the art to evolve of its own accord. It was difficult to let go of the control issues I initially had with making art, but this paradigm shift in thinking opened up an intuitive door to my creativity. My art now is all about process and takes on a life of its own. In fact it becomes a series of what I call happy accidents."

The apple

"After graduating from Art Center with a BFA degree in Illustration, I moved to New York at the behest of Mahurin. Although I was terrified at the idea of moving to this city, it was the center of publishing and if I was to make it as an illustrator this was where I had to do it. Trudging around Manhattan with my portfolio was a full-time job, but the work trickled in. *Rolling Stone* commissioned a portrait of Elvis Costello, *New York Times* magazine put a portrait of a young Ernest Hemingway on its cover, but it was a series of illustrations I created for *Sports Illustrated* that really put me on the map. These were for an article on Bobby Fischer that contained conceptual portraits and other pieces, 11 artworks in all. I had the opportunity to visit the places and people written about in the article. This in turn inspired other illustrative journalistic projects down the line.

"Living in Manhattan was like living in an illustration. It's the world crammed into a 5-mile-by-15-mile [8 × 24 km] island. The juxtaposition of images from day to day was surreal. Walking out of the front door of my building brought a rush of sound and sight. Beautiful models might be walking by while police peered inside a car at a murder victim slumped at the wheel and a homeless man snagged purses from a flooded gutter with a fishing pole. I was never at a loss for intense bizarre imagery.

"Sometimes the street found its way literally into the art. Rusted pieces of metal, grating, weathered plastic, broken glass, indescribable manmade things would complement a little corner of some piece I was working on. The city got into my blood.

"I met so many talented people in New York, including some who had been my early influences. Kent Williams got me interested in checking out the comic scene. I was blown away by his 'Blood' series and was equally knocked out when introduced to Dave McKean's *Arkham Asylum*. This was the end of the 1980s and after eight years of cranking out hundreds of editorial images for

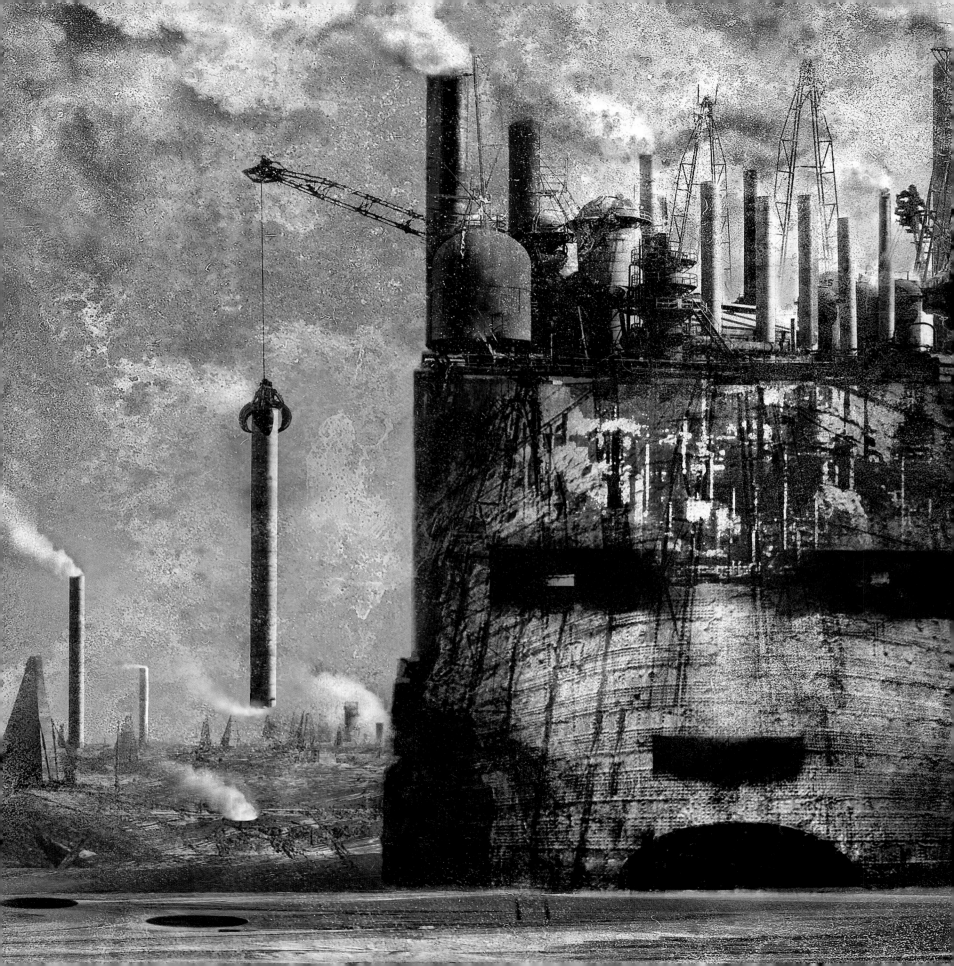

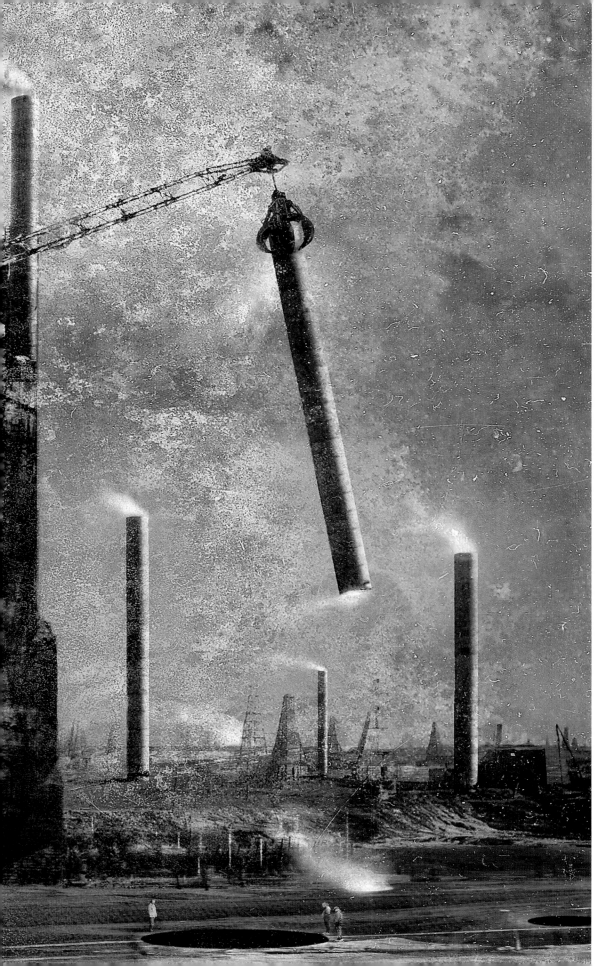

Monster
Mixed media/digital, 2001
Much of Greg's art is driven by the desire to make people think about social and political issues that ultimately affect us all. This image, created for a National Labor Federation calendar, is about the human cost of corporate mergers. The spiderlike monster greedily grabs all available filth-belching chimneys to add to its foul crown as tiny people look on helplessly in a landscape bereft of any other natural life. The lack of any uplifting color suggests it is a grave new world that some wish to create for us with their strategies of short-term greed and callous disregard for anything except profit.

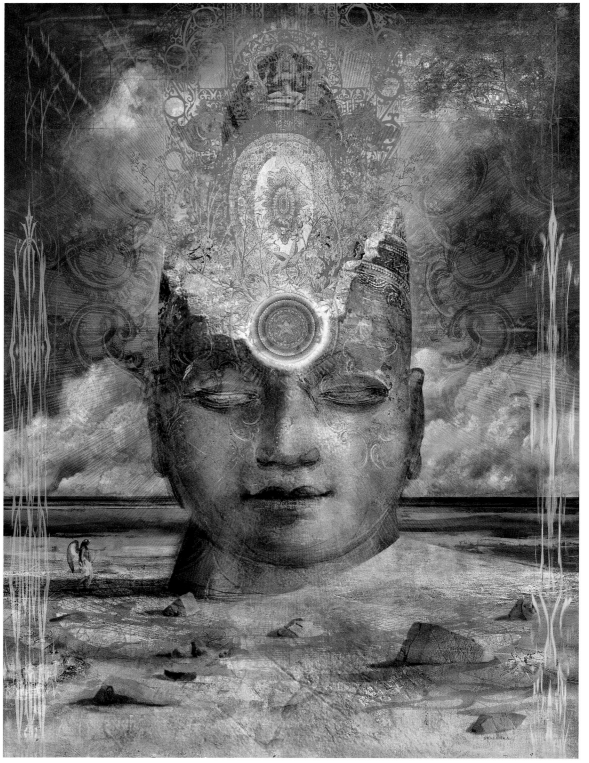

Expand Your Vision
Mixed media/digital, 1998

Greg wanted this poster, created for the Art Institute of Southern California, to convey the sense of opening up the individual's creativity. There are hints of many ancient beliefs in the busy swarm pouring forth from the character's third eye and also subtle references to the trinity and spiritual teachers hidden within the icon storm. "It was my attempt to communicate that inside us is an infinite resource of insight and wisdom, that we can all be fountainheads of creativity, that it's all locked in there somewhere and it is only a matter of knowing how to approach it in order to access its potential. These ancient mysteries can be found after some serious digging." This search is symbolized in the small angel approaching the deity, arms outstretched.

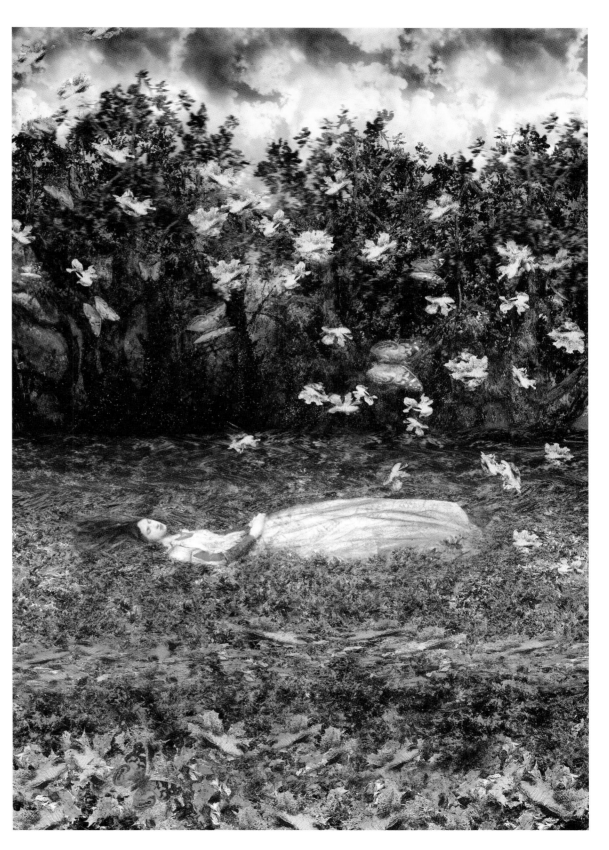

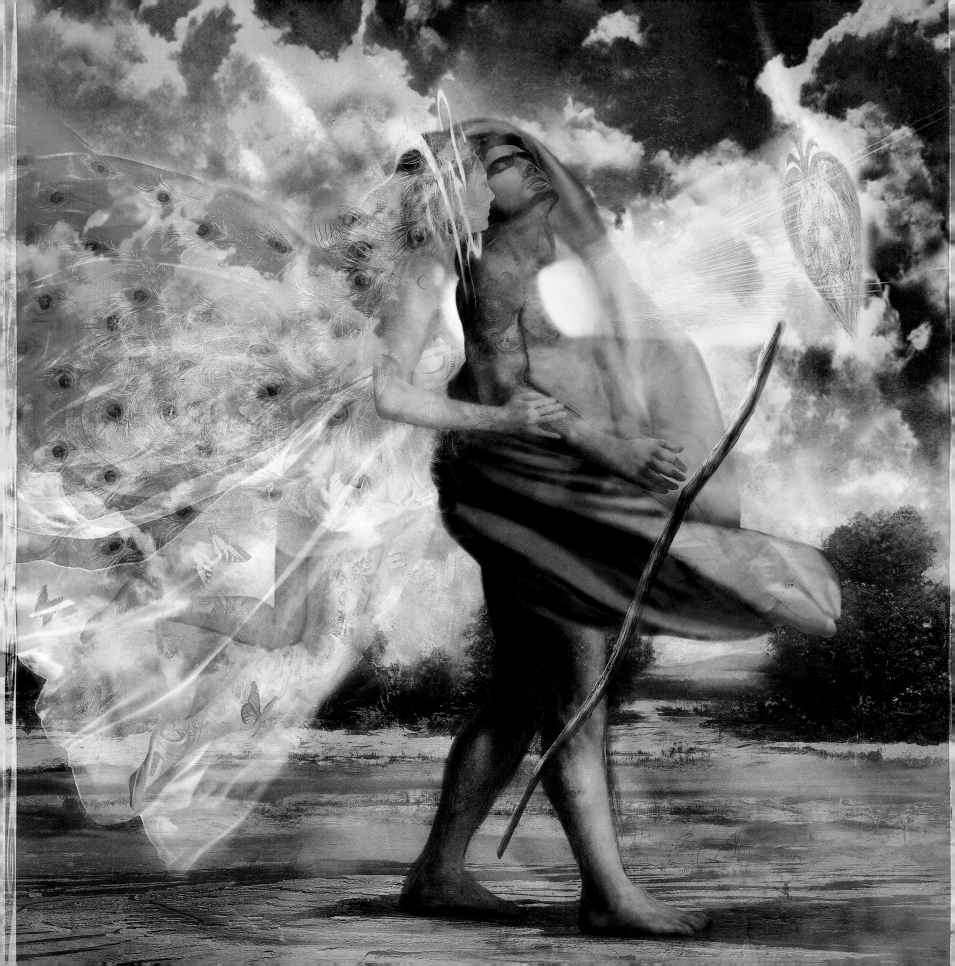

Ignite Thy Passion
Mixed media/digital, 1999
"This poster is another in the series commissioned for the Art Institute of Southern California. The idea for this image came out of a few sketches playing off the notion that one's personal vision stems from a desire that grows into a passion. The title came to my fiancée Roxana Villa in a dream. I snapped Polaroid pictures of her for reference, then started on some large drawings to which some painting was overlaid. Then these and numerous pieces of classical paintings were scanned into the computer. All this resulted in a file of almost a gigabyte. It was slow going.

"The focus was centered on the figures and I wanted an almost biblical quality to permeate the male figure to get across the feeling of the artist being the lonely wanderer. The design of the poster was a collaborative effort with my good friend Jeff Burne. I hired Paige Imatami to create the beautiful calligraphy that appeared in the poster."

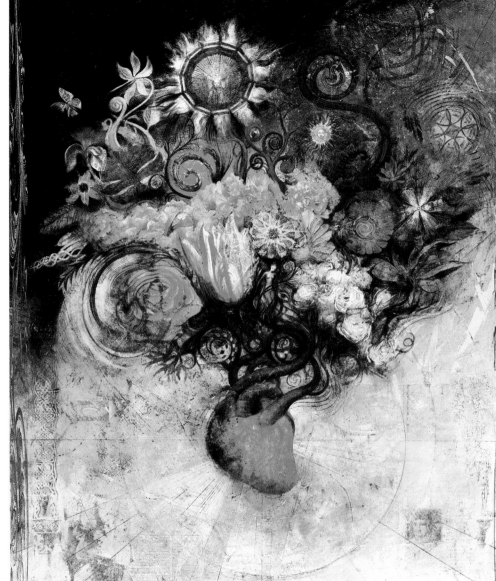

Art Heart
122 × 91.5 cm (48 × 36 in)
Mixed media, 2001
This poster was designed for National Portfolio Day, an event held annually at the Art Institute of Southern California. All senior school children with a desire for a higher education in art and design can come and look at the portfolios of the nation's art colleges to inform their choice. Greg is allowed great freedom in his choice of image by the art director, Anthony Padilla, which always results in him having fun in creating the piece. This one represents the love of creativity and is almost entirely painted, with a few elements of collage thrown in. "It represents my bow to the early Flemish still-life painters. The heart is a many splendored thing."

publications around the world I was reaching burnout. But no matter how grim a story, the art never turned out to be a complete downer. There was always a little glimmer of hope, some light at the end of the tunnel."

Social art

Throughout the 1980s Greg produced social and political illustrations for magazines and newspapers and some book covers. Most of the subject matter he illustrated was on the heavy side: apartheid, terrorists, war, government corruption, injustice, corporate monsters, pollution, murder, the mafia and child abuse. "I got a good look at the underbelly of humanity and saw how

everyone has an agenda," he says. "It was disconcerting to see how different publishers would run the same story and skew it so the reader would view it through their lens.

"Attacking all these assignments like a dog takes to a bone, I felt that I was finally making an important mark as an artist. I believed that looking at all the improprieties of the world was the first step to understanding, that recognizing the flaw or injury could bring us closer to healing it.

"In attempting to distil the essence of an article down to its universal themes, I wanted the nude or slightly clad figure to play a dominant role in most of my concepts. Debating with art directors about the virtue of using the

nude to convey mankind was never-ending. "The nude figure communicates timeless principles beautifully," I would argue. "Our readership will not understand it or will be offended" was the response. Sometimes I won, sometimes I didn't. But I always fought for it.

"Most of my figurative reference came from pictures of myself, my friends, and even my neighbors. I liked the Polaroid camera because of its immediacy and it gave me just enough information to go by. All the life drawing classes I had taken proved to be invaluable for understanding constructive anatomy. Magazines of all sorts continue to inspire and provide a wealth of visuals. I have a reference file started in my high-school years

that is still growing. The other thing I always fought for was a unique idea. I work very hard at conceptualizing. In this day and age of visual bombardment I want to create something that is new. The norm in this business is the obvious, the literal and the cliché, with too many editors and marketing people making the key decisions on the art."

Preparation and process

"My method for working through a job is generally as follows. First I find out the pertinent information about what the art is for, due dates, legalese and rights issues. I make it clear that I prefer to develop my own concepts. The manuscript and/or synopsis is sent to me. I generally like to look at both, as the synopsis gives a nice overview while the manuscript contains useful details.

"After attaching images to key words or phrases in the story I then start mixing and matching metaphors. This type of brainstorming gets a lot of unrelated images working together, increasing the possibility of an interesting combination. At the same time I am looking for the foundation of a theme. There is usually one idea that really sings, but I may throw in another sketch or two so the art director and editor can be a part of this process. The sketches are emailed. I have a pretty good track record of hitting the conceptual nail on the head, so usually the sketch phase is brief and I move onto the final. At this point the fun begins.

"Now the process takes over. Pictures are taken. The image is drawn on illustration board. Then different collage elements from magazines, newspapers and found objects are adhered to the board on and around the image. They can be textures, designs, people, landscapes, machinery and so forth—they are picked intuitively and whatever feels right goes down onto the board. I seal all this down with an acrylic medium.

"At this point I can start painting on it with acrylic paints. Putting on latex gloves, I dip my hands into different paints to slap down some color, moving it around with my hands. I also use brushes intermittently, and sometimes a blowdryer to speed up the drying process. I then scratch into the art with sandpaper, metal scrapers and combs and pull away paint from the image. Another coat of medium can be applied or sometimes I use clear packing tape. I can paint over the top of this again, starting to refine the image underneath. This process can go on for a while, building and destroying the surface. I will also cut into the piece with a craft knife and pull up parts of the paint and tape.

"At some point I will begin refining the image with oil paint. This dance between making and taking stops when I feel I have arrived at a balance of refinement and rawness."

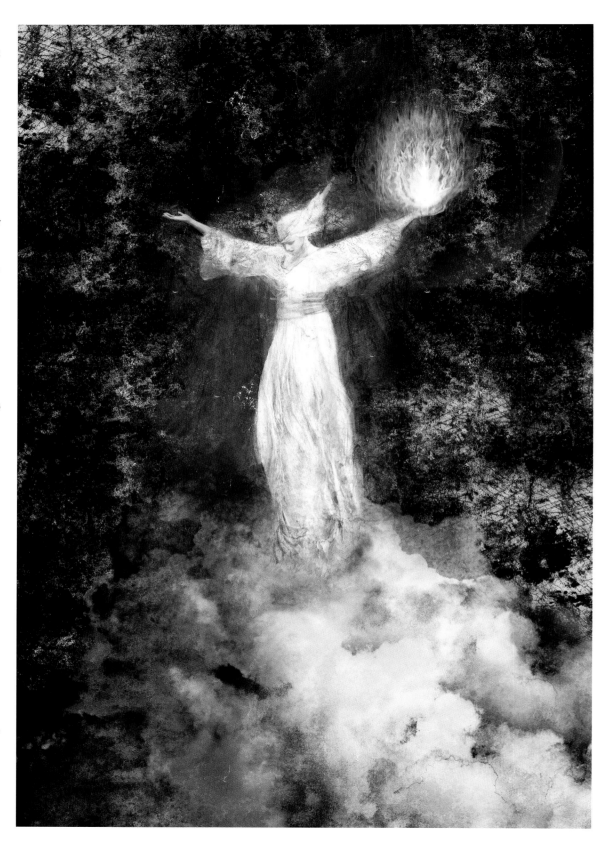

The Visitor
Mixed media/digital, 2002

This illustrates a scene near the end of the book *The Visitor* by Sheri S. Tepper (Eos) where a goddesslike figure rides a cloud of demons. The art director, Tom Egner, quickly decided demons were out, but Greg had recognized a symbolic purification taking place in the scene which he used as his starting point.

"I scanned my drawing into the computer and started a collage of elements that worked into the piece digitally. Clouds were used from my library of photographs and other references. The demon-substitute background textures became a fusion of distressed painted illustration boards and crackled old photographs. The fire was then digitally created with Photoshop tools. I created two versions of this art and Tom chose the darker version for the cover, but I like both equally."

 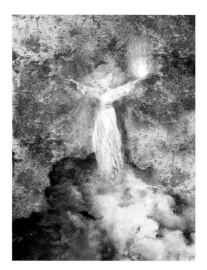

The computer

"When the computer becomes a part of the work I scan this traditional media art and then continue with the execution of the piece by digital means. I find that Photoshop fits perfectly over this low-tech foundation because it moves along the same lines of building, layering and breaking down the image. Adding images, textures and paint in the digital realm brings the art into another world.

"After working in cyberspace for a while, I may output the image on my Epson printer and work again in paint. Generally the art will be scanned back in again and finished in the computer. The finish is emailed to the client. The process from sketch to finish is usually one to three days, depending on the deadline and the complexity of the piece.

"Over the years I noticed that my best work seemed to express a quality that transcended the original idea or the technique. This quality was intangible, but its presence was there nevertheless. Decades of viewing art and creating it for publications around the world had taught me something about seeing. It's a vision I never want to lose. I learned that all great art has three aspects of mind, body and spirit working together at a very high level of sophistication.

"I call this a synergy of transcendence, mind being the concept or idea, body being the technique and materials and spirit being the passion, love or soul. If the art is missing one of these aspects or if one of them is poorly executed then the piece drops in quality and loses its power. If ever I am feeling somewhat bored or uninspired with a job, I remind myself not to lose sight of this knowledge."

Self-awareness

"The 1990s turned into a journey of self-awareness. Through serious meditation I found that there was a space, within a space, within a space. Doorways opened into landscapes of peace, love and wisdom. Inside this sacred place reality took on a new form, ideas flowed like water, problems met solutions. Worlds passed before my mind's eye, filled with saints, kindred spirits and multi-colored beings. I had found the infinite scrap file.

"The Indian yogi Paramahansa Yogananda said, 'Just behind your eyes, just behind your thoughts, just behind your feelings, is God. When you are calm, the whole universe of happiness rocks beneath your consciousness. The whole universe talks to you.' From my experience I know this to be true.

"Maybe this started a breakthrough, because during the last half of the 1990s my work began to change. I purchased a Power Mac 9500, and with this tool my images began to acquire an ethereal quality. Photoshop was part of this change, but I could feel something else was creeping back into the art. The dark began to fuse with the light, the sensual with the spiritual. Suddenly I was getting calls for fantasy book covers. The posters I was designing for the Art Institute of Southern California took on a mystical slant and even my editorial jobs revealed a hint of faerie. I was having fun hanging out with Kent Williams, Dave McKean, Pratt, Jon Muth and the rest of the gang at the Allen Spiegel Fine Arts booth during the San Diego Comic Conventions. A shift happened with my personal vision. It's still exciting to watch. Maybe my soul is growing and bursting the seams of my self-created limitations. Or is it the little boy beholding in awe the magnificent cathedral inside his head?"

DAVE SEELEY

"It was life drawing that best taught me the core concepts of gesture and lighting, both of which are critical in the making of significant architecture as well as illustration."

Dave Seeley has been doing art for as long as he can remember—or before, if you believe his mother. He would fill notebooks with colorful monsters in battles with skindivers or spacemen while entertaining friends at recess in primary school. Secondary school brought exposure to traditional art media and it was this ongoing interest, coupled with a strong bent for math and science, that led him to study architecture. "My perception at the time was that middleclass kids who did well in their studies just didn't become artists," he says. "At this point in my life I thought of artistic talent and intellect as distinct, and the pursuit of intellectual development was the responsible path."

Image junkie
In the late 1970s, while he was studying architecture at Rice University in Houston, Texas, Dave's addiction to images began to reveal itself with an inexplicable attraction to Paper Moon cards, which covered the walls of a local shop. He was enamored with the airbrushed, pneumatic styles of Peter Palombi, Dave Willardson and Charles White III. "I found myself framing cards and magazine covers with string, cut window glass and paper clips, and tiling my dorm room walls with shiny multicolored rectangles," he says. His irresistible attraction to a barrage of multiple images manifested itself once again with the advent of music television. "I was mesmerized by the split-second flash images of MTV. I would fall into a trance and lose contact with non-virtual reality."

Dave also rediscovered comics while in college—not the superhero variety, but the highly original, more political, science-fiction-based work of Frank Miller, Howard Chaykin and Michael Kaluta in the USA, and the work of the equally radical European artists Moebius, Enki Bilal, Paolo Serpieri and Milo Manara that he found in the magazine *Heavy Metal*. It was such a delicious mix of art, fantasy and libido that it fed his desire for fantastic imagery throughout his architectural studies.

Following graduation, Dave's image habit persisted. "I would collect used fitness, fashion and design magazines

awaiting trash pickup on the streets of Boston, just to knife out pages and file them away in categorized stacks. I really didn't know why I was doing this, because I wasn't producing any art at this point. I just chalked it up to the collector bug. Later, I began making art and used this collection as a reference file, a source I soon replaced with royalty-free stock photography when I became aware of ethical and legal issues surrounding derivative works.

"Toward the end of my architectural schooling it began to dawn on me that architecture was far more abstract than the simple idea of marrying art and science to make buildings. I was one of the fortunate students in that when I began to realize what architecture was, I was still interested in making it." Dave's initial degree was in both architecture and fine art, so he spent studio time painting, drawing and sculpting. "It was life drawing that best taught me the core concepts of gesture and lighting, both of which are critical in the making of significant architecture as well as illustration," he says.

Although Dave produced very little art when he began practicing architecture in Boston, the subverted desire to make art seems to have manifested itself in ardent art collecting. He amassed a huge collection of both American and European comics harvested during travels through France and Italy. It was his understanding wife who, upon return from their third such trip, called his bluff and signed him up for a bronze casting course at the local art college. "Here I started making art again, and found it exhilarating. I hadn't realized how suppressed my creative spirit had become until it was unleashed again. Curiously, my desire to collect was proportionately diminished. I found that my art and architecture were cross-fertilizing and the formerly distinct paths began to merge."

Instant gratification
It was in the display window of his favourite Boston comics shop that Dave discovered the work of Rick Berry and Phil Hale, who were then collaborating as Fetishtent Studios. He tracked down Rick at his home studio in

BIOGRAPHY

Dave Seeley was born on May 8, 1960 in Boston, Massachusetts and grew up in the suburb of Andover. He studied art and architecture at Rice University in Houston, Texas, gaining a dual BA in Architecture and Fine Art in 1982. During this time he became an avid collector of comics and fantasy art.

He gained a Bachelor of Architecture degree in 1984 and worked for a variety of architectural practices. He was project architect on the Boston Police Headquarters and the Parke du Valle Neighborhood housing project in Louisville, Kentucky, both of which won an American Institute of Architects Honor Award for Design Excellence.

In 1989 he tracked down Rick Berry and Phil Hale, with whom he began collaborative painting. Seduced finally by the charm and glamour of image-making, he decided on a career change.

In 1995 his work for Last Unicorn Games got him work for Wizards of the Coast on such major collectable card games as Magic: the Gathering and BattleTech. White Wolf publishers commissioned his first book cover in 1997.

In 1999 he signed on with Shannon Associates, who placed his artwork with Tor Books. They have become a faithful client of his. Other recent clients include the Village Voice, Random House/Ballantine Books and Lucas Film.

Dave lives and works in his studio in Boston with his wife and seven-year-old son. Between illustration assignments he will still do occasional architectural consulting work, and feels he is perhaps a bit too active in community-based city planning in Boston in his not-so-spare time.

His website can be seen at www.daveseeley.com

Demon Roast
Photodigital, 1999
Demon Roast was created as a chapter opener in TSR's role-playing game Darkmatter. "It's always difficult to compose a situation where the focus of the image is also the focus of the characters and you need to show the characters' faces. The interpersonal conflicts help do that here. I used the contrast of the sunlight streaming through the piers with the murky church interior to accentuate the moment of a surprise discovery."

Arlington, Massachusetts, with the intention just to collect a piece or two, but the pair immediately hit it off and Dave left with two pieces and a date to paint together. Over the next several years, he and Rick would regularly get together (occasionally with Phil too) for late-night collaborative oil painting-smearing sessions over beer and Irish whiskey.

"At the time, as part of a team at a local architectural firm, I had just completed design work on a major public building in Boston. This really should have been a young designer's dream come true, and in fact it was, for the first half of the three-year process. Then things started to go sour as the client got cold feet about an innovative design. I found that dynamic particularly debilitating to the creative spirit. It was largely the result of this experience that I shifted my focus to illustration. Pleasing art directors with the fruit of my creative labors seemed so reliable and direct in contrast to pleasing a nervous building client."

Rick Berry had taken on an art-directing gig for a new card gaming company and invited Dave to do several architectural images for the set. Subsequently, he was assigned several character images as well. Those images got him work with Wizards of the Coast for several collectible card games and launched his career as a professional illustrator.

"My early work for the gaming industry was in a mix of traditional media—oils, pencil and marker," he says. "I began using a computer and Photoshop early on, initially to make final adjustments to color or value in an otherwise finished piece, then to add all color to monochromatic pieces, and later to make substantial content manipulations. Next I began using photographic sources to lay in backgrounds and color schemes. Though I didn't find that digital work was notably faster for me, the computer gave me the ability to experiment at very little cost and I found this wonderfully liberating."

A combination of factors drove Dave towards book jacket illustration and the increased use of computers in his work. It became apparent that producing card art for the gaming industry was not going to make him an adequate living, so he made a concerted effort to break into the cover market where fees and time were both more generous. While shopping for an agent to open more publishing doors, he discovered that the market was largely for an extremely tight, photo-referenced style of illustration.

"Though I loved oil painting, I didn't have a genuine interest in honing the skills toward photo-realistic results," he says. "I love to see the medium in the painting. I did, however, have a strong curiosity about building images direct from the photo sources."

Combot
Photodigital, 1998
This is a refined version of the piece that was the beginning of Dave's photodigital period. It was inspired by doing about 30 card images for the BattleTech collectible card game for Wizards of the Coast and FASA. "I got the idea to put a kind of mech together from photos I had taken of heavy construction equipment in my neighborhood. I ran this idea past the art directors at both companies and although they both liked it, neither had any idea what to do with this kind of art." A personal work, it was published in *Spectrum 5: The Best in Contemporary Fantastic Art* (Underwood Books, 1998). Dave's photographs and early version of the image are shown right.

Combot

At this point Dave had logged enough hours in Photoshop to reach that "intuitive groove" level, and he began experimenting with digitally compositing multiple photographs to create completely photo-sourced pieces. The picture *Combot* was inspired by doing about 30 card images for the BattleTech collectible card game, featuring walking tanks resembling the "chicken-walkers" in *Star Wars: Return of the Jedi*.

He was compelled to put this image together after speculating about how the BattleTech mechs could have actually worked. Dave lives in the heart of Boston's Big Dig highway project, the epicenter of countless tons of hydraulic construction equipment. He began cutting and pasting photographs of the machines in his neighborhood until he got a plausible walking war machine design, then montaged the assemblage with some stock military shots of Desert Storm obtained from the Department of Defense and pictures of the F15 model plane hanging in his studio. "I worked the initial version as a kind of broad daylight CNN war correspondent shot, inspired by the DoD photographs I was using. I ran the image by the art directors at both Wizards of the Coast and FASA, and although they both liked it, neither had any idea what to do with it. It was

Lost In Thought
Oil, pencil, digital, 1998
Lost in Thought is a personal work, begun as a simple oil wash portrait done on a 101.5 × 76 cm (40 × 30 in) board. The introspective charm of the boy prodded Dave to flesh out the nature of his reverie by burning a pencil/photodigital image he had done for Wizards of the Coast's BattleTech card game into the background of the image. It was published in *Spectrum 5: The Best in Contemporary Fantastic Art* (Underwood Books, 1998).

this original *Combot* that was accepted to *Spectrum 5: The Best in Contemporary Fantastic Art,* 1998 along with the older *Lost in Thought,* which was a mixed media work of oil, pencil and photodigital. A few months after *Spectrum* was published, I got a call from an agent who was interested in representing me. She was curious about the two very different styles I had displayed in the book, and was clear that she had a market for the photodigital style of *Combot* but none for the loose paint of *Lost in Thought*.

"*Combot* was a breakthrough piece for me and I was excited at the prospect of chasing a photodigital approach to image-making, so I signed on with the art agents Shannon Associates and started building folio

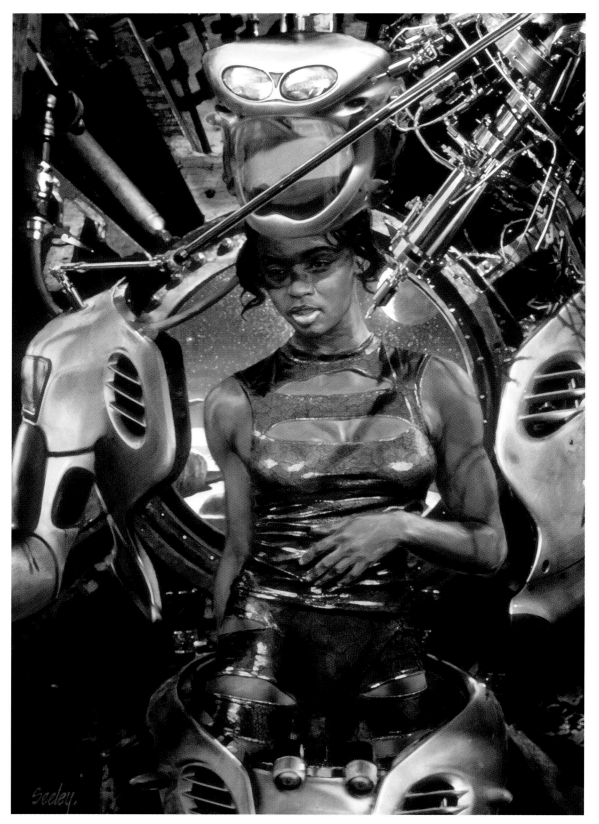

Venus of Io
76 × 51 cm (30 × 20 in)
Photodigital, with oil finish, 2000

This personal piece was inspired by a stock shot of a catwalk model. "She was caught in this graceful sway with a melancholy introspective expression—an incredible portrait of grace, beauty and strength. It's a personal libidinous favorite. I love to do strong women. At the same period of time I was fascinated with the latest motorcycle designs, which were pushing the industrial design envelope for complex curvilinear forms—a delicious combination of aerodynamics, gleaming fiberglass and exposed structural metal. I took a bunch of shots of a parked neighborhood bike and built the suit."

"Then I cut it up to dress-undress my Venus. The machine in the upper right was a stock shot of some lab machine that I used to create the robotic valet lending a helping hand. In the final painted version I buried a lot of the spider web of stainless steel tubing as too busy. I need to beware of crossing into the realm of just too much stuff. There's a wonderful and gritty story in this one and I feel compelled to do more work within its world."

Second Chances: initial sketch for art director approval.

Second Chances: interim draft showing figure resolution overlaid.

Second Chances: inverted pencil drawing layered into the image as bodysuits.

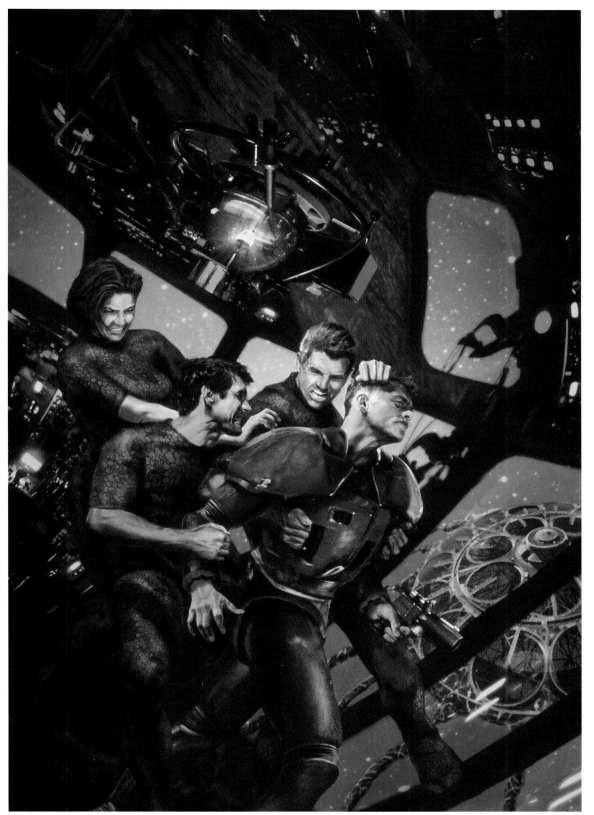

Second Chances
91.5 × 61 cm (36 × 24 in)
Photodigital, with oil finish, 2001

This was an unusual Tor Books commission for Dave in that the brief was very detailed. All the characters were described, including expressions and action. "I pulled each character from individual stock shots of models and then choreographed them. I drew over a print to resolve the figures and then drew a detailed overlay with the bodysuits. That drawing was scanned into the computer, the pattern was burned into it, and it was melded into the image. The ship out of the window was done in a similar way. Both the bodysuit reptilian quality and the extra-vehicular activity hardsuit ideas were pioneered in the *Venus of Io*. The interior of the ship was constructed from an aeroplane cockpit and cargo hold. I was tickled when author Susan Shwartz told me that she liked the finished piece so much that she used it as incentive to finish the book *Second Chances*—that explained why I was only given the first half of the manuscript"

images in that medium. It's amazing how much staying power *Combot* has had with me. I later reworked the image with a more dramatic sci-fi action and lighting. While others fade in my heart, I still have a strong affection for this one."

Frankenstein parts

Dave's approach to a piece depends on the media of the final work, which is usually dictated by the assignment. For a traditional media piece, he will begin with a sucession of drawings, take the successful ones and overlay them, refine them or combine them. He will then take reference photographs to bring in more realism, especially for figure foreshortening or mechanical and equipment detail. A surface will then be prepared for the application of a monochrome oil wash drawing which is further developed by wiping and scratching back to white—effectively a detailed finger-painting. Opaque oils are then laid in over the monochrome on either wet or dry paint, depending on the desired effect. "I'll barrier coat and glaze in colors for final color balance and value. At this point the piece may be finished—or ready to photograph for a digital phase. Each painting gets shot and scanned into the computer, it's just a question of whether or not I can leave it be when it gets there.

"The process for a photodigital piece is not all that different. I'll start by combing my massive database of photograph thumbnails. I have thousands of shots I've taken and scanned, and many more royalty-free shots I've collected. I've compiled database files with images I've picked out as particularly inspirational (for whatever reason) and often I'll start with one or more of those and build a piece around them. This stage of the process is really like casting a movie and doing location scouting. I'll pull out parts of various photographs and overlay, scale and rotate them to develop an initial composition. During this stage I'll often make a print and sketch over it to develop a direction or resolve anatomies. This is the stage that many clients see at the conclusion of the sketch phase. If the art director isn't used to digital work, they may be shocked by what they see. The piece can look very violent at this point before final color, tone, masking and relative sharpness is resolved between the various Frankenstein parts.

"Once the art director has agreed to the direction of the picture based on the sketch, I'll then begin to meld the disparate parts and start creating secondary elements. I'll find myself building a laser gun from a motorcycle, or an alien space ship from a fish. It's often the result of an intuitive visceral reaction to appropriateness of materials, texture and cohesive design aesthetic that will send me looking for a photograph logged deep in the

The Magnetic Fields
Photodigital, 1999
"This was a fun digital romp for *The Village Voice*. It's from a studio portrait of Stephan Merit from the Magnetic Fields band, shot by Raphael Fuchs. The concept sprang from Merit's charming otherworldly persona. The *Voice* wanted him done up as the Little Prince. I used shots of a 1950s power drill to build his spacesuit and ship, and some NASA shots for his planet. This is a good example of maintaining a certain design aesthetic throughout the piece."

Archform: Beauty
Photodigital, 2001
This dramatic piece was the cover for the book of the same name by L. E. Modesitt Jr (Tor Books). "I was really attempting to evoke the recording booth architecture in this one. It was inspired by a shot I took of a chrome sculptural sign I happened upon at a local television station. The tools and filters in Photoshop are wonderful for transparencies and reflections. I marvel at artists who do this with straight paint."

archives of my memory. Often I'll obliterate the entire underpainting that was the sketch. I'll sometimes overlay a printout and do a detailed pencil drawing, scan it, layer it into the image and meld it in place. After both the client and I are content with the final composition, I'll merge all the layers (usually 30 or more), filter, blur and sharpen to achieve the proper atmospheric perspective. Then I'll make final overall color balance and value adjustments while proof printing.

"I suppose the roots of what I'm doing are in collage, an art medium that I never really liked. Photoshop allows the collage to be seamless. Perhaps I'm attracted to this resolution of the barrage of multiple images involved in

the creation of photodigital pieces. I find that the sharp visual chaos of life survives the process and gives a satisfying smoke-and-mirrors illusion of reality."

The sliding scale

"Aspects of my background in architecture have proved to be assets in the world of image-making (the chicken?), though it's certainly possible that these were prior personal strengths that led me to architecture initially (the egg?). I work in a paradigm of creating a product for a client with specific needs. If those needs aren't met, it's not an adequate solution. The essence of significant architecture is solving the mundane, while aspiring to

Turtle
Photodigital, 2000

Turtle is another of Dave's personal works to be published in the *Spectrum: The Best in Contemporary Fantastic Art* series (Underwood Books), this time *Spectrum 7*. "This piece was just a bit of flat out fun, over-the-top shot at a merry band of stereotypical character types. *Turtle* was really inspired by *Combot*. Again, it uses construction equipment combined with some military stock for a near-future-world gritty ambience. This one took on its own chemistry between the various players and begs for a story arc. When does the movie come out?"

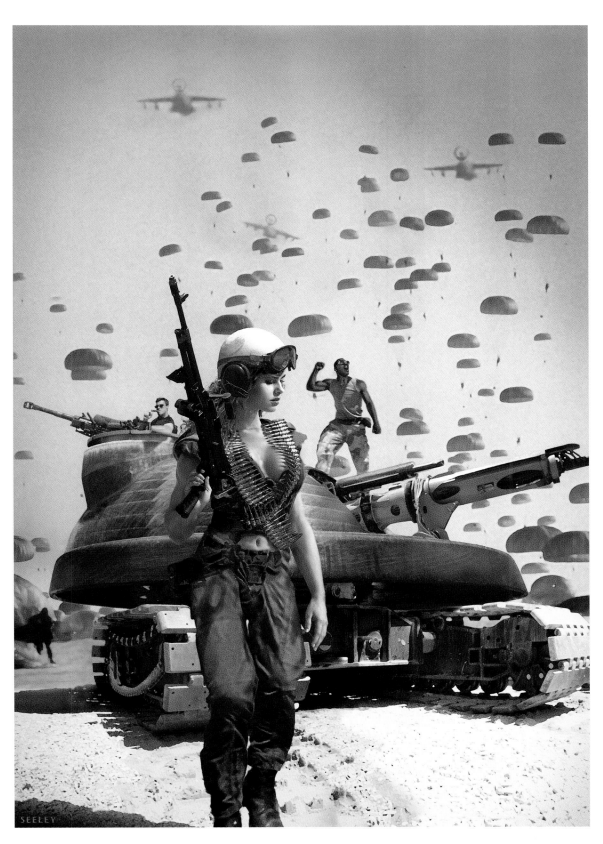

enhance the spirit of the user by the manipulation of built form, space and light. I approach illustration in the same way. Many artists feel boxed in by tight art direction, but for me there is a sliding scale with creative freedom/high risk on one side and specific direction/low risk on the other. The tradeoff of risk always balances the level of creative freedom. I love letting an image create itself, but there are times when I relish the challenge of the constraints.

"In retrospect, my work does seem inherently architectural and spatial. I'm sure this is the part of me that was drawn to architecture originally. I'm also a relentless materials fetishist, another architectural preoccupation. At any rate, I'm convinced that an interest in multiple fields engenders a cross-fertilization that's inherently positive for building overall strength in the work. Cross-genre illustration helps to enrich the work as well. I'm rooted in the fantastical future world-building of SF, but I love to do hard-boiled fiction and I've found that some of the most satisfying results for me come from depicting the clearly impossible in photodigital realism for editorial assignments. Each genre has its own paradigm. Working outside your paradigm makes you aware of its boundaries, and provokes you to push them when you return."

Broadening horizons

"I love image building in the super-wide-angle world. Early on, I would combine multiple consecutive panoramic shots taken with a 20mm lens and use the computer to montage them into a single shot. The resultant picture would have been impossible to take without the radical distortion of a fisheye lens, but in Photoshop I could correct it in a way that the distortion was almost transparent. The kick here is that it's closer to what your brain does with the picture from your naturally super-wide-angle eyes than to what you can approximate with a camera. I love that. It really puts you inside the picture. I think that as a society we're so used to looking at photography that we forget that it's a distortion of our visual perception. I happened upon that realization in photodigital image-making, but I now consciously chase that feel in traditional media work as well.

"I've recently been making archival prints of images at a well-developed stage and then oil painting over parts of them. This gives me a way of abstracting the piece just a little farther away from the photographic towards that ambiguous balance when it's not quite clear whether it's photographic or not. It's been fun to see people approach a piece hanging in a show within a few inches, trying to discern where pixel ends and paint begins. I'm

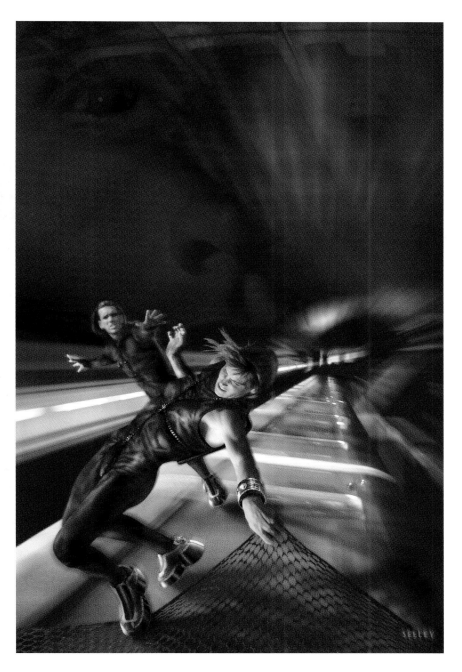

TinkerBot
Photodigital, 2000

This piece is a personal work that was published in *Spectrum 7: The Best in Contemporary Fantastic Art* (Underwood Books). "It is built from photographs shot at the Boston Museum of Science, an inspirational candy store for materials fetishists. The core of the image is a series of shots of a cutaway aircraft engine, which reminded me of a human torso." Dave pays strict attention to the lighting on each piece while putting the elements together, but on this image the lighting of the various parts was so contrary to the way that he wanted to compose them that he invented a light source in the "chest cavity" to resolve the conflict. "My little mechanic comes from two stock shots of kids. I wanted to give her an intimate cerebral relationship with her 'project' by focusing her attention on the center of the bubble, either making some adjustments or just communicating with the nonverbal ghost in the machine. In the end, I felt a personal affinity with the little girl Tinkerbot because we both like to work on robots in our spare time."

Transcension
Photodigital, 2001

The cover for *Transcension* by Damien Broderick was another commission from Tor Books. "I was taken with a certain pivotal moment in the manuscript when an illicit prankish train surfing expedition turns horribly wrong. The flavor of the scene dictated the dizzying blur and off-balance choreography, all overseen by the Artificial Intelligence authority presence."

sure that to some extent this satisfies a basic desire in me to paint. I find that I'm drawn to paint areas of flesh and clothing, favorite subjects in oil work, and it's certainly a joy to revel in the toxic sweet and sour aromas of oil painting. I find it amusing that my photodigital work, which came from traditional media roots, can return to a traditional finish, thereby completing a cycle of sorts. Maybe that love of seeing the strokes in the medium is the impetus, though perhaps I'm giving too much significance to the distinctions of media and those will evaporate with time."

Primordial soup

"I think I'm far more influenced by modern-day science-fiction film noir than by science-fiction illustration, both past and present. Because I came to illustration laterally, I've discovered the legacy of science-fiction art retroactively. As I've settled into the current SF culture, I've come to a better understanding of some of the greats of the past, and by extension what some artists of today are doing by contributing to that tradition, but initially I just didn't understand the paradigm. It really helps for me to hear an artist talk about his work. That gives me the tools to digest it.

"I tend to think of the art world as the proverbial primordial soup of collective consciousness, and various artists as crawling out onto the swampy embankment in different directions. They invariably evolve during their lifetimes and spawn other artists to continue the evolution. An artist coming onto the scene is birthed by the myriad parents he calls his influences.

"Rick Berry and I have collaborated on many pieces over the years, and we constantly share pieces in process to gain perspective from a trusted critical eye. It's so easy to become victim to tunnel vision when you are immersed in a piece. Outside perspective is the way to widen that vision, so I share a virtual studio with some trusted art mates including Rick, Darrel Anderson and Jon Foster. I'm also fortunate to be part of an online list called Artdog—about 50 artists who share art, criticism and commentary. This kind of peer exchange is an incredible tool for artistic growth."

Mary Widow
101.5 × 76 cm (40 × 30 in)
Oil on board, 1991
"This personal work dates from the late-night, whiskey-fuelled, collaborative painting sessions with Rick Berry. Rick had a hand in this one if foggy memory serves."

Cockpit
Photodigital, 1999
"This piece was my agent's favorite. She liked the retro-Sixties quality." The static poses of the ship's crew are nicely offset against the dramatic sweep of the planet below, seen through the many windows of the orbiting spaceship. This arrangement also allows many surfaces to be highlighted, which increases the perception of depth in the picture.

Piper
91.5 × 61 cm (36 × 24 in)
Oil on panel, 2001
"This is all oils and it was a pleasure to do a full painted piece again. It was a bleak tableau picture about a lesbian vampire submissive/dominant relationship, painted for *Realms of Fantasy* magazine. Someone later pointed out to me that it was a Pietà. I plan on doing more work along these lines in parallel with the photodigital image-making."

Dream Thief
Photodigital, 1999
The *Village Voice* article this picture was commissioned for was about covert 'guerrilla' biographers stalking celebrities. The *Voice* wanted an image that suggested an intrusion into the subjects' mind—stealing their thoughts. The use of a model dressed as a burglar literally conveys this but by use of light reflected from the victim's eyeball Dave has also created a particularly striking picture.

DARREL ANDERSON

"These days my catalyst of choice is the computer. Very shortly after my first exposure to digital art, I realized that the machine itself was a creative medium—a tool that could be re-formed to accommodate my approach to drawing and painting."

Darrel Anderson has been creating and inventing professionally for almost 30 years. His early love of science was diverted into the visual arts when he was a teenager, although his attraction to art was originally based on its use as a tool for visualizing ideas and inventions. These two major passions were finally pulled together in the early 1980s when an illustration job landed an Atari 800 on his desk and the inevitable tight intertwining of art and science in his creative pursuits commenced.

Two-fisted brain

Darrel's approach to drawing is rather like the old joke that says that you carve an elephant by means of cutting away everything that does not look like an elephant. "Michelangelo's assertion that the figures were already in the stone and he simply liberated them is perhaps a bit too deterministic for my taste. The way I see it, the figure (or the elephant) coalesces in the mind and on the canvas or in the stone—pieces already there, along with countless other forms real and imagined, known and unknown to the artist. The medium, be it canvas, stone or pixilated screen, is the catalyst.

"These days my catalyst of choice is the computer. I realized very shortly after my first exposure to digital art that the machine itself was a creative medium—a tool that could be re-formed to accommodate my approach to drawing and painting. I woke up the napping left side of my reasonably ambidextrous brain and started working on both sides of the screen. Ironically, I've come to think that this rigid, analytical medium may prove to be uniquely suited to the intuitive, organic methods that I find essential to art."

While specifics of technique have changed over the years and across media, the essence of how Darrel goes about making art is constant. It is an extension of what all kids (and most adults, if it hasn't been wrung out of them) do naturally—find faces and figures in clouds. "Using evocative grounds—scribbles on paper, splashes on canvas, chaotic pixels—I tap into the mind's keen ability to recognize pattern and form. I play in the medium, pushing it in the general direction of the imagery I hope to find. Everything about the image evolves during the process. Composition, palette, concept, content—all are more discovered than planned.

"It's a kind of collaboration with the medium. The computer has great potential—not yet fully realized—to be an extraordinary collaborator."

Mining for ideas

Regardless of medium, all of Darrel's art begins with some sort of scribble, a controlled chaos designed to trigger that highly evolved part of our brain that finds faces in clouds. "While I'm scribbling, 'wrong' lines outnumber 'right' lines easily, but who cares? If I drew just one line it would be quite right or quite wrong (and I probably wouldn't know which until it was too late). A chaotic scribble—floating around where I suppose the desired line lives—contains lots of nearly right lines, and other right lines. I'm not out to hone a preconceived image, rather I'm seeking a kind of image. I have to keep looking throughout the process, and the likelihood of discovering something that transcends my original concept is high. For me this scribble search is the only way; if I am forced to formulate the image beforehand I become inept.

"This is especially true when seeking expressive forms. Dave McKean, in *Fantasy Art Masters,* talks about making a shirt 'feel like the wind, or like a constricting skin, or angry, or like a consoling embrace.' Such expressive forms are almost always found in unexpected places—some stroke I never would have planned. I don't really know what those things look like—not in the way that I know what an actual shirt looks like—but I can sense it, recognize it, as I'm working. I set out to evoke the desired forms through choice of media and application, then tease it out during the creative process. I think with the media, see with the media.

"It's possible, however ill-advised, to be pretty analytical when the goal is literal representative form. But even if I was just after a plain old shirt, I'd go about it the same way. All art is abstraction, and a slavish chase

BIOGRAPHY

Darrel Anderson was born in Glendale, California, in 1953. Unable to drop out in an appropriate manner, he completed high school in 1971 while failing to actually graduate.

He and his pals formed Everyman Studios in the early 1970s, taking on any artistic endeavor including publication of numerous underground comics. Darrel was editor and publisher of an alternative newspaper, *The Everyman Flyer*. Many years later, he and fellow Everyman Rick Berry co-founded Braid Media Arts.

His involvement with digital art began with the creation of screen graphics for a computer game rendition of *The Martian Chronicles* in the early 1980s. Darrel developed his own graphics tools for that project and went on to author, with Jeff Anderson, 3D object deformation and particle systems for AutoDesk's 3DStudio, and GroBoto, a software package designed to be a conduit for Art/Math synergy.

Darrel has received numerous international awards including top honours in PIXAR's call for images, and MacWorld's Macintosh Masters competitions. His work has been featured worldwide in digital and SF/Fantasy publications.

In 1995 he created and established one of the earliest and longest-running extensive independent art sites on the web, www.braid.com.

With members of Braid and PCA Graphics, Darrel created the animated CGI climax of the 1995 film *Johnny Mnemonic*. In 2000–2001, he produced 48 images for the SCI FI Channel's website (www.scifi.com).

He taught at the California State University's Summer Arts Program and was a guest speaker at the Digital Burgess ALife conference and at Tufts University.

Darrel is single and lives in Colorado Springs, Colorado, in close proximity to two brothers, two nephews and a niece.

His websites are www.braid.com and www.groboto.com

offWorld
Digital (GroBoto/POV-Ray/Photoshop), 2001
Darrel tried a new technique here, subtracting one 3D object from another, much like creating a doughnut form by subtracting a cylinder from a disc. "In this case the subtractive geometry is a duplicate of the original form (composed of solid cylinders much like those off in the distance). The resulting form was discovered by tweaking the offset, subtractive power and scale of that copy." This is a good example of what Darrel calls playing in the medium.

of photo-realistic representation is a waste of time and effort. A great caricature looks more like the person than any photograph, and a beautifully painted sky, all of its brushwork undisguised, can likewise be hyperrealistic."

This "evocative scribble" approach of Darrel's is much more than the "happy accident" notion that many artists talk about—it is more like a bizzaro world pratfall, an accident in a reverse world, where you end up at the top of the stairs looking better than you did when you first stumbled. It is a continuous sequence of tiny accidents, some of which are kept while others are discarded. The process is rather like biological evolution; everything is a mistake, but some of them work and so they survive.

"I have to say, it's fun. I'm attached to this approach because it's effective, and I'm enthralled with it because it's exciting. There is a sense of exploration and discovery that greatly enhances the already satisfying act of crafting an image."

Art nerd

"Appropriately, I wasn't taught this method of drawing, I discovered it. More accurately, we discovered it.

"I left high school filled with naive disdain for all forms of conventional wisdom and shunned formal education in favour of a haphazard pursuit of art. That led to an ongoing collaborative pursuit of all aspects of

Chess Bone City
Digital (GroBoto/POV-Ray/Photoshop), 2000
This piece, inspired by Bradbury's *Martian Chronicles*, was produced for the SCI FI Channel's website, www.scifi.com. The original GroBoto model was reinterpreted as MetaBalls by POV-Ray. Metaballs takes simple geometries such as spheres and cylinders and melds them together. The effect here is quite constrained, almost as if the whole thing is built out of little wax discs and spheres then brushed over lightly with a blowtorch.

"Part of the fun here is in the unpredictable results of that virtual blowtorch. From there it's a matter of finding the right camera angles, lighting, and adding textures. Textures are derived from other digital imagery—chaotic, organic-looking stuff created by colliding a variety of scanned materials and digital bits (often culled from my details of my other images, or those of collaborators—anything rich and complex will do). I kept the overall lighting subdued to allow the bright little lights tucked into the nooks and crannies to work."

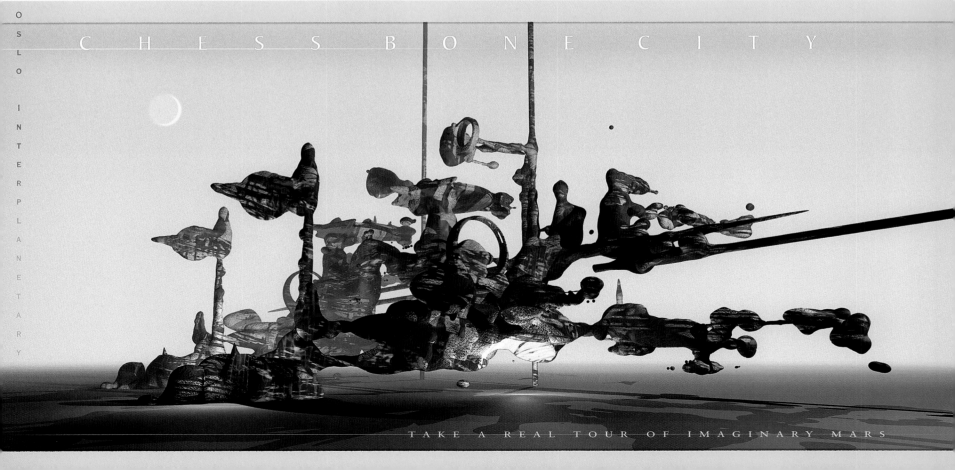

CHESS BONE CITY

OSLO INTERPLANETARY

TAKE A REAL TOUR OF IMAGINARY MARS

AUTONOMOUS

SAN FRANCISCO

BOTS GONG TO WORK ANGCISCO

SELF-REPLICATING, SELF-GOVERNING SYSTEMS SINCE 2051

Autonomous Architecture
Digital (GroBoto/POV-Ray/Photoshop), 2000
Darrel wanders through his 3D creations with his virtual camera looking for the perfect shot. This is a small part of a larger GroBoto model of a spherical cage seen from inside. It is composed of strings of small discs and spheres, which have been melded together using MetaBalls.

"A second GroBoto Model—the massive architectural elements—was positioned off in the distance. The whole scene was then rendered with fog and exaggerated perspective to give a feeling of grand scale. The line work was created using a series of Photoshop filters and applied over the rendered image as a layer. I'm still a draughtsman at heart and find the economically descriptive quality of line very satisfying."

creativity with Rick Berry and others in our group of artists, publishers and hippies known as Everyman Studios. We learned from each other. During that period Rick and I fell upon this evocative scribble method of drawing, and it accounts for much of what my art is about. But to get the whole picture I have to reach back a bit further.

"I loved science fiction as a kid, but hardly needed it—I was four years old when Sputnik went up, eight and nine for Gagarin and Glenn, 15 when man landed on the moon. A passion for math and science coalesced with an art 'knack' at an early age. However, science was king—I was drawing plans, not making pictures, and I was on the rails towards some sort of science career. It was all about invention, design and experimentation, and in many ways that hasn't changed. However, the train jumped off the math/science track in my high school

years and has been careening down the unmarked back roads and goat paths of art ever since.

"So, with all that science stuff pretty much suppressed, I scrambled, along with those art buddies, to survive. Underground comics, technical illustrations, signs, advertising art, prints, science fiction and fantasy conventions, we'd do anything—learn as you go. We floundered a lot, learned many things the hard way, didn't have much in the way of experienced mentors to say 'Hey, you know, that would be a lot easier if . . .' On the flip side, our shotgun approach led to a lot of innovation and discovery as well as fearlessness about media and method. One of the things we took to was collaboration. We were inspired by the 'Jams' in underground comics and we had little reservation about messing with each other's work.'

silverSmith
Digital (Degas/Spectrum/Flo'/Photoshop), 1985–2000
This is evidence of the evolution of digital tools and of Darrel as a digital artist. "I hope I was a better artist than these early digital pieces might suggest. More than a decade later, I used Photoshop to revive this piece. You can clearly see how the original pixels have become physical elements in the newer works. The piece really broke free from its primitive origins when I used Flo' (2D distortion software, no longer available), to turn the head slightly downward, finally freeing him from the raster grid."

neoZero
Digital (Spectrum/Fix/Photoshop), D. Anderson/R. Berry, 1987–2000
This was originally a piece created by Rick Berry. When Rick needed to use the original file for a reprint of William Gibson's *Count Zero* (Ace Books, 1987), Darrel pulled it from their archives and started playing around with it. "I bumped up the resolution and started colliding it with other images in Photoshop. The blocky pixels were transformed into texture and detail while maintaining a taste of the piece's primitive digital origins."

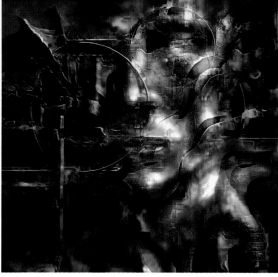

My three collaborators

"Sure, collaboration is useful and instructive in a very pragmatic way, giving access to techniques you don't personally possess, but more amazing is the shared mind effect. With embarrassing ease your pal will vault over a stumbling block that has hopelessly mired a piece. As I work, I inevitably lose perspective and fresh eyes are free of the fog and bias obscuring my view. Also, they are different eyes, a different mind. What your collaborator sees as the image is constructed in his mind is not the same image as yours. He interprets the image differently, brings insights you may be incapable of seeing. And here's the kicker: after enough collaboration you can access that other mind even when it's not around and think your way around a problem by donning your pal's hat.

"Are ego and pride taking control of your art? Try a dose of collaboration. Could be that some precious part of your work, something you labored over for hours, just has to go—for the sake of the overall composition, or perhaps because it's just flat wrong. It's tough to let go, but your pal isn't hindered by your attachment to the work. That's not to say he's always right. Collaboration requires a lot of trust and respect. Digital media takes some of the pressure off, as alternatives can be explored without obliterating anything. Consequently it's a great collaborative medium, although there is a lot to be said for the strengthening of artistic relationships that occurs when someone irreversibly saves or ruins, say, your oil painting.

"Collaboration with other artists, whether hands-on, over-the-shoulder, across time or space, is essential. All art is collaboration at some level; solo creation is a myth. Originality is the unique blend achieved when an artist adds his or her mind to the mix.

"I also think of the viewer's interaction with the art as collaborative. John Singer Sargent, N.C. Wyeth, Frank Frazetta, Jeff Jones, Francis Bacon, Marshall Arisman, Rick Berry, Phil Hale, Dave McKean, John Berkey, all of the Impressionists and many more artists understand the value of leaving something unsaid, undelineated. You have to leave room for the viewer. Just like artists chasing scribbles, kids staring at clouds, the viewers see images with their minds, not their eyes. Leaving room for that mind to work results in a collaboration with the viewer, making the image more powerful and personal to that individual.

"I have trouble with some of my own digital 3D work in this regard as it is too discreet, too delineated and the only thing saving it is the truly odd content and form which still leaves plenty of room for interpretation. Nonetheless, I look forward to messing it up a bit, blurring the boundaries, by combining it with other media and improving the 3D tools.

"The third collaborator is the medium. Characterizing the medium as a collaborator may seem like a stretch, and it is. Compared to the human interaction with studio mates and viewers, the passive, mindless contribution of the medium is small. But I think that may change as the digital medium matures. It is not passive and whether imbued with the mind of the software designers, or the debatable qualities of artificial intelligence, it is not quite mindless. Its little mote of a brain is growing."

Digital scribbles

"I love digital tools, although I find them perpetually unsatisfactory. I suppose that's why I keep trying to build better ones—or those that suit me better, anyway.

"Rick Berry characterizes the traditional painting kingdom this way: 'Oil is king, watercolor is queen and all others are mere peasants.' If I were to place digital tools in the same realm, I'd go with wizard—they are part alchemy, part sleight of hand, more and less than they seem. In one way they are uniquely powerful in that they are infinitely malleable. No other medium matches their latitude of exploration and experimentation; there is countless variation of color, composition, even addition, subtraction, distortion and relocation of

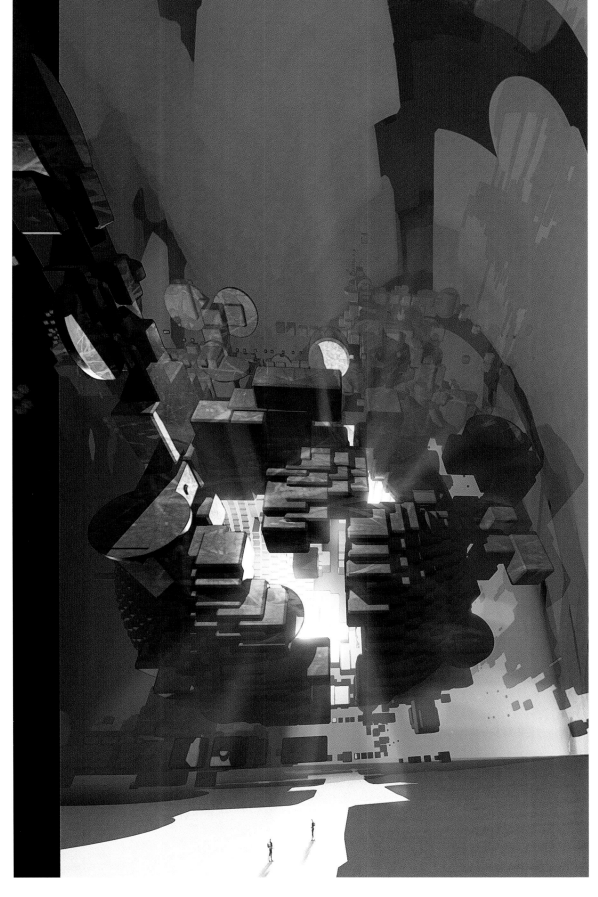

Kiln
Digital (GroBoto/POV-Ray/Photoshop), 2000
This unpublished work started as another GroBoto scribble. Many 3D
renders also produce additional image data which become channels in
Photoshop and then serve as creative tools. The depth map shown here
(*below*) translates the object's distance from the viewer into shades of
gray. "These are great as masks for applying filters and other effects in
Photoshop, serving to gradually fade the filter, color adjustment or
whatever, based on the gray level of that mask," says Darrel.

A line drawing (*bottom*) was then extracted from the 3D rendering, using
a Photoshop filter that delineates edges. This line drawing was applied
over the full rendered image as Photoshop layer to subtle effect.

After the initial 3D render, the entire process was all done in Photoshop,
laying in a backdrop, adding atmospheric effects, pushing color and
contrast around until it felt right. Darrel feels that this is painting of a
sort, and it certainly helps to rub off a little of the plastic sheen of the
pure rendered images.

discrete elements. Digital images never die. While traditional images can be revisited by an artist—overpainted, traced, reworked—the ability of digital works to be re-formed, spawn variants, recombine, is unparalleled. The artist is free to pursue any whim without consequence, free to go back to an earlier version should a detour prove disastrous. This give and take aspect of digital media is ideal for evocative scribbling, and for collaboration.

"All that said, the digital medium also suffers from significant shortcomings. It's not as immediate and responsive as natural media. I scribble more quickly and easily on paper. Of the artists I know who are versed in both, nearly all prefer to start the creative process with natural media.

"Traditional media are also much richer, tapping into the endless variety of nature. While the digital environment is potentially very rich, we can only access a minuscule corner composed of a relatively small handful of algorithms manually typed into code by graphics programmers. Nature has been busy for aeons creating a palette of materials with infinite resolution and form.

"You can paint with anything, twig, brush, rag, fingers; you can dribble, splash and scrape; the materials corrode, stain, age and interact in countless unpredictable ways. Digital forces us to work through detached and limited devices—mouse, tablet, keyboard, scanner. To a large degree, their actions are limited and predictable.

"I can't interact with the digital medium in exactly the same ways I do with natural. I don't really want to, don't think that I should. It would be just as foolish to attempt to make watercolor behave like oils. Similarly, I've little interest in digital tools that attempt to mimic the look and feel of natural media. The digital medium has its own unique properties—like all media, it should be exploited for what it does best.

"However, I do want to employ the same creative process—evocative scribbling, seeing with the media. I've found ways to do that. Digital drawing and painting tools (primarily Photoshop) allow me to collide and manipulate images, creating a rich visual ground that is very effective. However, over the years I found most digital 3D tools too constructive and analytical—all planning and no play—so I've set out to create 3D tools that will let me scribble."

Evolving digital tools

"I have to play to see. I'm attempting to enable that play, even 'bottle' aspects of it, in a 3D software tool—a concoction of knack, vision and recursive and genetic algorithms—called 'GroBoto.'

pipeOrgan
Digital (GroBoto/POV-Ray/Photoshop), 2000
This is predominantly a pencil drawing which was then put through Photoshop, where it was colored and tidied up. The "scribble" origins of the picture are clearly evident in the arch of woven twigs.

Clockwork Ballet
Graphite/digital (Photoshop), 1994–2000
Part of a series of mock 21st-century poster designs, this piece is also primarily a pencil drawing scanned into Photoshop, where it was colored, filtered and reworked. The original typeface was hand drawn.

"Groboto is a graphics application that combines algorithmic and freehand 3D drawing and building tools. Given my modus operandi of creativity—for art and just about anything else—it was inevitable that GroBoto would be 'evolved' as much as it was engineered. Over time, GroBoto tools emerged—enhanced algorithmic engines with direct user control, a kind of hand/math collaboration. For example, there is a GroBoto tool that 'grows' tapering, spiralling tendrils. A combination of control sliders and mouse action gives the artist a degree of control. However, the tool has predefined behaviors, and the final result depends in part on those behaviors and on information that new elements inherit from existing pieces of the model.

"Obviously these tools require the artist to relinquish some control. I desire that loss of control. I want the media to surprise me, to contribute something unpredicted. It's that notion of media collaboration that I mentioned earlier. In order for these tools to work effectively for a lot of artists, not just me, it is essential

Thorn
Digital (GroBoto/POV-Ray/Photoshop), 2000
Created for the www.scifi.com website, this is another GroBoto model reinterpreted through POV-Ray as MetaBalls, allowing the model a mercury-like quality that melds together rather like the T1000 in James Cameron's *Terminator 2*. The result this time is decidedly more menacing than that of *Chess Bone City*. Part of the fun for Darrel is in the unpredictable geometry with which the medium surprises him.

Overleaf

dataArch
Digital (3D Studio/Photoshop), 1998
This image employed some early algorithmic creation tools Darrel developed as "plug-in" modules for 3D Studio—precursors of his GroBoto tools. These earlier tools did little more than scatter a bunch of simple geometries around randomly. Darrel achieved control over the final form by providing another larger 3D object that acted as an armature. "The image was created over a 72-hour period as a rush job for *Wired* magazine, who proceeded to destroy it in print by amping up the saturation."

that they cover a broad aesthetic spectrum. Widening that spectrum requires input from many artists, most of whom have no interest in programming. That's where genetic algorithms and artificial life come into play.

"Artificial life, genetic algorithms, new concepts in robotics, possibly intelligence and life itself centre around a concept called 'emergence.' In this context emergence refers to complexity and sophistication arising from the confluence of many small, simple, independent elements. We see this manifested in the behavior of a flock of birds, a beehive and, at least in theory, complex organisms and their minds. Emergence occurs when simple rule sets, applied repeatedly, result in highly complex forms.

"Genetic algorithms borrow from biological evolution. They use cycles of breeding (combining parts of two or more pieces of code, usually with some random mutation, to create 'offspring'), and selection (some analytical or aesthetic test applied to those offspring). Repeated over time, these cycles tend to 'evolve' code that improves with each generation. In Artificial Life (or 'ALife') experiments these genetic algorithms are employed in an attempt to evolve complex digital entities that exhibit the reproductive and survival behaviours we associate with biological life. This differs from the better-known Artificial Intelligence or 'AI,' which attempts to directly create or simulate human intelligence. ALife models much simpler forms. However, many proponents of ALife theorize that it may be the best path to AI. They believe that intelligence may well be an emergent phenomenon as well."

Darrel got his first in-depth exposure to genetic and Artificial Life algorithms in 1997 at a conference called Digital Burgess in the town of Banff on the southern side of the Canadian Rockies. It brought together programmers, palaeontologists and artists to explore relationships between biological evolution, artificial life and digital art.

"Inspired by the works of Karl Sims, Tom Ray, Larry Yaeger and others, I began folding some simple genetic algorithms into GroBoto—most recently, an aesthetic selection tool. The user can 'evolve' a 3D form from scratch, and/or cultivate new variants by crossbreeding existing 3D forms. These 3D forms combine and mutate, producing a slate of new forms. From those the artist picks the ones he or she likes best. Those picks then 'breed' and mutate—and around we go. Through this process, the users are creating 3D forms that reflect their personal aesthetic. More significantly, they are creating the algorithms that produce those forms— they are creating tools that are infused with their personal aesthetic!"

Orchid
Digital (GroBoto/POV-Ray/Photoshop), 2000
At least a dozen GroBoto scribbles were created for this model and discarded before the right elements were in place to start evolving the image for the www.scifi.com website. These sketches are not precious to Darrel as it typically only takes him less than a minute to create one. As in a real photographic studio, it is the lighting and resultant shadows, the camera angles and surface details that bring the pictures to life.

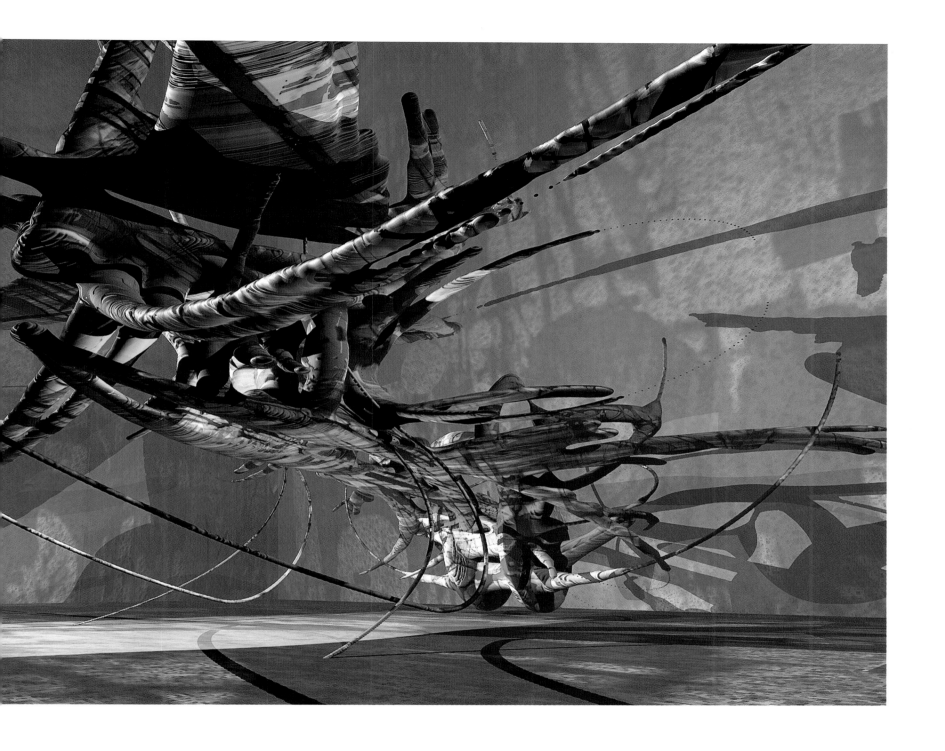

And you call this art?

"OK, I admit it, I'm back in the lab with beakers and test tubes. I'm deep into the process of image-making, experimenting with digital tool creation—art the by-product strewn around the bench. But art is still the point. I don't particularly enjoy programming, it doesn't respond too well to the evocative scribble approach, and alas I still code that way—I can't help it. That's one of the reasons I want to get this stuff to code itself. I wouldn't bother at all if it didn't ultimately lead to art.

"I'm so deep into this experiment that finding any intersection with the world of illustration is rare. Fortunately the SCI FI Channel website recently went looking for some abstract, alien, 3D graphics for the online fiction section of their site. This was a weirdly neat fit with my experiments at the time—work that had been deemed wholly unsuitable for another project despite my best efforts to round the square peg. That SCI FI Channel series of about 50 images allowed me to develop and refine some of this stuff without starving. I was developing the tools while scrambling to meet weekly deadlines—assembling the aeroplane as it rolled down the runway.

"Ultimately I think this sort of tool will be versatile enough to contribute to any artistic task. It's analogous to the early days of computer graphics, when they were confined to labs, dismissed by many as toys. Now we have the horsepower on our desktops to support the level of imaging needed to produce illustration for print and decades of development with feedback from artists, resulting in tools that accommodate myriad creative methods.

zConduit
Digital (GroBoto/POV-Ray/Photoshop), 2000
Part of a corporate art installation for Neovation at Boulder, Colorado, this piece originated in 3D Studio using predecessors of Darrel's algorithmic GroBoto tools. It was heavily reworked in Photoshop using a variety of filters and layering. This is the direction Darrel would like to go with his 3D work, much of which he feels is too clearly delineated and thus runs the risk of closing off some potential for artist/viewer collaboration. In this picture many of the rendered edges have been disturbed and the space disrupted, allowing the interpretation of the image to be less constrained.

"Genetic algorithms are beginning to yield both practical applications and hazardous scenarios on a par with any cyber fiction. My interest is primarily artistic. I believe these technologies can be used to create tools that both express and expand an individual's artistic abilities—tools created in part by the artist, and that learn from the artist.

"Digital tools will certainly continue to catch up with natural media in terms of intuitive response, richness of texture and form and quality of input and output, but I don't imagine they will ever replace them. More significantly I think wholly new kinds of creativity and collaboration will evolve. I already feel that I am, in some small way, collaborating with everyone who plays with GroBoto. I sense that I'm discovering art that I never imagined."

Science-fiction art

"As I scribble, it's survival of the fittest line. Lines that evoke a familiar or desired form are emphasized. Lines that are less useful are eliminated, or fade into obscurity as the strength of the favoured lines grows. It seems to me that it's analogous to the process going on in my brain at that very moment (and throughout my life), with neuron pathways—lines—connecting, strengthening, or fading and dropping off as my mind is wired and rewired.

"This evocative scribble method of drawing (drawing in the broadest sense, from charcoal to digital) seems similar to aspects of our brain's internal mechanisms. In turn, some of those adaptive aspects of brain and mind seem analogous to the process of evolution. There is something unpredictable, seemingly magical, about the discovery of imagery that occurs during this scribbling—perhaps a kind of emergence. It has the ability to evoke content and quality of vision beyond the artist's apparent knowledge and skill.

"I see tremendous potential in digital tools, including those that use genetic/generative/emergent strategies. I believe that creative tools that employ those strategies—strategies that probably played key roles in the development of the artist himself, as organism and creative individual—will allow us to explore uncharted places of mind and vision. Maybe it's just a fantasy, but I enjoy playing with the notion."

pipeDream
Digital (GroBoto/Photoshop), 1998
One of Darrel's earliest GroBoto constructs, this was created before he had the ability to export GroBoto models into "real" 3D programs. The textures, perspective and high resolution were all produced in Photoshop and because of this the image has less 3D rendered sterility and more evidence of the artist's hand. Darrel hopes to introduce this quality into all of his 3D work.

BIBLIOGRAPHY

The following books have more pictures by the artists within this book. Those that are now out of print may still be found in libraries and second-hand bookshops, both on the street and online.

Spectrum: The Best in Contemporary Fantastic Art 1–8 by Cathy & Arnie Fenner (Underwood Books, 1994–2001)
The Frank Collection: A Showcase of the World's Finest Fantastic Art by Jane & Howard Frank (Paper Tiger, 1999)
Infinite Worlds, the Fantastic Visions of Science Fiction Art by Vincent Di Fate (Virgin Books, 1997)

Judith Clute
The Paper Snarl Fanzine Fantasy Art Collection, ed. Paul Barnett (Paper Tiger, 2002)

Phil Hale
Goad: The Many Moods of Phil Hale (Donald M. Grant, 2001)
Double Memory: Art and Collaborations with Rick Berry (Donald M. Grant, 1992)

John Harris
The Paper Snarl Fanzine Fantasy Art Collection, ed. Paul Barnett (Paper Tiger, 2002)
Mass: The Art of John Harris (Paper Tiger, 2000)

Ian Miller
The City, co-author James Herbert (Pan Macmillan, 1994)
The Luck in the Head, co-author M. John Harrison (Victor Gollancz, 1991)
Ratspike (Gamesworkshop Books, 1989)
Secret Art (Dragon's Dream, 1980)
Green Dog Trumpet (Dragon's Dream, 1979)

Keith Parkinson
Knightsbridge, the Art of Keith Parkinson (FPG, 1996)
Spellbound, the Keith Parkinson Sketchbook (SQP, 1998)

J. K. Potter
Neurotica (Paper Tiger, 1996)
Horripilations (Paper Tiger, 1993)

Anne Sudworth
The Paper Snarl Fanzine Fantasy Art Collection, ed. Paul Barnett (Paper Tiger, 2002)
Enchanted World, the Art of Anne Sudworth (Paper Tiger, 1999)